Golf's Golden Age

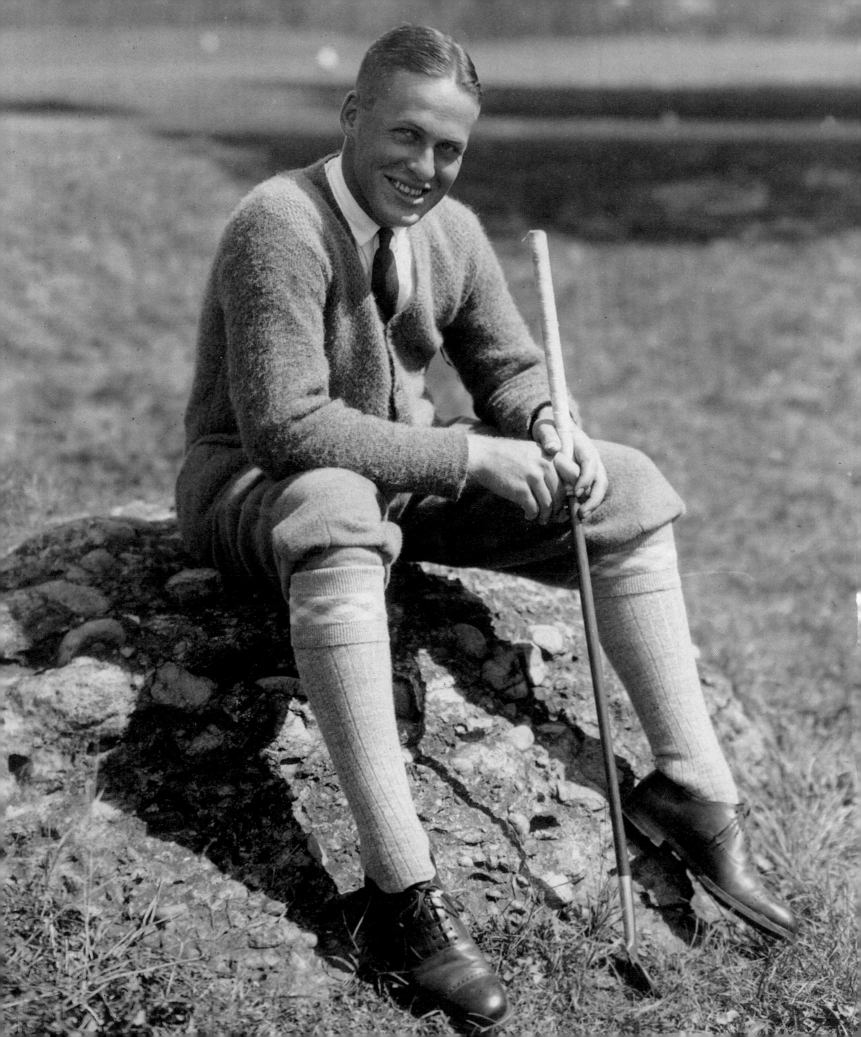

Golf's Golden Age

ROBERT T. JONES, JR.
AND THE LEGENDARY PLAYERS OF THE '10s, '20s, AND '30s

BY RAND JERRIS WITH RHONDA GLENN, DAVID NORMOYLE, AND MARTY PARKES

WITH PHOTOGRAPHS BY GEORGE S. PIETZCKER

FOREWORD BY
ARNOLD PALMER

THE UNITED STATES GOLF ASSOCIATION IN PARTNERSHIP WITH

NATIONAL GEOGRAPHIC

WASHINGTON, D.C.

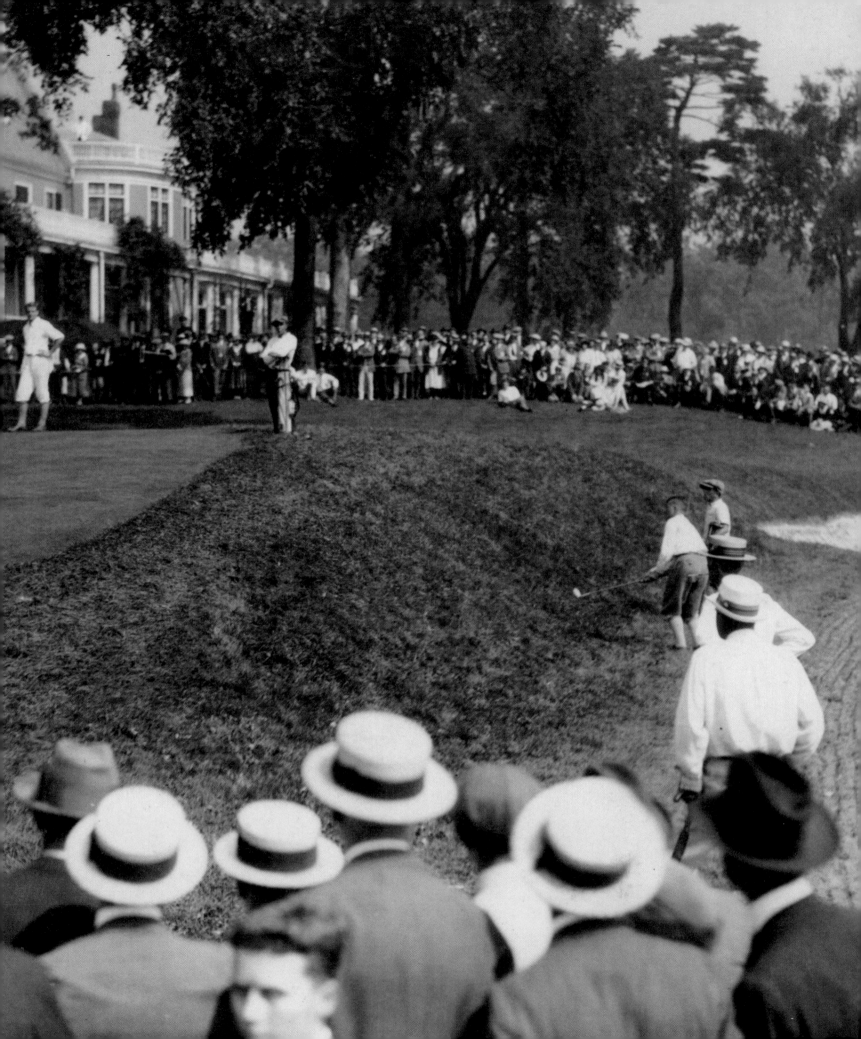

1910s	1920s	1930s
Eben Byers	Tommy Armour	Les Bolstad
H. Chandler Egan	Jim Barnes	Billy Burke
Chick Evans	Archie Compston	Harry Cooper
Robert Gardner	Bobby Cruickshank	Findlay Douglas
Walter Hagen	Leo Diegel	George Dunlap
S. Davidson Herron	George Duncan	Olin Dutra
Harold Hilton	Johnny Farrell	Johnny Goodman
Charles Blair Macdonald	Harrison Johnston	Ky Laffoon
Johnny McDermott	Joe Kirkwood	Lawson Little
Francis Ouimet	Willie Macfarlane	Don Moe
Ted Ray	Max Marston	Henry Picard
Alex Smith	Bill Mehlhorn	Charlie Seaver
Jerry Travers	J. Wood Platt	Denny Shute
Walter Travis	Gene Sarazen	Horton Smith
Harry Vardon	Macdonald Smith	Ross Somerville
	Jess Sweetser	Craig Wood
	Cyril Tolley	
	George Voigt	
	George Von Elm	
	Cyril Walker	
	Dr. O. F. Willing	

OPPOSITE: Bob Jones plays to the 18th green in his semifinal match against Cyril Tolley in the 1922 U.S. Amateur at The Country Club (Brookline).

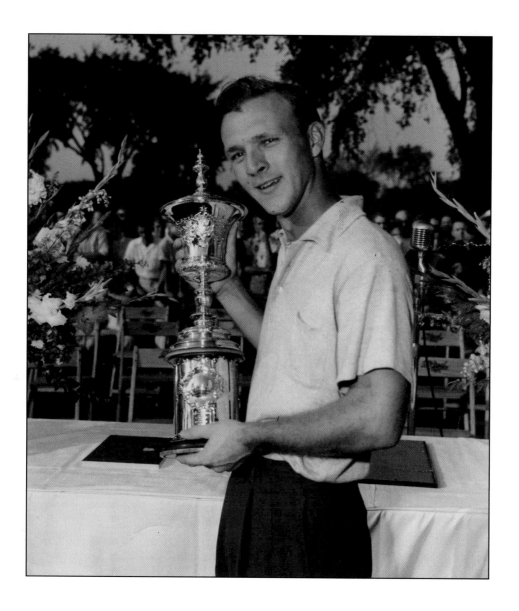

Foreword

HOW THINGS DO CHANGE WITH TIME. Many years ago when I was just a boy and golf was coming into my life for the first time, I wanted to read all about the game and its great players. That led me to Bob Jones and the marvelous career he had fashioned as an amateur player. Now, here I am many decades later honored to have been given the opportunity to express my thoughts about that legendary man and introduce this new book by the United States Golf Association commemorating the 75th anniversary of Bob Jones's historic and never-duplicated Grand Slam in 1930.

Back in my own amateur days, I gave serious thought to trying to follow in Bob Jones's footsteps as a career amateur player, but that all changed in 1954 when I won the United States Amateur Championship at the

Country Club of Detroit. I took tremendous pride in that victory and was thrilled to have my name emblazoned on the same Havemeyer Trophy that bore the name of Bob Jones an unprecedented five times. But it also convinced me that I could play the game well enough to compete successfully on the professional tour. Everything that has happened to me ever since grew out of that turning point in my life.

One of the greatest moments came the following year when I went to Augusta, Georgia, to play in my first Masters and mingled with Bob Jones and the other great players of that era whom he had invited to play in his very special tournament at beautiful Augusta National. Mr. Jones, as I always called him, was the epitome of a gentleman from the first time I met him until the last time I saw him. I felt humble and at the same time comfortable in his presence. It pleased me when he would come out on the magnificent Augusta National course to watch me play a hole or two, arriving in a cart that had already become necessary because of his failing health. I went to Augusta for the Masters for the 50th time in 2004 and marveled once again at what had evolved with the tournament Jones and Cliff Roberts had started as that spring gathering of friends.

This book is a literary treasure. It contains the exquisite and rare photographs taken by the talented George Pietzcker, most of them appearing in print for the first time here. They were among the many personal papers and photographs donated by the Jones family to the USGA's Museum and Archives in Far Hills, New Jersey, after his death. This unique publication rekindles memories of a bygone era when golf was still in its early phases of developing into one of the nation's greatest leisure activities.

Even though I never had the chance to try to duplicate Bob Jones's fantastic Grand Slam feat, I was certainly conscious of the achievement and in 1960 sowed the seeds for the creation of a modern variation of it. Why, I suggested after I had won the Masters and the United States Open that year, shouldn't golf have a Grand Slam that would be accomplished by a player winning all four of the world's major championships in the same season. Of course, I had my eye and my heart set on doing just that by winning the two remaining majors—the British Open and the PGA Championship—that summer. Unfortunately for me, it didn't happen that year nor has it happened since that time for anyone. Of all the men over the years who played in all four of the events each season, only Tiger Woods really came close in 2000.

Though a different challenge, its unsullied record offers further evidence to the remarkable nature of that marvelous feat of Bob Jones 75 years ago and should bring this book's readers an understanding of how and why it happened.

Arnold Palmer

ARNOLD PALMER
National Chairman, USGA Members Program

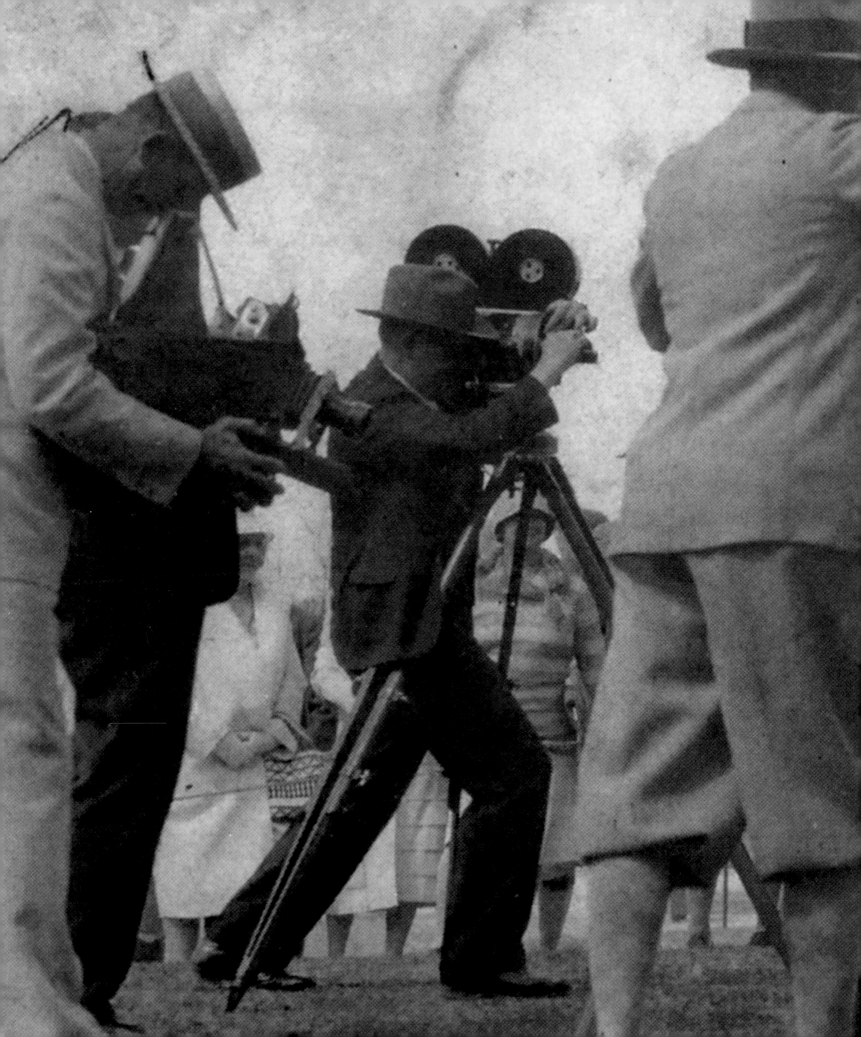

Introduction

The United States Golf Association Museum and Archives, located in Far Hills, New Jersey, is the premier repository in the United States for historical materials pertaining to the game of golf. Since its creation in 1936, the USGA Museum has assembled a collection comprising more than 42,000 artifacts, a library of more than 20,000 volumes, some half a million photographic images, and several thousand hours of historic film, video, and audio recordings. Many of the greatest figures in the history of the game have contributed to the growth of these collections.

One of the most noteworthy gifts to the Museum and Archives arrived in 1980, when the family of Bob Jones donated to the USGA his vast collection of personal papers. Some 10,000 letters to and from Jones document his friendships with many heroes of the game, from Gene Sarazen to Jack Nicklaus to President Dwight D. Eisenhower. In addition to Jones's private correspondence, the donation included several hundred photographs from his personal collection. Among these, one group of 50 photographs is of special interest.

In the 1910s, 1920s, and early 1930s—roughly the same years as Jones's competitive career—a talented photographer from St. Louis traveled the country documenting the newsworthy moments, places, and individuals of the American golf scene. George S. Pietzcker, in his role as official photographer for the USGA, captured in particular the small circle of premier amateur and professional golfers who competed against Bob Jones at the height of his career. Jones's personal collection of photographs included some four dozen remarkable portraits of these individuals. One imagines Jones, in the later years of his life stricken with syringomyelia, a debilitating and ultimately fatal disease of the central nervous system, sitting down with these very photographs and recalling the friends, colleagues, and competitors they portray.

In 1930 Bob Jones completed golf's Grand Slam, capturing in a single year the Open and Amateur Championships of the United States and Great Britain. Previously no player had come close to matching Jones's remarkable achievement, and none have since. It was, and remains today, the greatest feat in the history of the game. In a way, this book celebrates the 75th anniversary of the Grand Slam. It does not, as other books that will certainly be published this year, set out to document in detail Jones's four championship victories. Instead, this book aims to illuminate the great players that Jones played with and battled against at the height of his career. It is our intent to present an intimate portrait of the legends and heroes of golf's Golden Age.

OPPOSITE: George Pietzcker (standing at left) at work at Pinehurst in the early 1920s

George Pietzcker

THE MAN BEHIND THE CAMERA

A REMARKABLE PHOTOGRAPHER FROM ST. LOUIS BY THE NAME OF GEORGE PIETZCKER traversed the country documenting the personalities, places, and happenings of the golf world from the early 1910s until the mid 1930s. For almost 30 years, "Photo" Pietzcker was a fixture at every major golf tournament played in America. In the course of these three decades, he amassed a collection of golf photographs that by some estimates exceeded 15,000 images.

Born in the small town of Sour Lake, Texas, on January 18, 1885, George Sealy Pietzcker received his formal training at the Illinois College of Photography in Effingham, Illinois. He returned to his family's home in St. Louis upon his graduation and opened a studio in a house on Clemens Avenue. Early in his professional career Pietzcker accepted assignments from several St. Louis newspapers, including the *Globe-Democrat*, *Star*, and *Post-Dispatch*. During World War I, he enlisted in the U.S. Army as a member of the Photographic Division of the Signal Corps and was placed at the front as an aerial photographer.

But it was as a photographer of the American golf scene that Pietzcker secured his reputation. He attended his first golf tournament one year after completing his studies in Illinois, working the 1906 Western Amateur at the Glen Echo Club in St. Louis. Apparently he was quite taken with the game, its colorful players, and rich landscapes, for then and there he decided to specialize in golf photography. For several years his work appeared in Chicago-based *Golfers' Magazine*, but his reputation quickly spread and soon his images were picked up by all of the major golf periodicals of the day, including *American Golfer* and *Golf Illustrated*.

In 1913 Pietzcker covered the U.S. Open for *Golf*, an early publication of the United States Golf Association, where he captured some of the most indelible images of Francis Ouimet's historic victory. Soon thereafter he signed on as the official photographer of the USGA. For the next 20 years he provided a visual record of the country's national championships and champions.

Many of the photographs that Pietzcker created were journalistic in nature, intended simply to document the important events, places, and individuals of the championship golf calendar. Most remarkable among Pietzcker's works, however, are the photographic portraits he created of the notable golfers of his day. These full- and half-length portraits captured the individual character, style, and personality of his subjects more successfully than any golf photographer previously. During the 1920s and 1930s, Pietzcker advertised and sold framed prints of these portraits to individuals and clubs around the country. There is no record of how many sets of these "National Golf Champions" Pietzcker may have distributed. Today they are extremely rare. In the mid-1930s, Pietzcker relocated his studio to Miami Beach, Florida. He attended fewer and fewer championships as the years passed, and his reputation as one of the game's greatest photographers was slowly forgotten. George Pietzcker passed away in December, 1971, the same month and year as Bob Jones, leaving a rich visual legacy of golf's Golden Age.

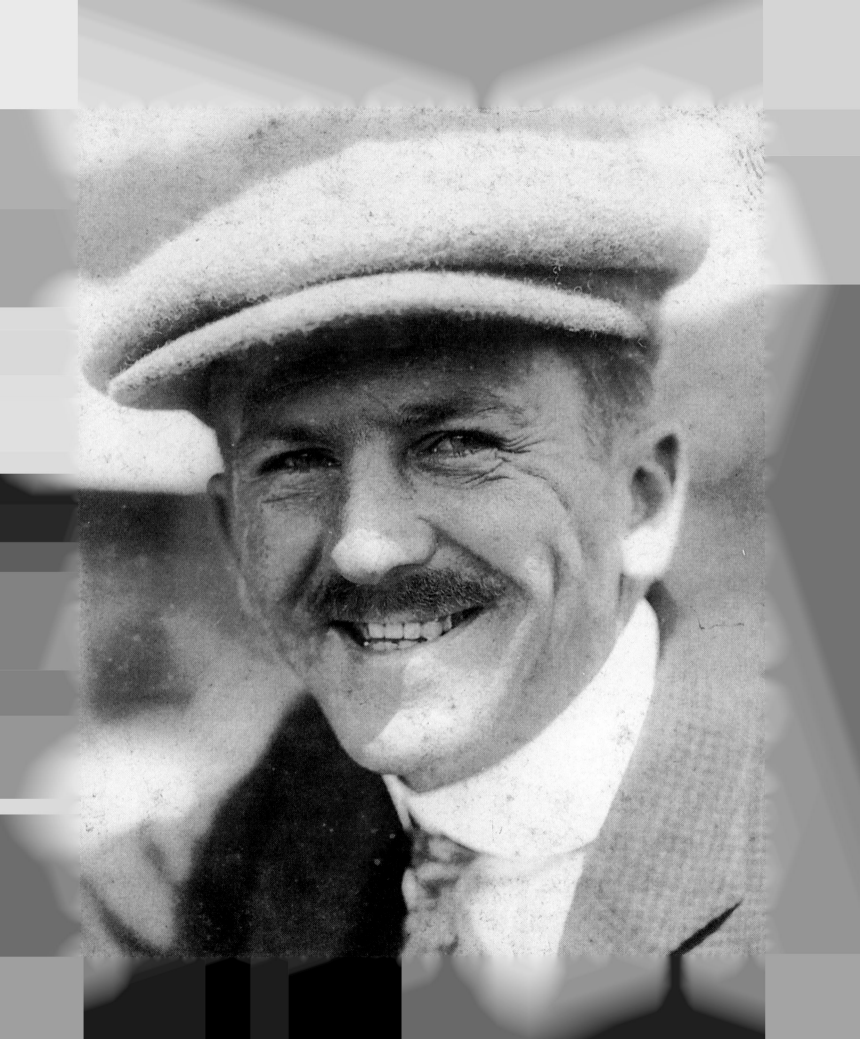

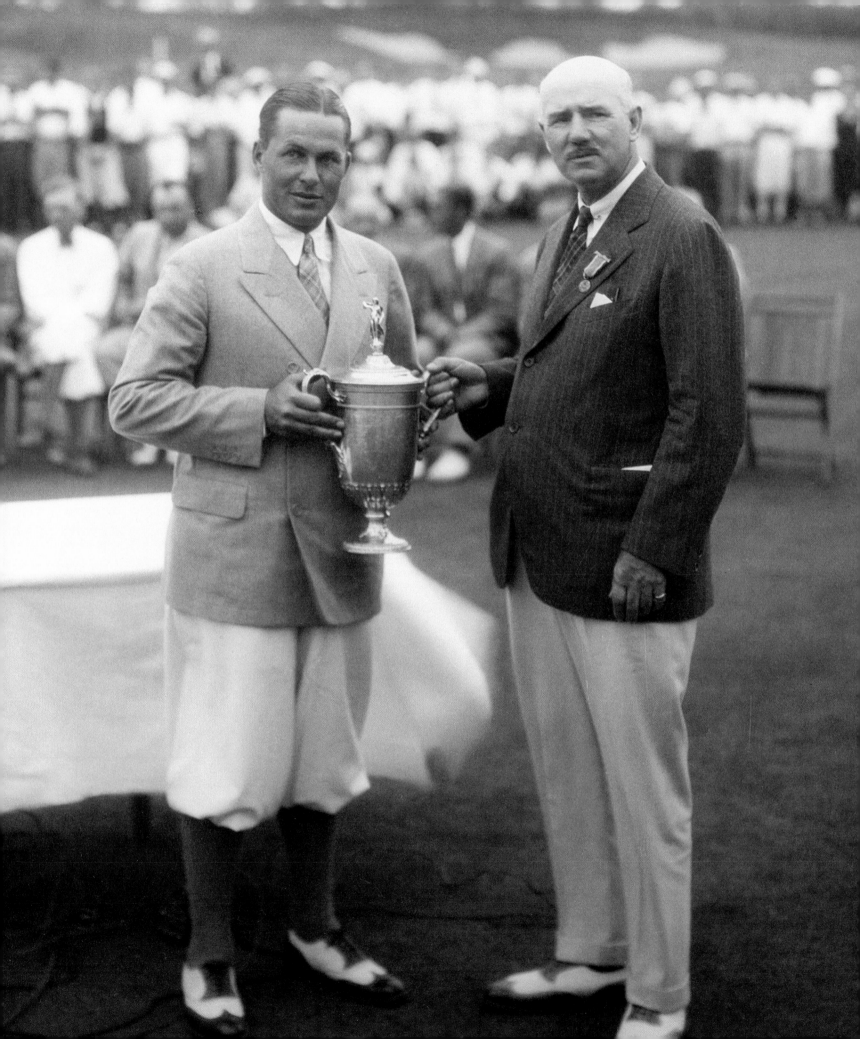

The Meaning of
Jones's Grand Slam

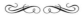

ON JULY 2, 1930 THE OCEAN LINER *Europa* sailed into New York harbor bearing a precious piece of cargo. Cigars were stamped for the occasion, statuettes were cast, and Broadway's Canyon of Heroes prepared to receive a familiar face. On this warm summer day a massive policeman, dressed in the heavy blue wool of the New York Police Department, struggled to balance his physical discomfort with the burden of controlling the swelling crowds. A man walking up Broadway approached the obviously distressed officer and asked, "What's the parade for?" The officer replied, quite officiously, "Oh, for some godamned golf player!" In later years, when Bob Jones heard this story, it became one of his favorites. After all, he was the object of the parade celebration.

Since 1886 there have been more than 200 ticker-tape parades in New York to honor heroes—homebred and foreign-born—and to commemorate the great accomplishments of the age. Receiving such a parade represents a cultural pinnacle of sorts. Few know that Robert Tyre Jones Jr., a golfer, was the first individual to receive the honor twice. It was neither the first nor the last time he stood apart from the crowd.

Why did Jones stand apart? Why did who he was and what he did matter? One possibility is that he was golf's answer to the celebrated Mozart, a child prodigy with limitless potential. Yet how often in history has the legacy of such potential equaled its promise? In that alone Jones was exceptional: he exceeded an entire sport's understanding of what was possible. He performed at a level previously unmatched and seemingly unmatchable for as long as the game will be played. He provided a stark contrast to the conven-

OPPOSITE: USGA President Findlay Douglas presents the U.S. Open trophy to Bob Jones after his victory at Interlachen in 1930.

tions of the day—a true amateur in a commercial age. And that overtly individual success made a bold statement about what one person with character could achieve in an increasingly automated world. Yet in all his pursuits he was reluctant to wrap himself in the praise of others, a quality that made him even more compelling.

America produced an inordinate number of heroes in the 1920s. Sport, particularly, spawned more than its share. Putting together a laundry list of notables isn't much of an exercise. The names Babe Ruth, Red Grange, Jack Dempsey, and Bill Tilden roll off the tongue of the literate sports fan as would the names of the Founding Fathers to an elementary school teacher. The exploits of these heroes followed a similar pattern: individual conquers all, shatters records, and propels his sport into the future. And the public's interaction with them struck a common theme, as well, with mass adulation, aided and abetted by the rise of mass communications. For heroism, like fire, requires multiple ingredients to come alive; without just one, the light goes out. If fire's three critical elements are heat, oxygen, and fuel, the formula for heroism is analogous: achievement, recognition (though mass communication), and public adulation.

This long decade between World War I and the onset of the Great Depression witnessed the development of a number of important cultural forces that affected how average Americans understood the world around them, forces that informed the role sport played in their lives. The advance of technology through mass production, and the consumerism that rode its coattails, made people feel less like individuals with a stake in the American experiment and more like the machines they increasingly operated on a daily basis.

Popular films of the day portrayed industrial workers packing themselves into street cars and factories like sheep to the slaughter—never knowing where they were heading, but making sure they kept their noses to the tail in front of them. They were, as historian Roderick Nash called them, "the Nervous Generation," having to balance the unhappy memories of the Great War with the economic change and prosperity of the decade. Paradoxically, morality was increasingly legislated while moral relativism was on the rise, the former through Prohibition and the latter through new global social and political movements. The Roaring Twenties may seem glamorous in retrospect, but beneath the surface was a profound anxiety.

Much of the anxiety with the modern world, and the heightened embrace of individual heroes, came from a fear that the American moral character was eroding. Since the early 1890s, when the federal census declared the American frontier "closed" and Frederick Jackson Turner advanced his theories about the relationship between the strength of the American spirit and the hard edges of the frontier, the country had become increasingly urbanized, commercialized, and with the massive influx of immigrants, ethnically divided. There was a widespread concern that America was becoming just another country, that it was no longer exceptional. The public sought to celebrate the individuals who fulfilled what Americans, collectively, feared they had lost.

Since the earliest times, sport had been a metaphor for man's struggles against nature, himself, and his fellow man. And that's where heroes of the age came in. Bob Jones wasn't a hero because of the Golden Age. The Golden Age became what it was because of the accomplishments of heroes like Bob Jones. He shared the formula of heroism with the others, he had his achievements, the recognition, and the adulation, but even then he was an anachronism—an individual out of place and time in the modern world. He was of the Golden Age, but he clearly stood apart.

On that July day in 1930, at 28 years old, Jones was honored like visiting royalty, only better. Handsome, modest, and uncertain about being introduced as the "greatest golfer in the world by the worst (New York Mayor Jimmy Walker)," Jones was just two months away from his sport's defining accomplishment and four months away from retirement from the game. It's safe to say the blasphemous policeman didn't have an inkling that either of those things would come to pass.

There is a temptation to accord sweeping cultural importance to an event such as the Grand Slam. But the policeman's indifference to Jones's place in golf history teaches us something about the finicky nature of heroes, confirmed by Jones himself, who said: "The proof was convincing that not everyone in New York had been quivering with delighted excitement at my triumphant return."

Accolades came fast and furiously for Jones in the summer of 1930. Quite apart from his record-setting appearances on Broadway, he became not only the one man ever to win the British Open, British Amateur, U.S. Open, and U.S. Amateur in a single year, he is the only one, amazingly, to do so in an entire career.

Jones had been down the Canyon of Heroes before, after his first victory in the British Open in 1926, but this time was different. That July he was halfway to the curiously named "Impregnable Quadrilateral." Expecting to see the recently captured prizes from the British Amateur and British Open championships, Atlantans by the thousands rode a special train up from Georgia to welcome their Bobby home in person. They were not disappointed, even if the object of their affection was quite overwhelmed by the attention.

By this point in his career, even the most unsophisticated fan would assume that Jones had grown accustomed to lavish celebrations in his honor. He had been a known quantity on the national golf scene since he was 14. In July of 1930 he had just earned his 11th major championship victory since 1923, with two more to come. Yet he never quite got the hang of relishing what it meant to be adored. He was never totally comfortable as a hero. Again, his reluctance as a hero made him even more attractive.

Three years earlier, a fair-haired, then 25-year-old aviator from Minnesota was fêted in similar fashion. He was not known for his golf accomplishments. He did, however, change the world in his own way. Charles Lindbergh shared several key traits with Bob Jones, not the least of which was his desire to shed fame's harsh glare. We know that in 1927 Lindbergh flew the *Spirit of St. Louis* solo across the Atlantic to appreciative headlines around the world. He cast off the shackles of history to soar into the modern world, or he rejected the crass anonymity of the modern world to champion the individual—both are paradoxically true. In their individual achievements Lindbergh and Jones did the same thing: they attained the unattainable.

"Lindbergh said that the hardest thing he had to do in crossing the Atlantic was to keep awake," wrote Jones about the man just 41 days his senior, born, as he was, in 1902. "It is not so easy," he continued, "to understand why the hardest thing a golfer has to do is keep awake—mentally." It would be something if Jones wrote these words in the autumn of his life, looking back and searching for meaning in his career. But Jones published the article called "The Hardest Thing in Golf" in the June 1930 edition of *American Golfer*. Jones was in the midst of accomplishing the hardest thing in golf, the one thing that will almost certainly never be done again, and it is clear that Lindbergh's struggles as the reluctant hero of a staggeringly individual feat weighed heavily on his mind.

Jones made his way directly from the tickertape parade in New York to Lindbergh's home state and won the U.S. Open at Interlachen, in Minneapolis, by two strokes over the strongest field in all of golf, professional and amateur alike. The distinction between the two is an important part of Jones's story, that much is known, but it serves a more important purpose here.

To examine Jones in the light of his contemporaries and defend the claim that he was an anachronism, understanding the appeal of his amateurism and his lack of commercialism is essential.

Jones was different from Ruth, Grange, Dempsey, and Tilden not just because he was an amateur in their professional world but because, unlike them, Jones was

Scorecard from the final of the 1930 U.S. Amateur Championship when Bob Jones defeated Gene Homans to claim the final leg of the Grand Slam

clearly not the model for future generations of athletes in his sport. How many of Jones's Golden Age heroes can claim degrees in Engineering and English Literature from Georgia Tech and Harvard? How many can claim to have studied law at Emory and possess a graceful gift for language, an ease with history, wit, and allusion that most thinkers would envy? Or better yet, how many athletes of his caliber in the succeeding 75 years can stake a claim to Jones's intellectual talents? The short answer: none. Jones was singular not only as an athlete, but as a man actively engaged in the modern world.

As America emerged from its Golden Age of sport its standard bearers were commercialized athletes playing for pay. Jones may have inspired countless youngsters to play golf, but the great ones didn't follow his lead when it came to amateurism. They admired Jones but they made their living like Walter Hagen. There have been amateur golfers of great distinction in years following Jones, though not since John Goodman in 1933 has a true amateur won the U.S.

GOLF HOUSE
EAST COURSE

Thirty-fourth
NATIONAL
AMATEUR
GOLF CHAMPIONSHIP
September 22·23·24·25·26·27 *1930*
MERION · CRICKET · CLUB
ARDMORE·PENNSYLVANIA

Open. Jones wasn't the last of a reluctant, dying breed that refused to seek adoration for its greatest feats, but his achievement represented a coda. After Bob Jones, amateurism began its gentle march into a long good-night—it ceased to be an end in itself, it simply became a step toward professionalism. Unlike so many other Golden Age heroes, Jones's greatest composition was his requiem.

There's a certain irony that Jones's great triumph will probably never be repeated. A hallmark of individual achievement is that it signals progress, is repeatable and inspirational. Achievers achieve and the rest of us follow. They open the door to the impossible and then others spend part of their lives trying to walk through it. Lindbergh certainly did this. Yet in spite of humanity's march forward and the general ascension of sport, what Jones did will, in all likelihood, never be done again.

It is said that when Lindbergh landed safely in France 33 hours and 30 minutes after taking off from Long Island, New York, he remarked simply, "Well, we've done it." A writer of the day pointed out that Lindbergh, in 1927, "had no idea of what he had done. He thought he had simply flown from New York to Paris. What he had really done was something far greater. He had fired the imagination of mankind."

When it was finally over for Jones, when he turned Gene Homans into a historical footnote, 18,000 people surrounded him on the 11th green at Merion Cricket Club in suburban Philadelphia. It wasn't like the countless thousands at Le Bourget Aerodrome outside Paris who rushed Charles Lindbergh and made his accomplishment theirs, and that was for two key reasons. First, Jones was already a great champion before the Grand Slam; it was not a moment for him to be snatched from anonymity. Second, and more elusive, is that Jones's achievement can be understood only by Jones himself. It can be celebrated, but never fully understood. History counts on one hand the number of competitors who possess the make-up to do what Jones did, even though they never could. Lindbergh was merely the first in a long line.

In the closing moments on that green at Merion, Jones experienced similar feelings about the smallness of it all. In the moments after he completed the Grand Slam he only had the achievement of that day to comprehend. Even among 18,000 people and the thousands listening to the radio broadcast, the recognition and public adulation hadn't fully consumed him. He described a "wonderful feeling of release from tension and relaxation" that he had been wanting so badly for so long a time.

The reluctant heroism and humanity of Jones is something that sets him apart from his Golden Age colleagues and also keeps him at a bit of a distance. He was lovable, though not in the roguish sense like Babe Ruth. He had the qualities of the hero but his greatness is not by nature empathetic. He was, as a result, revered more frequently than he was embraced. Much of that stems from the individual and solitary nature of his accomplishment. It just seems so impossible to fathom that we cannot grasp its magnitude, even 75 years later, for it is so deeply personal. If anything, time has clouded our understanding of him more than it has revealed it. The hardest thing in golf, or in flying, is indeed to stay awake. How Jones managed it we will never fully know.

— DAVID NORMOYLE

OPPOSITE: Official program for the 1930 U.S. Amateur Championship **Above:** Tickets for the final two legs of the Grand Slam, the 1930 U.S. Amateur and U.S. Open

A Note on Match Play
and Amateur Championships

MOST GOLFERS TODAY ARE FAMILIAR WITH THE STROKE PLAY FORMAT— every shot is counted and the player with the lowest score wins. But match play, the oldest form of competition, is not as commonly understood.

During golf's Golden Age, amateur golf competitions such as the U.S. Amateur and U.S. Women's Amateur were conducted principally at match play. Following two qualifying rounds of stroke play, the players with the lowest aggregate totals were either seeded or randomly arranged in elimination brackets. Play then proceeded completely at match play. The winners of each match advanced until there was only one player left. With 64 players, this occurred after six matches.

Match play is a competition scored by holes rather than total strokes. The match always starts at "All Square." That is, the match is even and neither player has an advantage. A player may win a hole if he completes the hole in fewer strokes than his opponent. It does not matter how many strokes the hole is won by. For example, Player A may score a four on a hole and Player B may score a seven, but Player A would be "1 up" for having won the hole, although the hole was won by three strokes. If the players complete the hole in the same number of strokes, it is said that they have "halved" the hole.

In an imaginary match between players A and B, A wins the 1st hole, and so is 1 up. After A wins the 2nd hole, A is 2 up. The players halve the 3rd hole, so there is no change in the status of the match. B then wins the 4th hole, which leaves A once again 1 up. B wins the 5th hole, so the match returns to All Square. When B then wins the 6th hole, he takes the lead, 1 up.

The match continues in this fashion until one player is leading by a greater number than the number of holes left to be played. For example, if B is 5 up with four holes left to play, the match is over. Player A cannot possibly come back. B is said to have won the match, "5 and 4." If the players are still All Square after the 18th hole, the match is continued hole by hole until a winner is determined.

While match play is unfamiliar to many players, it is one of the most exciting forms of golf competition.

OPPOSITE: Cover from the official program
of the 1928 U.S. Open at Olympia Fields

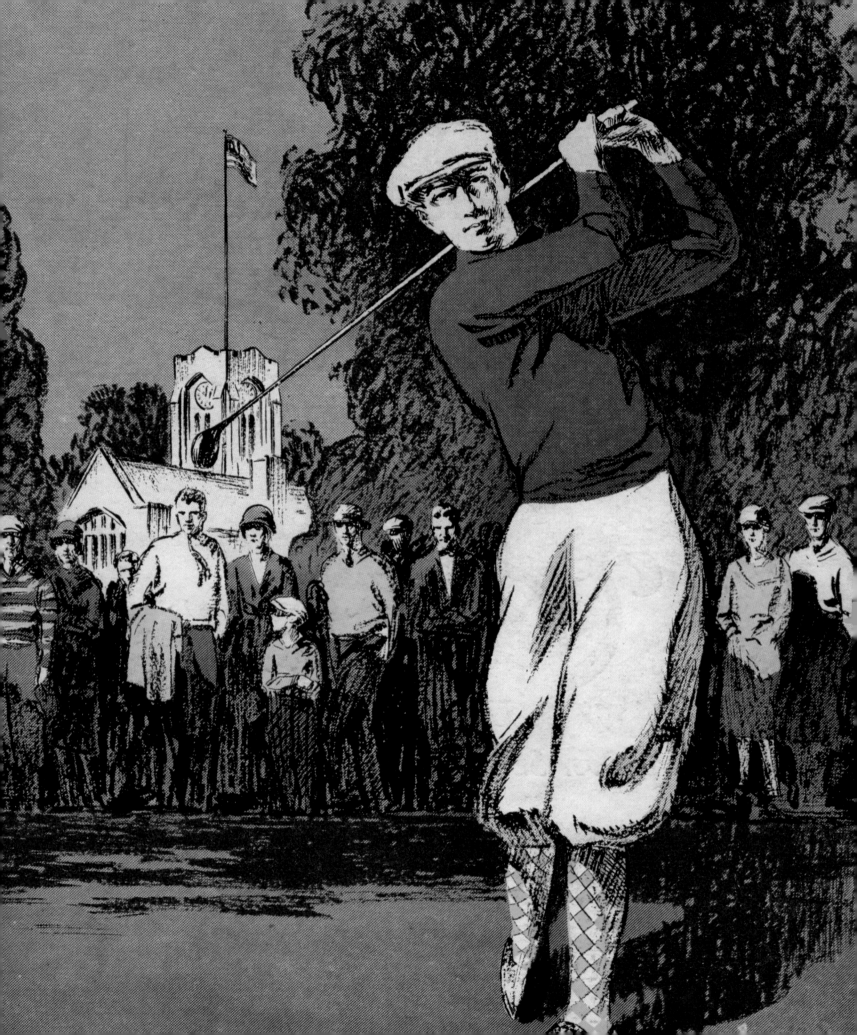

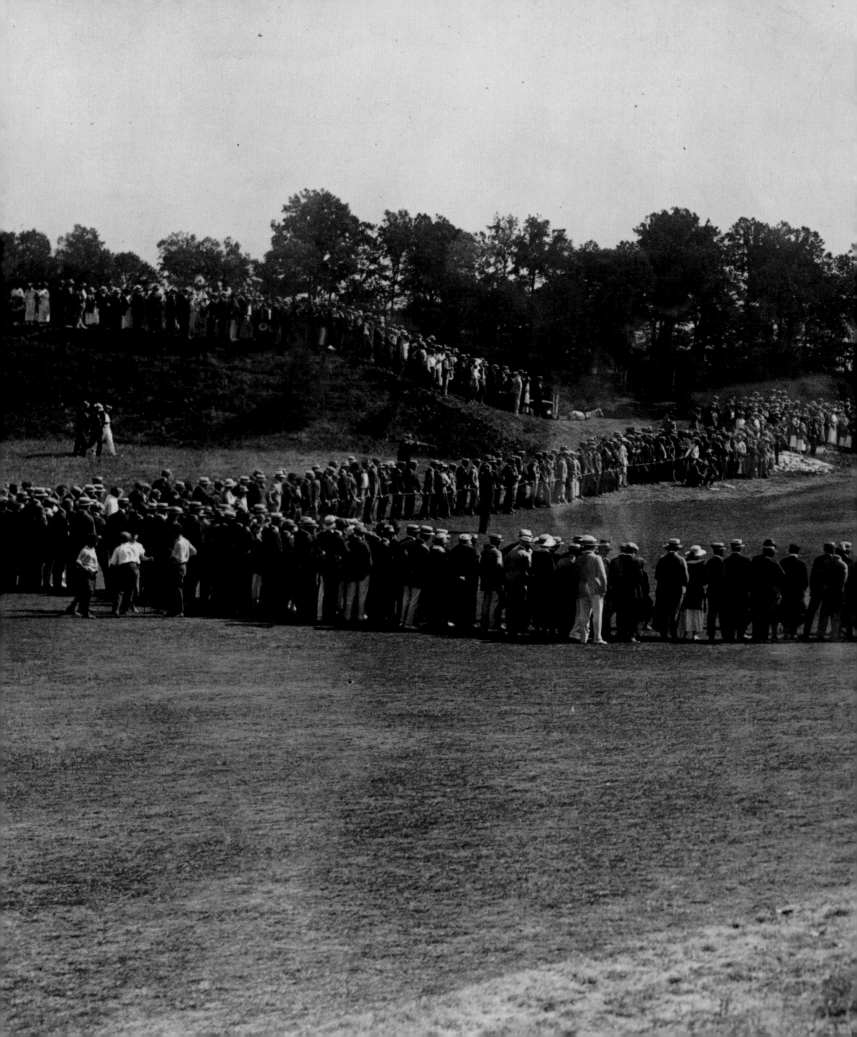

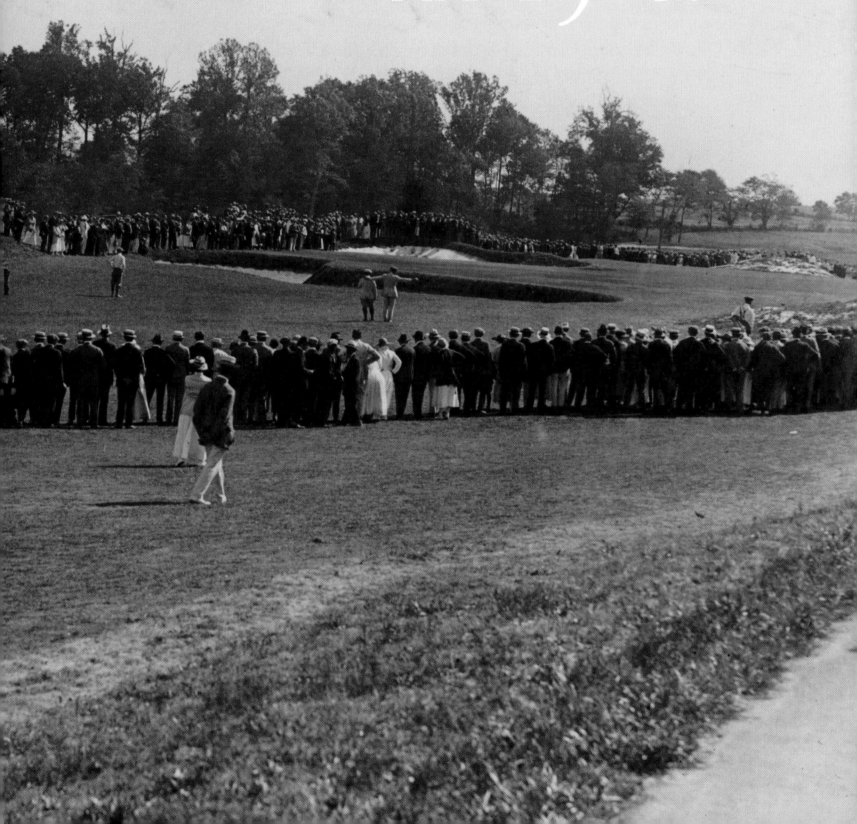

THE 1910s

ONCE GOLF WAS INTRODUCED IN AMERICA, its spread was swift, sure, and intoxicating, but it would take some years before American players would win their own national championships.

At the turn of the century the destination of a majority of English and Scottish players had been the United States. The first 16 winners of the U.S. Open were either Englishmen or Scotsmen and it wasn't until 1911 that America produced a champion. He was John J. McDermott, a self-assured, determined product of the Philadelphia caddie sheds. McDermott feared no one on a golf course and won again in 1912, incidentally becoming the first man to break par for 72 holes.

In 1913 a young Massachusetts amateur picked up the torch for the American side. Francis Ouimet caused a sensation when he upset the legendary British pro-

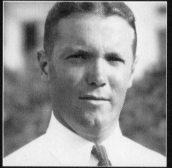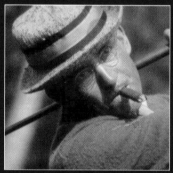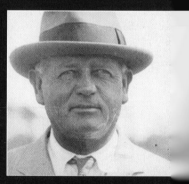

fessionals Harry Vardon and Ted Ray in an 18-hole playoff at The Country Club to win the 1913 U.S. Open. Ouimet's victory caused a groundswell of interest among Americans and, at 20, he had captured the fancy of the multitude and contributed largely to the popularity of the game among his nation's players.

Together, McDermott and Ouimet ushered in an era of American dominance. One after another, Americans ruled their national open. Golf's most colorful personality, Walter Hagen won in 1914, imbuing the championship with dash and color it had not previously known. Amateurs Jerome Travers and Charles Evans,

ABOVE LEFT TO RIGHT: Chick Evans, S. Davidson Herron, Walter Travis, Alex Smith

Jr., were part of the American wave that rolled over the championship when they won in 1915 and 1916, respectively.

The Scottish and English professionals were still playing well, just not well enough to beat the Americans on their own soil. After McDermott's win in 1911, there were only 12 foreign-born winners of the U.S. Open over the next 94 years.

American emergence was just as marked in the U.S. Amateur. Whereas seven foreign-born players won the championship prior to 1912, in the next 93 years Americans would win all but four titles.

The native-born Travers was just 20 when he first won the Amateur, in 1907, and he repeated in 1908. By 1912 he was a seasoned player and easily captured the Amateur two years running. The 1916 Amateur was notable in that it marked the

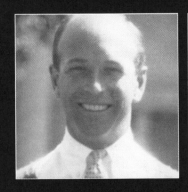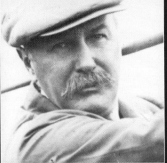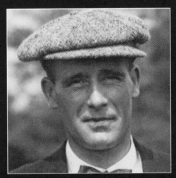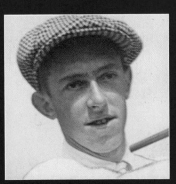

first appearance of Bob Jones in a USGA championship. While he was just 14 years old, he advanced to the quarterfinals, giving notice of the prodigious career that was yet to come. Meanwhile, Ouimet, Evans, Robert Gardner and Davy Herron, Americans all, would dominate the U.S. Amateur throughout the decade.

They came out of the caddie yards and collegiate ranks, they emerged from such diverse playing fields as hardscrabble professional tournaments and country clubs, but American golfers of every stripe were honing their talents and beginning to dominate the game.

— RHONDA GLENN

ABOVE LEFT TO RIGHT: Robert Gardner, Charles Blair Macdonald, Harold Hilton, Francis Ouimet

Eben Byers

E BEN MACBURNEY BYERS WAS AN AMERICAN CLASSIC, a turn-of-the-century millionaire with a love of fine living and a taste for the exotic. Moreover, he was an ardent sportsman, particularly enamored with golf. In the late 1800s, his father had founded the A. M. Byers Company, one of the world's largest manufacturers of iron pipes. The young Byers ostensibly went to work for his father upon his graduation from Yale in 1901. In reality, he spent most of his time enjoying his family's vast financial resources, traveling the world to compete in tournaments at prestigious clubs.

In 1902 and 1903 Byers advanced to the final of the U.S. Amateur, but lost each time. Based upon his success in the national championship, but also on his ardent promotion of the game, the then 25-year-old Byers was elected to the USGA Executive Committee in 1905. Just one year later, Byers's efforts were ultimately rewarded when he defeated Canadian champion George S. Lyon in the final at Englewood Country Club, becoming the first sitting member of the Executive Committee to capture a USGA Championship.

During the 1916 U.S. Amateur at the Merion Cricket Club outside Philadelphia, Byers came face to face with the future of American golf. At the age of 14, a young prodigy from Atlanta by the name of Bob Jones had advanced to the match-play rounds, where his first opponent was the national amateur champion of 1906. To the great surprise of the gallery and the media, Jones defeated Byers, 3 and 1. Not only did Jones consistently outdrive the former champion, but as the correspondent for the *New York Times* noted, "the really remarkable part of his play was his recovery from awkward positions, where the most hardened veteran might have been pardoned for losing his head or courage." In truth, Jones spent much of the day battling his fierce temper. Following the match in which both players were witnessed tossing clubs, Jones quipped, "We both showed our tempers out there, and I only won because he ran out of clubs first." Byers's defeat by Jones in 1916 marked the end of his competitive career in the U.S Amateur, as he never again advanced past the stroke-play qualifying rounds.

Yet despite his lasting contributions to the game he loved, the most remarkable aspect of Byers's life may well have been his tragic death. While recovering from a freak injury sustained on board a cross-country train, Byers became addicted to Radithor, a blend of water and radium that was the preferred curative in wealthy social circles. Indeed, Byers became so intoxicated with the drug that he consumed as many as 1,400 half-ounce bottles in the two years that followed. The sad reality, however, was that the radium caused the disintegration of his flesh and bones. When he stopped taking Radithor in 1930, Byers was losing weight rapidly, his teeth were falling out, and he was suffering from terrible headaches as the radium eventually rotted holes in his skull. He passed away two years later at the age of 51.

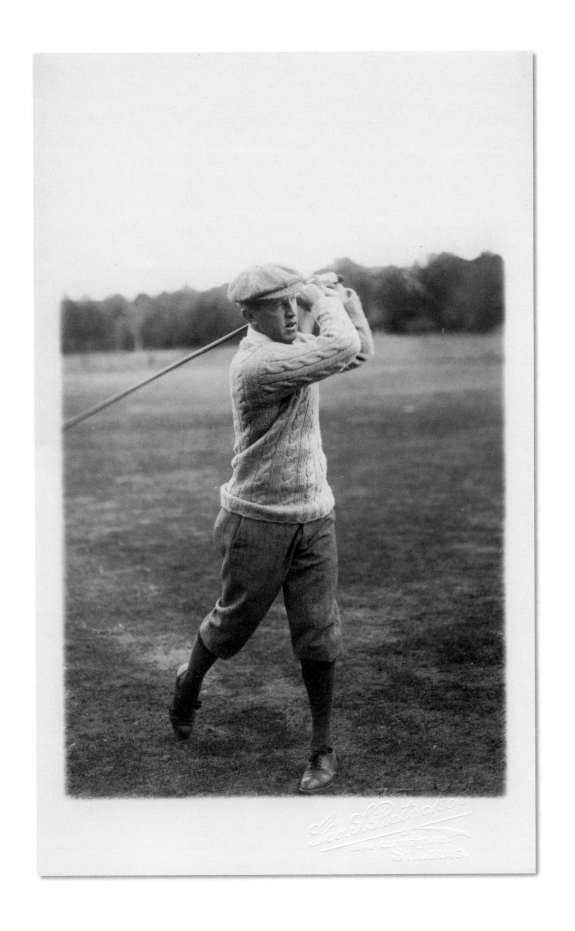

H. Chandler Egan

———

I N THE EARLY YEARS OF THE 20TH CENTURY, HENRY CHANDLER EGAN emerged as one of the premier players in America. He captured the Intercollegiate title in 1902 as a sophomore at Harvard. That same year, he defeated his cousin Walter to claim the prestigious Western Amateur, then followed up with victories in the same championship in 1904, 1905, and 1907.

During a time when amateur golf was dominated by players from the East Coast, Egan, a Chicago native, gained national prominence by winning the U.S. Amateur at Baltusrol Golf Club in 1904. After claiming medalist honors in the qualifying rounds, Egan rolled through the match-play bracket to face Fred Herreshoff in the final. Just 18 years of age and about to enter his freshman year at Harvard, Herreshoff was overwhelmed by the "veteran" Egan, who had one year remaining in his collegiate career. Egan led by nine holes at the end of morning play, and closed out his opponent in the afternoon for a decisive victory, 8 and 6.

The following summer Egan defended his title at the Chicago Golf Club. Playing before an enthusiastic home crowd, Egan battled his way through a field characterized as the best assembled to date for the amateur championship. In the all-Chicago final, Egan was in the rough more often than not, but still defeated D. E. Sawyer, 6 and 5. One observer remarked that watching Egan play was "as good as reading *Roughing It* by Mark Twain."

Seemingly at the height of his career, Egan abruptly disappeared from national competition a few years later. He moved to Oregon in 1911, to a farm with 115 acres of apple and pear trees located 300 miles from the nearest golf course. For several years his orchard prospered, and Egan had little to do with golf. When he eventually returned to competition in 1914, he advanced to the final of the Pacific Northwest Amateur, where he lost to Jack Neville. The following year at the Tacoma Country and Golf Club, Egan exacted revenge upon Neville in the semifinals, then defeated former California Amateur champion Paul Ford to claim his first of five Pacific Northwest Amateur titles.

It wasn't until 1929 that Egan again entered the U. S. Amateur. This was his first appearance in the championship since 1909, when he finished runner-up to Robert Gardner. Earlier in the year, Egan had partnered with Alister MacKenzie on a remodeling project at Pebble Beach to prepare the course for the championship. He knew the course well, and though he had not played in national competition for 20 years, his game remained sharp as ever. To the delight of the galleries and the media, the 45-year-old advanced to the semifinal round before losing, 4 and 3, to Doc Willing.

Egan secured his final Pacific Northwest Amateur in 1932, and in 1934 was selected to represent the United States in the Walker Cup. Shortly after his move to Oregon, Egan established a reputation as a golf course designer, completing many significant projects on the West Coast before his unexpected death from pneumonia in 1936.

Chick Evans

———◆———

I N THE 1920S AND EARLY 1930S, IT WAS NOT UNCOMMON for a championship golfer to carry 20 or even 30 clubs in his bag. Some players carried two sets of clubs—one right-handed and one left-handed—should they find their ball in some precipitous location. One notable exception was Chick Evans, the legendary amateur from Chicago. In the 1929 U.S. Amateur at Pebble Beach, Evans sported just seven clubs—driver, brassie, spoon, driving iron, mashie, niblick, and putter. "How he does it is hard to say, for he never seems to lack the shot called for," Bob Jones once noted. "Possibly he figures that it is better to know a few clubs well, than to have a slight acquaintance with a great number."

Evans, whose competitive career spanned more than 50 years, was endowed with remarkable creativity and shot-making skills. He began winning local tournaments at the age of 17. In 1909 he posted his first significant victory at the Western Amateur, a championship he would win eight times. Thereafter, the victories flowed steadily—the Western Open in 1910; the French Amateur and North and South Amateur in 1911; Western Amateur titles in 1912, 1914, and 1915. In 1916 he became the first player to secure the U.S. Amateur and U.S. Open titles in the same year. In 1920 he won the U.S Amateur again. For a period of 15 years, Evans was among the elite players in America, amateur or professional. Had he not run into Bob Jones, who soon replaced Evans as the premier amateur in the game, his career might have been even more remarkable.

Evans and Jones first faced off at the 1920 Western Amateur in Memphis. Playing some of the best golf of his young career, Jones radiated confidence when he met Evans in a 36-hole semifinal. "We sparred like boxers," Jones recalled, and the two stood level with two holes remaining. Playing the 35th hole of the match, Jones looked in good position to gain the advantage. His ball was on the green in two, while Evans's approach found the bottom of a deep grass hollow. Evans managed a fine recovery, pitching his ball to 12 feet and sinking the putt for four. Meanwhile, Jones struck his approach putt wide, leaving himself six feet to halve the hole. "I'll never understand my own putt," said Jones, "which hit the cup, ran clear around it, and came out on the same side as I was, and looked me in the eyes and said: 'You're licked!'" And he was. Evans claimed a 1-up victory by playing safely at the last.

"We had one of the greatest matches I ever took part in," Jones would later write, "and I want to say that the way he beat me proved, to my mind, that Chick is one of the gamest and best competitive golfers the world ever saw."

Evans may have defeated Jones at Memphis in 1920, but Jones never lost to the same man twice. He exacted his revenge in the 1926 Amateur at Baltusrol, defeating Evans in the quarterfinals, 3 and 2.

Robert Gardner

N June 1, 1912, a Yale senior named Bob Gardner established a new world record in the pole vault, soaring 13 feet, 1 inch, in the National Intercollegiate Championships at Franklin Field in Philadelphia. A remarkable individual with surprisingly diverse talents, Gardner was the captain of the track team and golf team at Andover Academy and Yale. He was also head and second tenor of the famed Yale Glee Club. In 1926, as a member of the Racquet Club of Chicago, Gardner teamed with college friend Howard Linn to claim the 1926 National Racquets Doubles Championships. And he was a two-time U.S. Amateur golf champion.

From 1909 to 1926, Gardner ranked among the elite in American amateur golf. He reached the final of the U. S. Amateur four times, claiming the title in 1909 while a freshman at Yale, and returning six years later to defeat John Anderson in the final at the Country Club of Detroit. Gardner also played on the first four American Walker Cup teams, compiling a record of 6-2-0 and serving as playing captain in 1923, 1924, and 1926. He captured the Chicago Open in 1914 and the Chicago District Amateur in 1916, 1924, and 1925. In 1920, in what many historians consider one of the finest final matches in British Amateur history, Gardner and Cyril Tolley went head to head in a slugfest at Muirfield until Tolley secured a victory on the 37th hole.

In the third round of the 1916 U.S. Amateur at Merion, Gardner, the defending champion, squared off against young Bob Jones. "Although I had no such thoughts at the time, I have since had emotions of sympathy for Bob Gardner on that day, and at the same time admiration for the gallant and courtly way in which he met and handled what must have been a very difficult situation," Jones recalled in his autobiography. "Gardner was a tall, handsome, athletic young man who looked every bit the champion he was. On the other side was I, a pudgy kid of fourteen, playing in my first National Championship. I was wearing my first pair of long pants and I owned one pair of golf shoes, a pair of old army issue into which I myself had screwed some spikes." The lead changed three times in the morning round, and when the players broke for lunch Jones enjoyed a 1-up lead. Attracted by the tight match, the gallery swelled in the afternoon. The tense match broke open at the eighth. Jones looked certain to win the hole when Gardner's approach landed on the ninth tee. But a well-played chip and putt earned Gardner a valuable half. Young Jones lost his composure. "Frankly," Jones admitted, "I blew up." Gardner won five of the next seven holes and beat Jones, 5 and 3. "There was no tougher competitor than Bob Gardner in the tournament," Jones later recalled. "If I had beaten him, I might well have beaten the others."

Three years later, Jones would get some revenge in the 1919 Amateur at Oakmont, defeating Gardner, 5 and 4, in the second round.

Walter Hagen

I NEVER WANTED TO BE A MILLIONAIRE," WROTE WALTER HAGEN in his autobiography. "I just wanted to live like one." From humble roots in Rochester, New York, Walter Hagen became America's premier professional golfer, and the premier showman of professional golf, during the Roaring Twenties. His smile was broad and infectious, his dress impeccable, and his manner dashing and bold. At the peak of his career, he traveled with an entourage that comprised three limousines, a chauffeur, a manager, a personal caddie, and suitcases full of cash. He refused to accept the second-class status of the professional golfer, and single-handedly elevated the social standing of the trade. "All the professionals who have a chance to go after the big money today should say a silent thanks to Walter each time they stretch a check between their fingers," Gene Sarazen once wrote. "It was Walter who made professional golf what it is."

Walter Hagen may have been a showman, but he was also an outstanding golfer. His particular strength was match play, for his flamboyant manner and supreme confidence placed his opponents at an immediate disadvantage. Moreover, his temperament could not have been better suited to the vagaries of the game. One story told by Bob Jones records Hagen's response to a shot that had taken an unfortunate bounce into the long grass. "Well," said Walter with a smile, "here it is and from here I have to play it." He did not have a classic swing, and he rarely put together four consistent rounds, but he understood how to recover when he found himself in trouble. And his "impossible" recovery shots disarmed more than a few opponents.

Hagen won a remarkable total of 11 major championships during his career. He first rose to national prominence with a victory in the 1914 U.S. Open at Midlothian Country Club in Chicago. He claimed a second National Open title in 1919 at Brae Burn outside Boston. He won the British Open in 1922, 1924, 1928, and 1929. In 1921 he captured his first PGA Championship, defeating Jim Barnes, 3 and 2, in the final at Inwood Country Club. He did not defend his title in 1922, but was runner-up to Gene Sarazen in 1923. Then, in one of the most remarkable feats in the history of American golf, Hagen captured four consecutive PGA Championship titles between 1924 and 1927. He won 22 consecutive matches against the best professionals of his era en route to his four consecutive titles, and won 30 of 31 matches over the seven year period beginning in 1921. Had Bob Jones not captured the Grand Slam in 1930, Hagen's record in the PGA Championship might be regarded today as the supreme accomplishment of golf's Golden Age.

"I have always been grateful that I was lucky enough to come along at a time when there were so many players of competence, color, and personality," Bob Jones once wrote. "It isn't necessary for me to name them all, but [Walter] Hagen on all counts stands near the very top of the list."

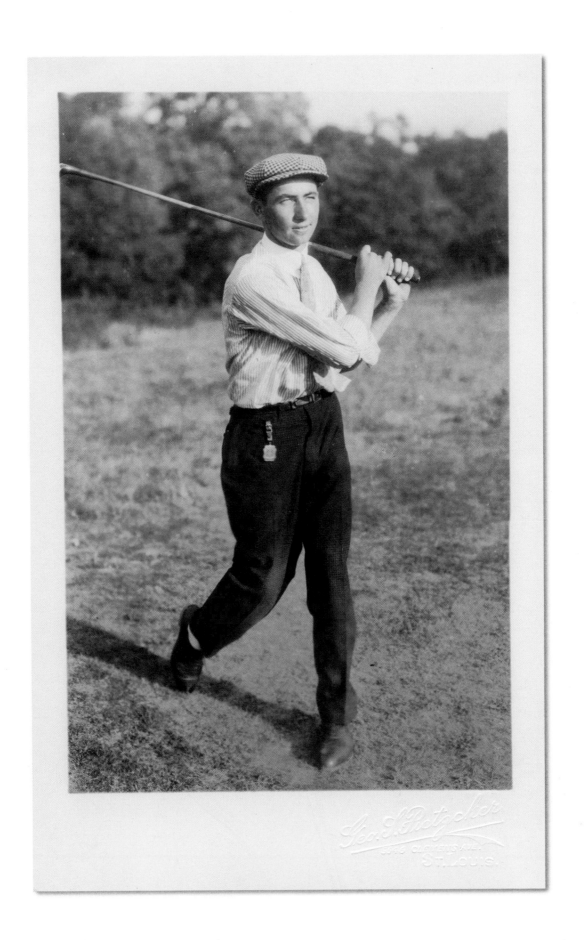

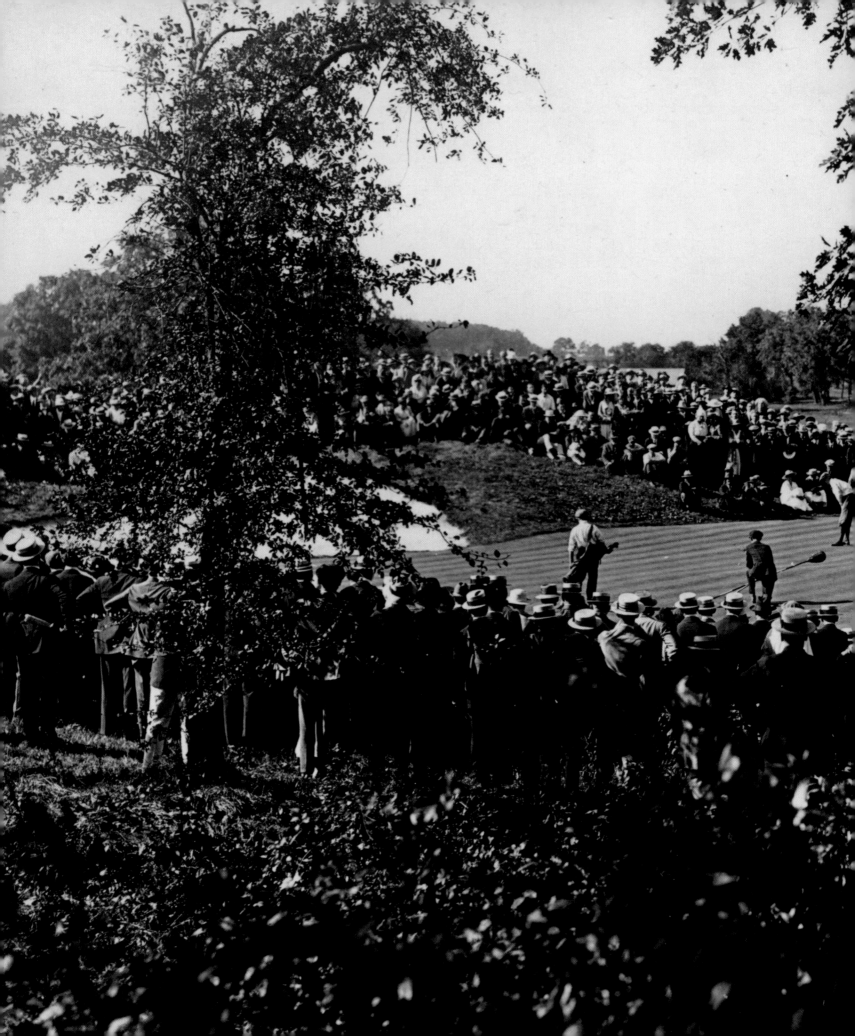

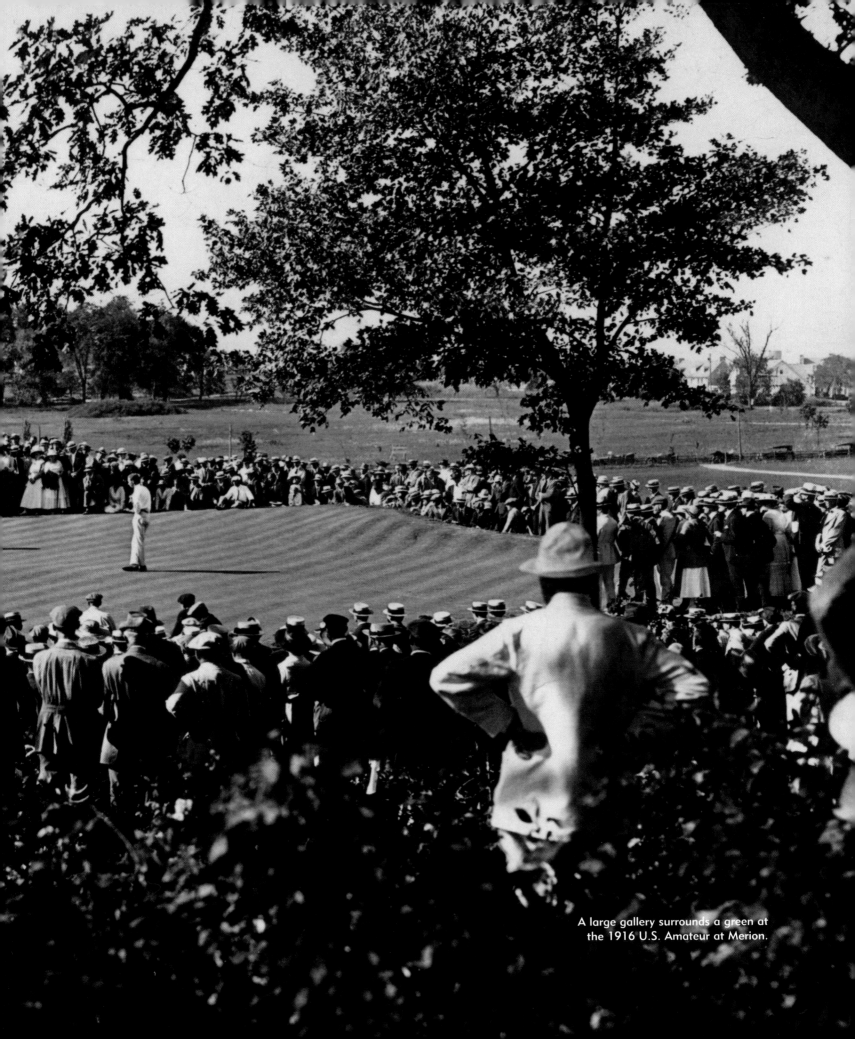

A large gallery surrounds a green at
the 1916 U.S. Amateur at Merion.

S. Davidson Herron

S OME GOLFERS SECURE THEIR PLACE IN HISTORY with numerous championship victories over the course of several decades. Others are remembered for a single moment when their skills and talents were mustered in a collective effort that brought them to the pinnacle of accomplishment. In one week in the late summer of 1919, S. Davidson Herron secured his place in golf history with a victory in the United States Amateur.

Davy Herron grew up in the Allegheny foothills of western Pennsylvania, where his home over-looked the bunkers, greens, and fairways of the famed Oakmont course. He was known to many as the kid who sold lemonade to golfers on hot summer days. Herron took up the game at a young age, and played as many as six rounds on long summer days. He also played in the company of Eben Byers and William C. Fownes, who earlier in their careers had won the national amateur championship.

Under the guidance of Fownes, Oakmont had been transformed into the toughest test of golf in America. The 6,700-yard course was dotted with more than 350 bunkers, the coarse sand raked with deep furrows, and the wildly undulating greens were rolled to incredible speeds with quarter-ton rollers. Having refined his game under the most extreme conditions, the burly Herron was a fearless shotmaker.

In 1919 the United States Golf Association brought its national championship to Oakmont for the first time. It was believed that the tough test would bring forth the best players in the game. Early in the week the names of defending champion Chick Evans and 1914 U.S. Amateur Champion Francis Ouimet were bandied about as favorites. Also high on many lists was Bob Jones. Just 17 years old and playing in only his second national championship, the "boy wonder" from Atlanta drew vast galleries.

But it was Herron, who twice led the Princeton University golf team to the intercollegiate championship title, that tied for medalist honors. Having returned home to Pittsburgh following the war, Herron had accepted a position in Eben Byers's pipe foundry. The grueling work left little time for golf, but did tone and strengthen the muscles that made his swing so powerful. Herron muscled his way through the match-play bracket with decisive victories in three of four rounds. He would then face Jones in the final. More than 6,000 spectators turned out to witness the battle. All square at the end of the morning round, Herron began sinking long putts in the afternoon. When an inconsiderate marshal roared "Fore!" in the middle of Jones's swing at the 12th, Herron seized control of the match and closed out Jones, 5 and 4, to win the championship. "I feel sure Davy would have beaten me any-way," Jones later wrote in his autobiography, "he was playing the best golf of the field."

Herron continued to play tournament golf, but never at the same level that he reached in 1919. He won the Pennsylvania State Amateur in 1920 and 1929, and in 1923 represented the United States in the Walker Cup.

Harold Hilton

I N 1911 THE CURRENT BRITISH AMATEUR CHAMPION, HAROLD HILTON, journeyed to America to compete in the U.S. Amateur at the Apawamis Club in Rye, New York. Hilton was the first reigning British Amateur champion to compete in the American championship, but never revealed his precise motivations for making the trip. Nonetheless, his appearance was a novelty to his fellow competitors. Chick Evans, one of the leading contenders for the title, noted Hilton's particular disdain for American mosquitoes. "We youngsters found his dislike of them very amusing," Evans wrote, "We learned, too, that he limited himself to fifty cigarettes a day."

It was little surprise, however, when the chain-smoking Hilton captured the qualifying medal with a two-round total of 150, then marched his way with ease through the match-play bracket. In the final, Hilton faced off against Fred Herreshoff, a big hitter from Vermont who had claimed medalist honors the previous year. Heavy rains on the morning of the final were not enough to keep away a record gallery that turned out to watch the American attempt to defend the nation's honor. Hilton played steady golf in the morning round to take a 4-up lead. In the afternoon, the rains were replaced by oppressive heat and humidity. With 13 holes to play Hilton enjoyed a 6-up lead, but then wilted. He went seven over par for the remaining holes, and would have lost the match but for missed putts by Herreshoff at the 35th and 36th. At the first playoff hole, Hilton pushed his approach right of the green, headed out of bounds. But his ball caught a greenside mound—possibly caroming off a rock—and came to rest 20 feet from the hole. Two putts later Hilton secured the Havemeyer Trophy. Nineteen years before Bob Jones's historic Grand Slam victories, Harold Horsfall Hilton had become the first player to capture the British Amateur and U.S. Amateur in the same year.

Hilton's victory at Apawamis further cemented his reputation as one of the greatest amateurs in the history of the game. In 1892 he became only the second amateur to win the British Open with his victory at Muirfield. Hilton added a second Open title to his resume with a win at his home club, Royal Liverpool, in 1897. He won his first British Amateur title in 1900, defended successfully in 1901, then claimed the championship a third and fourth time in 1911 and 1913. He was also a four-time Irish Amateur Open champion.

Standing five feet seven, Hilton was extremely strong for his size. He is remembered as a fast and powerful striker of the ball. "His address to the ball was, to be sure, very careful and precise; he placed his feet and faced his club to the line with great exactness," the great British golf writer Bernard Darwin explained. "These preliminaries over, he seemed to throw care to the winds, and one had a wild and whirling vision of a little man jumping on his toes and throwing himself and his club after the ball with almost frantic abandon."

Charles Blair Macdonald

G OLF WAS ON THE RISE IN AMERICA IN THE SUMMER OF 1894. Although most Americans had never heard of the game, a handful of elite clubs were firmly established, including Chicago Golf Club, The Country Club in Brookline, Massachusetts, Shinnecock Hills on Long Island, St. Andrew's in Yonkers, New York, and Newport in Rhode Island. It was decided that summer that the crowning of a national champion could help elevate the status of the fledgling sport.

Under the leadership of Theodore Havemeyer, the "Sugar Baron of New York," the Newport club stepped forward to host the best in the country in a 36-hole stroke-play event in September. The leader at the end of the first round, with a score of 89, was Chicago's Charles Blair Macdonald. Macdonald's early lead came as little surprise. Many—including Macdonald himself—considered him the premier player in the country. In the second round, however, disaster struck when Macdonald's ball came to rest against a stone wall. He moved his ball away, but officials penalized him two strokes. When subsequently he lost the championship by one stroke to W. G. Lawrence, a member of the host club, Macdonald lost his composure. He berated the tournament committee and condemned the championship as a fiasco.

Tall and broad shouldered, with a regal bearing and an elegant moustache, Charlie Macdonald was a formidable man. He was pompous and arrogant, but held considerable influence. He won his argument, and the national championship was replayed that October at St. Andrew's. A stronger field gathered in Yonkers for the second tournament, this conducted at match play. Macdonald rolled through the field to meet Lawrence Stoddart of St. Andrew's in the final. Feeling tired and unwell from a premature victory celebration, Macdonald heeded poor advice from a friend and consumed a bottle of champagne and a large steak for lunch. He struggled throughout the afternoon against an opponent he should have overpowered, and lost the match on the final hole. To the dismay of those assembled, Macdonald launched a verbal assault against his opponent, the event, and the club. No one club, he argued, had the authority to conduct a national championship. Only a governing body could make such a claim.

In an effort to restore credibility, representatives from Brookline, Newport, St. Andrew's, Shinnecock Hills, and Chicago gathered in December at the Calumet Club in New York City for the purpose of establishing a national governing body. And so was born the Amateur Golf Association of the United States (later the name changed to the United States Golf Association). In October 1895, back again in Newport, the first official amateur championship conducted under the auspices of the USGA was won, at last, by Charlie Macdonald.

For all his bluster and conceit, Macdonald was a visionary who understood and revered the ancient traditions of the Scottish game. Following his victory in the inaugural Amateur championship, Macdonald remained an integral part of the game, serving on the USGA's first Rules committee and establishing himself as America's first golf course architect.

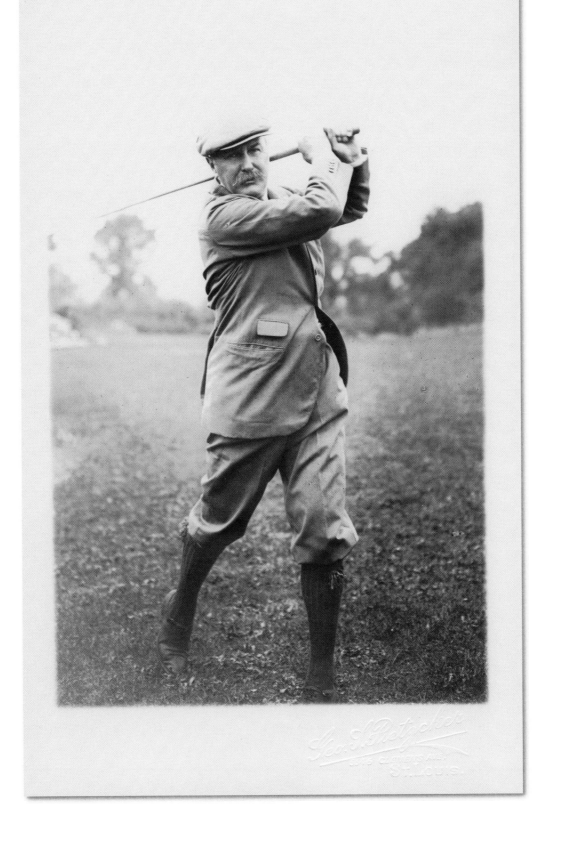

Johnny McDermott

J OHN JOSEPH MCDERMOTT WAS BORN IN PHILADELPHIA ON AUGUST 12, 1891. He was introduced to golf at the age of nine, when he started to caddie at Aronimink Golf Club. He was a young man with a fiery temper, a loner with an overabundance of self-confidence, but he excelled at the game quickly. He first played in the U.S. Open in 1909, quietly finishing in a tie for 48th, 32 strokes behind George Sargent.

In 1910, however, McDermott began his meteoric rise to the top of American golf. He defeated four-time U. S. Open champion Willie Anderson by one stroke in the Philadelphia Open, and brimming with confidence entered the U.S. Open. McDermott finished in a tie with Alex and Mac Smith, but lost the playoff to Alex by four strokes. Encouraged by his performance, but bitterly disappointed by the loss, McDermott vowed to win the following year.

At the Chicago Golf Club the following June, McDermott again finished in a three-way tie with Mike Brady and George Simpson. McDermott's 80 in the playoff was good enough for a two-stroke victory, and he became the first golfer born and raised in America to claim the national open title. At age 19, he also became (and remains today) the youngest champion in the history of the event. Moreover, his victory was inspirational to an entire generation of young professionals and amateurs who now recognized that the country's premier titles were within their grasp. Several decades of domination by Scottish and English professionals had come to a close.

McDermott proved himself again in 1912, successfully retaining the U.S. Open trophy with a two-stroke victory over Tom McNamara at the Country Club of Buffalo. But shortly thereafter, things began to unravel. McDermott suffered heavy losses when a major investment went sour, and the first signs of depression set in. Then in June 1913, McDermott defeated the legendary English professionals Harry Vardon and Ted Ray in the Shawnee Open, but arrogantly insulted the visitors during the trophy presentation. The media derided his "unsportsmanlike remarks" and the USGA considered rejecting his U. S. Open entry, citing his "extreme discourtesy." In the end he played, finishing in eighth place, four strokes behind Vardon, Ray, and Francis Ouimet. But he could not shake the reaction to his misplaced comments. He became more and more withdrawn, and had trouble sleeping. He won the Western Open in the fall of 1913, but the North and South Open of 1914 would be his last victory.

Scheduled to play in the 1914 British Open at Prestwick, McDermott missed the starting time for his qualifying round. Dejected, he left England aboard the *Kaiser Wilhelm II*. As the great liner was leaving the English Channel, it collided with a large freighter. Badly shaken, McDermott returned home on a different ship, and collapsed in his pro shop at the Atlantic City Country Club just two months later. In 1915 he suffered a complete nervous breakdown. At age 24 he was diagnosed with chronic schizophrenia and committed to institutions for the remainder of his life.

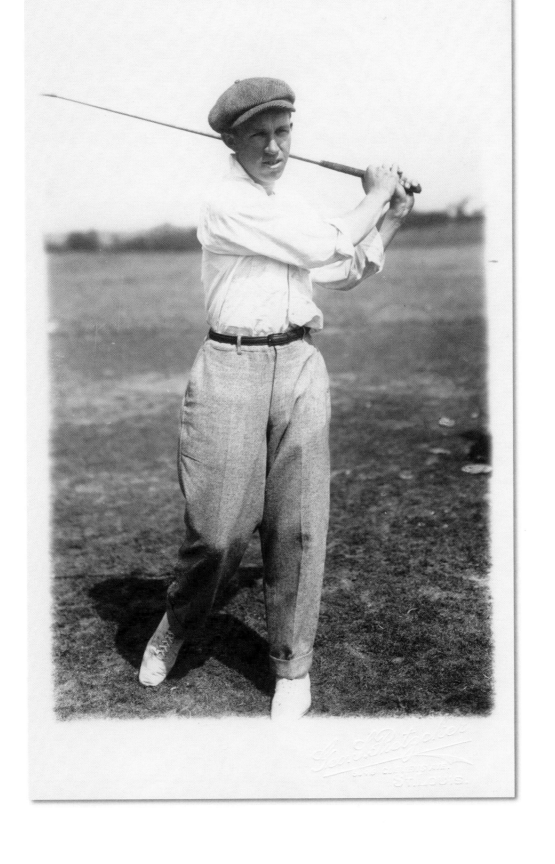

Francis Ouimet

IN THE HISTORY OF AMERICAN GOLF, FEW EVENTS RIVAL Francis Ouimet's victory in the 1913 U. S. Open at The Country Club in Brookline, Massachusetts. Ouimet, a 20-year-old amateur, defeated the two greatest British professionals of the day, Harry Vardon and Ted Ray, in a playoff for the national title. The stunning victory of the unheralded amateur placed golf on the front page of many American newspapers for the first time. One year later Ouimet again proved his mettle, capturing the U.S. Amateur at the Ekwanok Country Club in Manchester, Vermont.

Following his victory at Brookline, Ouimet became both idol and hero to many Americans, including young Bob Jones. Indeed, Jones was rendered entirely speechless the first time he had occasion to shake the hand of the champion at the 1915 Western Amateur. In the years to come, however, Jones developed a deep and lasting friendship with the man he once described as "one of the gentlest, kindest boys in the world."

Ouimet and Jones squared off on four occasions in the U. S. Amateur, the first in 1920 when the two advanced to the semifinals at the Engineer's Club on Long Island. With a mature intensity that allowed him to focus solely on the task at hand, Ouimet presented stern competition for the 18-year-old Georgian. Jones, by his own admission, was filled with "ebullient young spirit" and "youthful conceit." Ouimet had Jones 3 down at the end of the morning round, and never let up. He closed out Jones on the 13th, 6 and 5, but lost in the final the following day to Chick Evans.

Never again would Jones lose to Ouimet in the national amateur, exacting revenge in 1924, 1926, and 1927. "I played some pretty darn creditable golf in the Amateur in the twenties," Ouimet once wrote, "then I'd run into Bobby, and he would absolutely annihilate me." Indeed, Ouimet once likened a match against Jones to getting one's hand caught in a chain saw. "He coasts along serenely waiting for you to miss a shot, and the moment you do, he has you on the hook and you never get off. If the young man were human, he would make a mistake once in a while, but he never makes any mistakes." Only after Jones retired from championship golf would Ouimet reclaim the spotlight, securing a second national amateur title with his 6-and-5 victory over Jack Westland in the 1931 U.S. Amateur at Beverly Country Club in Chicago.

Beginning with his victory in the 1914 French Amateur, and continuing for more than three decades, Francis Ouimet remained one of the great international figures in the history of the game. He represented the United States in the first Anglo-American match at Hoylake in 1921, and participated in every Walker Cup match from 1922 to 1949 as either player or team captain. In 1951 the Royal and Ancient Golf Club of St. Andrews bestowed their supreme honor on Ouimet, as he became the first American named captain of the prestigious club.

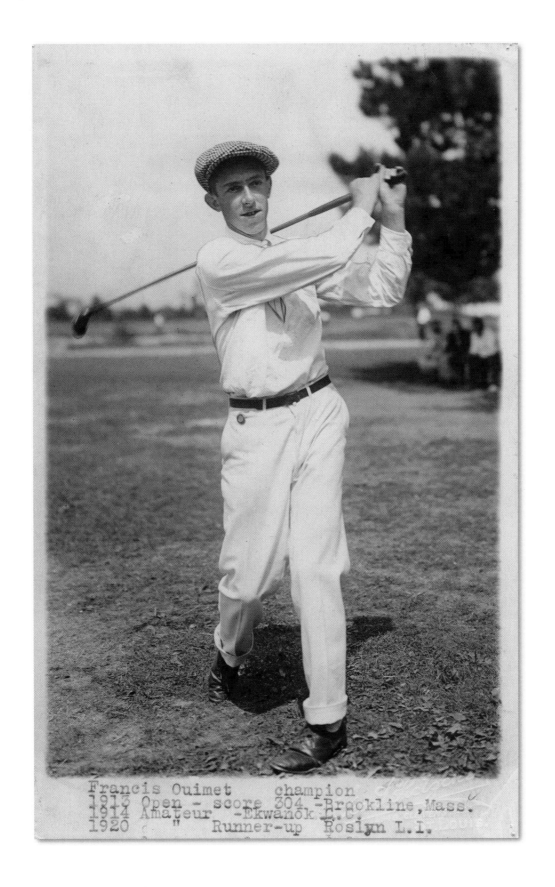

Francis Ouimet champion
1913 Open - score 304 -Brookline, Mass.
1914 Amateur -Ekwanok C.C.
1920 " Runner-up Roslyn L.I.

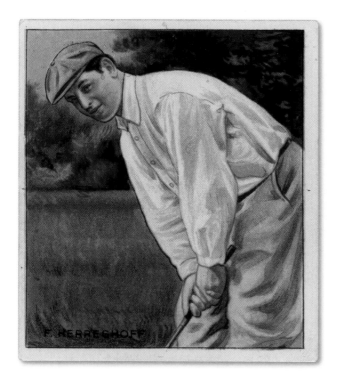

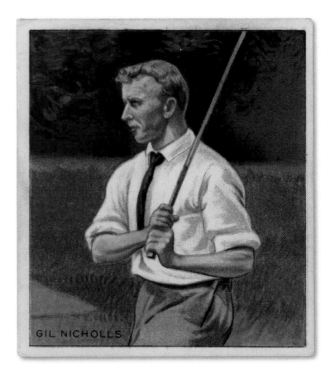

Mecca Cigarettes' "Champion Athlete and Prize Fighter Series," issued in 1910, included several of the prominent professional and amateur golfers of the day.

ALEX SMITH

Ted Ray

N OCTOBER 1913, THE LEGENDARY ENGLISH PROFESSIONALS Ted Ray and Harry Vardon played an exhibition match against Stewart Maiden and Willie Mann at the East Lake Golf Club in Atlanta. Vardon and Ray emerged with a 1-up victory, when Ray sank an eight-foot putt on the 36th green to halve the hole and secure the match. "This was the first big match I had ever watched and I followed every step of the 36 holes," recalled Bob Jones, who was just 11 years old at the time. "Ray's tremendous driving impressed me more than Vardon's beautiful, smooth style."

In the afternoon round, Ray played a shot so remarkable that Jones was to speak and write about it for many years to come. Playing the 12th, Ray outdrove his opponents by a considerable distance, but his ball came to rest behind a 40-foot tree. He seemingly faced two options, forced to deliberately slice or hook the shot around the tree to reach the green some 170 yards away. But Ray saw another possibility. "Without hesitation he drew a mashie-niblick," Jones recalled, "and he hit the ball harder, I believe, than I ever have seen a ball hit since, knocking it down as if he would drive it through to China." The ball shot straight up in the air and cleared the tree by several feet, tracing a high arc through the air until it dropped on the green not far from the hole. "I remember how men pounded each other on the back, and crowed and cackled and shouted and clapped their hands," Jones continued. "A sort of wonder persists in my memory to this day. It was the greatest shot I ever saw."

Ted Ray was just the sort of golfer who awed galleries and silenced competitors with his prodigious strength. He was a giant of a man, both on and off the course, renowned for his forthright manner and for the trademark pipe clenched between his teeth. As a golfer, he was a bit unorthodox. His body swayed considerably during his swing, which concluded with a violent lunge down and through the ball. He could be very long, but also terribly wild, off the tee. Yet he still displayed rhythm and grace, and developed both a superior short game and fine putting stroke.

Ray was born in 1877 on the Isle of Jersey. He accepted a position as club professional at Ganton in 1903, before moving to Oxhey in 1912, where he remained for 29 years. He captured the British Open in 1912, was second in 1913 and 1925, and finished in the top 15 on 15 occasions between 1900 and 1920. In 1913 and 1920 Ray and Vardon toured the United States, playing exhibition matches against top amateur and professional players. During the 1913 tour, Ray tied Vardon and Francis Ouimet at the U. S. Open in Brookline, but lost in the playoff. In 1920 he redeemed himself by claiming the U. S. Open at Inverness by a single stroke over Vardon and three others.

Alex Smith

———————

A LEX SMITH WAS BORN IN THE WINTER OF 1874. His father was the greenkeeper at Carnoustie, the famed links on the east coast of Scotland. Alex and his brothers grew up immersed in golf. He was apprenticed to a local blacksmith at an early age, and there acquired the skills that would later serve him as an accomplished clubmaker. His golf skills developed more slowly, but by the mid-1890s he was talented enough to land a position as a golf professional at two clubs in England. He returned to his native Carnoustie in 1897, and became the foreman in the clubmaking shop of Bob Simpson.

In 1898 Smith heeded a greater call, and headed across the Atlantic to accept the position of golf professional at Washington Park Golf Club in Chicago. He was not alone. By some estimates, as many as 300 aspiring professionals left Carnoustie to accept appointments at clubs around the world. Four of his own brothers—George, Jim, Macdonald, and Willie—were among those who found their way to America to support the burgeoning game on this side of the Atlantic.

Smith quickly earned a reputation as one of the finest players and teachers in America. He traveled from city to city compiling an impressive resume of victories: two Western Opens, four Metropolitan Opens, three Eastern PGA championships, three California Opens, and two state titles in Florida. His most important wins, however, came in the U.S. Open. He recorded three second-place finishes between 1898 and 1905, before he finally broke through in 1906. Playing through driving rain in the final round at Onwentsia, Smith posted a 75 for a four-round total of 295, becoming the first to break 300 in the U.S. Open. At Philadelphia Cricket Club in 1910, Smith completed four rounds at 298, to finish in a three-way tie with his youngest brother Macdonald and Johnny McDermott. He posted a 71 in the playoff to claim his second Open title in five years.

Smith's competitive record provided an entrée into the country's most exclusive clubs. He wintered in Florida at Belleair near Tampa or in Miami at the Biltmore. Summers were spent in New York, at Nassau, Wykagyl, and the Westchester Biltmore. Along the way he taught many of the game's best. Glenna Collett, six-time U.S. Women's Amateur champion, took lessons from Smith twice a week during the summer months in Connecticut, then followed him south to Florida in the winter. Jerry Travers, the winner of four U.S. Amateur titles and the 1915 U.S. Open, worked with him at Nassau. Smith even tutored the legendary Walter Hagen, and Gene Sarazen once called Smith the greatest teacher he had ever seen.

In the spring of 1915, Smith witnessed a young Bob Jones "violently reposition" his club after hitting a bad shot. Smith disapproved of what he saw in the 13-year-old prodigy. "It's a shame," he said, "but he'll never make a golfer. Too much temper." Even the greatest teachers can be wrong sometimes.

Jerry Travers

EROME DUNSTAN TRAVERS WAS BORN MAY 19, 1887, into a wealthy Long Island family. He took to golf at age nine, constructing an improvised course in the backyard of his father's estate on Oyster Bay. When the family thereafter joined the Nassau Country Club, he became a protégé of two-time U.S. Open champion Alex Smith. "I was a youngster who preferred learning the science of golf rather than enjoying it as a mere diversion," Travers once explained, "I practiced for days." He competed in his first U.S. Amateur at age 15, and posted his first important victory in 1904, defeating reigning British Amateur champion Walter Travis on the third extra hole to capture the prestigious Nassau Invitational.

Travers secured his first national title at age 20, claiming the 1907 U.S. Amateur at the Euclid Club in Cleveland, Ohio. He successfully defended the title in 1908, but for reasons that are not entirely clear chose not to play in 1909 and 1910. He returned in 1911, losing in the third round to the eventual champion Harold Hilton, but reestablished his position as the country's premier amateur with decisive victories in the 1912 and 1913 championships. Attempting to claim a third consecutive title in 1914, he lost in the final to Francis Ouimet.

To compensate for his size—he stood five feet seven inches and weighed 135 pounds—Travers developed a tendency to overswing, particularly with his driver. As a result, he was wild and erratic, a tendency he only curbed by playing irons off the tee. The greatest demonstration of his perseverance came at the 1915 U.S. Open, when Travers, regarded strictly as a match player, overcame severe driving problems to win the U.S. Open at Baltusrol.

Early in his career, Jerry Travers was regarded as a ruthless competitor. Chick Evans called him "the coldest, hardest golfer I knew." Still, Travers employed a rather carefree attitude toward the game, playing only when the mood struck him. Following his victory in the 1915 U.S. Open, he largely disappeared from competitive golf, claiming it was impossible to make a living and compete in amateur golf. It seems more likely that at age 28 he had simply lost his discipline and desire to compete.

In 1924, several years after his retirement from competition, Travers wrote of American golf, "I believe that many of us here are prone to take the game too seriously, which doesn't help in the slightest to mould the proper mental attitude towards it. I am convinced that the average player would get more enjoyment and better scores if he abandoned the national habit of overemphasizing the care necessary in every shot." Time, it would seem, had provided some valuable perspective.

Following the collapse of the stock market in 1929, Travers faced severe financial troubles. He eventually turned professional, playing exhibition matches and giving lessons at a local driving range. Abandoning the game altogether in the early 1940s, he spent the last ten years of his life inspecting aircraft engines.

Walter Travis

————————

M ANY EYES FOCUSED ON YOUNG BOB JONES when he played in the U.S. Amateur for the first time in 1916 at Merion Cricket Club. Among those most critical of the 14-year-old was three-time U.S. Amateur champion Walter Travis. While noting that Jones "would never improve on his shotmaking," Travis suggested that Jones "might better learn the occasions upon which they should be played." Moreover, he continued, "his putting method is faulty."

Even at such a young age, Jones had profound respect for Travis, whom he regarded as one of the greatest putters in the history of the game. Hoping to solicit some advice, Jones scheduled an appointment with Travis the following day. But he failed to show up on time, and the disgruntled Travis departed promptly. Several years passed before Travis again consented to meet. In 1924, at the Augusta Country Club, Travis finally offered Jones the tips that transformed Jones into one of the greatest putters of his own generation.

First, Travis altered Jones's putting grip, reversing the way in which he overlapped his hands. Travis wanted Jones to place his entire right hand on the club, allowing him to regulate more effectively the speed of the putt. Further, Travis prompted Jones to alter his stance, placing his feet close together so that his heels almost touched. Finally, Travis suggested that Jones take the club back with a longer, sweeping motion, and visualize the subsequent stroke "as an attempt to drive an imaginary tack into the back of the ball."

Australian by birth, Travis did not take up the game until he was 34, having acquired his first set of clubs on a trip to London. Recognizing that putting comprised half the game, he dedicated himself to becoming the best putter possible, practicing with a hole just a little larger than the ball itself. His reputation as an outstanding putter was thereby established early in his competitive career.

Respected for his aggressive, competitive temperament, Travis entered his first national championship in September 1898, playing in the U.S. Amateur at the Morris County Golf Club in New Jersey. He advanced to the semifinals before losing, 8 and 6, to Findlay Douglas, the eventual champion. In 1899, at the Onwentsia Club outside Chicago, he again lost to Douglas in the semifinals, but in 1900 he finally broke through. Playing at his home club, Garden City Golf Club on Long Island, Travis defeated his nemesis, Findlay Douglas, 2 up, to capture the Havemeyer Trophy. He successfully defended his title in 1901 at the Country Club of Atlantic City, and in 1903 added a third amateur to his resume at the Nassau Country Club. His success in America led Travis abroad, and in 1904 he became the first foreigner to win the British Amateur with his victory at Sandwich.

"The Old Man," as he was widely known, continued to win significant titles well into his fifties. His last important victory came in the 1915 Metropolitan Amateur. He founded and edited the popular magazine *American Golfer*, and later became an well-regarded designer of golf courses.

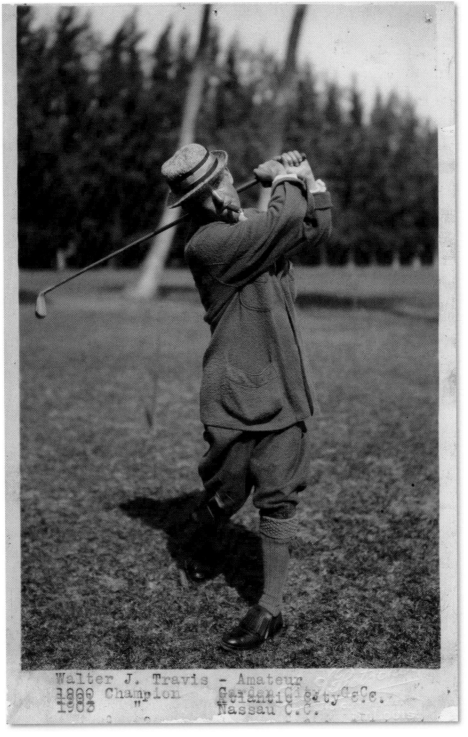

Walter J. Travis – Amateur
1900 Champion Garden City G. C.
1903 " Nassau C. C.

Harry Vardon

I N THE 1920 U.S. OPEN AT THE INVERNESS CLUB OUTSIDE TOLEDO, legendary English professional and six-time British Open champion Harry Vardon was paired with Bob Jones for the two qualifying rounds. The 18-year-old Jones, playing in his first national open championship, was both thrilled and intimidated by the pairing. Jones had first seen Vardon play in an exhibition match at East Lake in 1913, when he was just 11 years old. Since that day, Vardon had been both "a hero and an idol" to the Atlanta teen.

The seventh hole at Inverness was a short dogleg par 4, tempting longer players to drive over a broad chasm and tall trees. Playing their second round of the day, Vardon and Jones both hit long drives, leaving a short pitch to the green. Following a fine approach by Vardon, Jones attempted to loft his ball onto the putting surface with his niblick. He looked up on the shot however, and topped the ball, which scuttled over the green into the back bunker. To this point in the round, Vardon hadn't said a word to Jones. Seeking to ease his embarrassment over a poorly played shot, Jones took it upon himself to speak: "Mr. Vardon, did you ever see a worse shot than that?" Vardon replied, quite simply, "No." "I still regard it as the funniest and most conclusive estimate I ever heard on anything," Jones wrote years later in his autobiography.

Born in Grouville on the Channel Island of Jersey in 1870, Vardon was introduced to the game as a caddie at the age of seven. When his older brother Tom left for England to work as a golf professional, Harry followed. He accepted a position first at Ripon, but later moved to Ganton, where he soon established himself as one of the premier professionals in the game. Vardon was at his peak from 1896 to 1903, winning four British Open titles. Shortly thereafter, he was struck down by tuberculosis and never fully recovered. In 1900, 1913, and 1920, Vardon toured the United States, playing exhibition matches against premier American players. In 1900 he captured the U.S. Open, and in 1913 lost in an historic playoff to 20-year-old amateur Francis Ouimet. Throughout his career, Vardon was revered as the game's supreme stylist, with a swing that epitomized both grace and power.

Following their rounds together in the 1920 U.S. Open, Vardon and Jones remained friends for many years. After capturing the 1930 British Open at Hoylake, Jones and Vardon joined British professionals Ted Ray and James Braid in a charity match at Oxhey, Ray's home club. Playing the 17th hole, Jones played a marvelous approach with his mashie niblick to within three feet of the hole. Vardon responded, in his very soft voice, "Ah, Master Bobby's 'ot today." "Since we had first played together in 1920, he had always addressed me as "Master Bobby," Jones later recalled. "Harry was a very great player and fine gentleman. Every round I played with him was an event in my life."

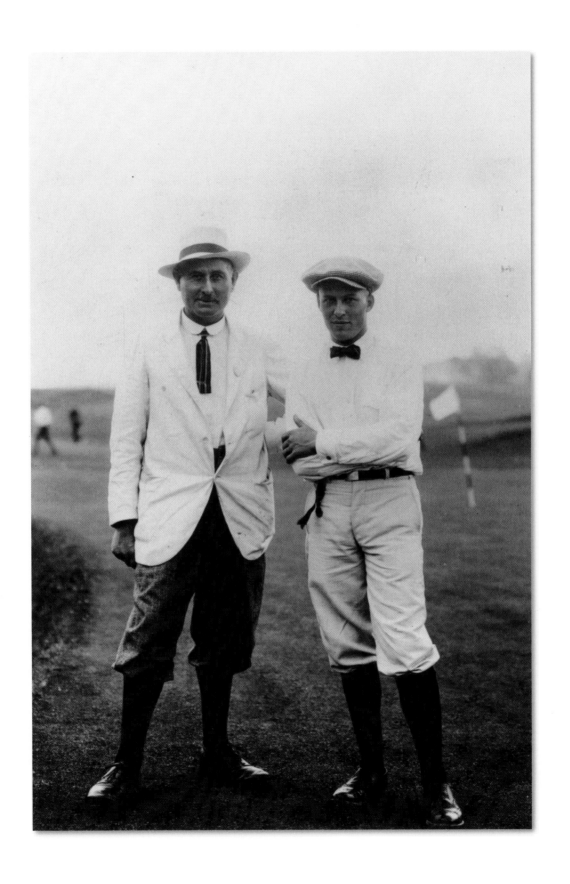

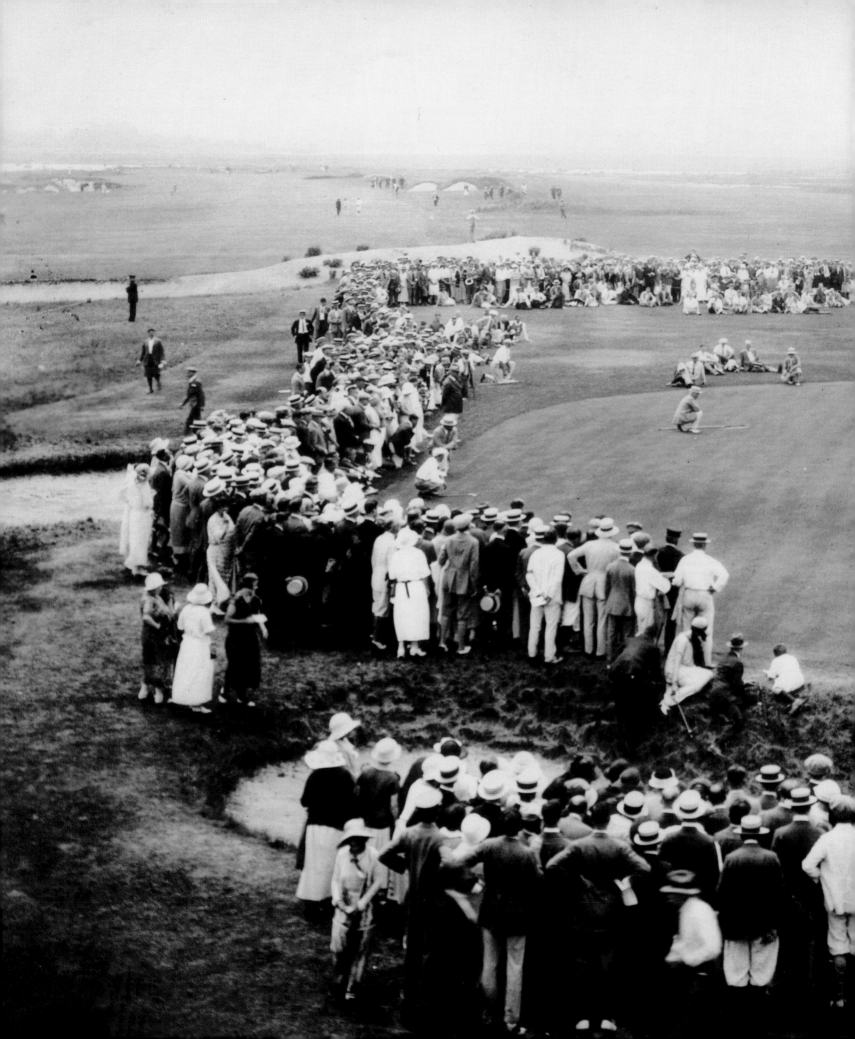

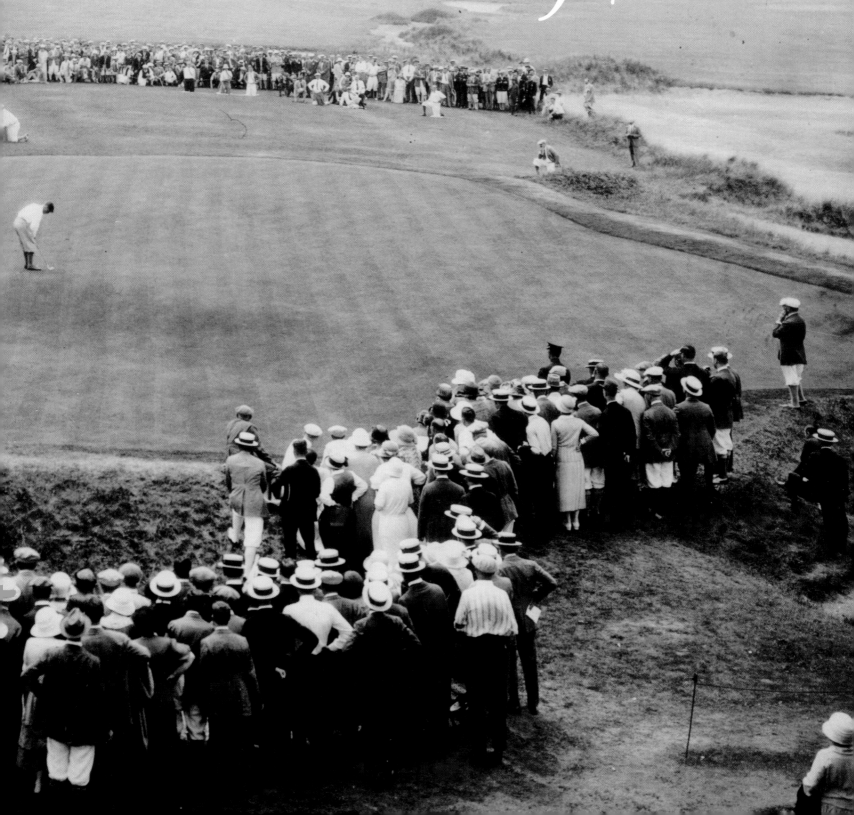

THE 1920s

THE 1920S DEFINED AMERICAN GOLF and Robert Tyre Jones, Jr. While his meteoric career would culminate in the extraordinary year of 1930, its foundation caught fire in the Roaring Twenties. Jones won the U.S. Amateur in 1924, 1925, 1927, and 1928 and was runner-up in 1926. His record in the U.S. Open was even more astounding. From 1922 through 1929, he finished first or second every year but 1927. He won the U.S. Open in 1923, 1926, and 1929, lost playoffs for the title in 1925 and 1928, and finished second in 1922 and 1924. Overseas he won the British Open in 1926 and 1927. A dedicated student, he concurrently blazed through his studies in Law and Engineering from three different universities.

Francis Ouimet couldn't force Jones to loosen his grip on the U.S. Amateur. Ouimet tried mightily. He was runner-up once, a semifinalist five times and a

 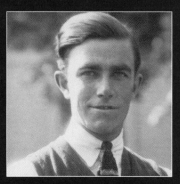

quarterfinalist once but he would not win the national championship again until after Jones retired. Ouimet's career, however, was far from over. He won the prestigious North and South Amateur in 1923 and became well-known abroad because of five Walker Cup appearances.

The era also featured Walter Hagen and Gene Sarazen, professionals who occasionally intruded on Jones's dominance. Walter Hagen, the dashing "Sir Walter," won the British Open in 1922 and 1924 and captured four straight PGA Championships from 1924 to 1927. By 1926 Jones had also won the U.S. Open twice, and a match between the two was proposed to promote Florida real estate. Over 72 holes, Hagen

ABOVE LEFT TO RIGHT: **Tommy Armour, Jess Sweetser, George Von Elm, Johnny Farrell**

smashed Jones, 12 and 11, but the loss had no impact on Jones's adoring public. He was the pure amateur, "Our Bobby," and readers hungrily devoured newspaper copy about his every stroke and statement. By 1929 Hagen was 36. He would win tournaments for another half dozen years but his game, particularly his putter, had lost its luster.

Gene Sarazen, meanwhile, was playing his way into prominence. The former caddie won the 1922 PGA Championship when Hagen chose not to defend and captured the U.S. Open with a dazzling final round of 68 to become the first to hold both titles at once. The diminutive Sarazen's swagger appealed to many golf fans. After he won the 1923 PGA he began fooling with his swing , and there was a dearth of victories. By 1927, however, his swing was back together and he would win another 20 tournaments before the end of his career.

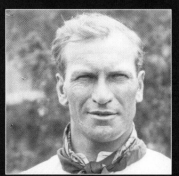 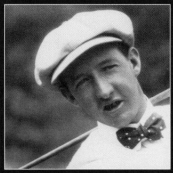 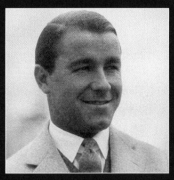 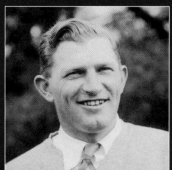

Bob Jones then, stood virtually alone. The more he won, the more he was expected to win and he began speaking of the pressure and his impending retirement as early as 1926. That year Jones was attempting to win his third straight U.S. Amateur. He held the U.S. Open, British Open, and 1925 Amateur crowns, but ran into flaxen-haired George Von Elm in the final. "Gix" simply outplayed him and beat Jones, 2 and 1. Jones, of course, bounced back to win several more U.S. Amateurs and U.S. Opens. Both championships would play equal parts in 1930, his incredible year.

— RHONDA GLENN

Tommy Armour

———◆———

THE SON OF A CONFECTIONER WITH A PASSION FOR GOLF, Tommy Armour spent much of his youth on the golf course in the company of his brother, Sandy, and their close friend Bobby Cruickshank. When war broke out in Europe in August 1914, Armour, then a student at the University of Edinburgh, heeded the call to arms. Soon after the Germans invaded Belgium, Armour enlisted as a machine gunner with the Black Watch Highland Regiment of the British Army.

Heralded as one of the outstanding members of his regiment, Armour quickly rose through the ranks to become a major in the tank corps. He was injured seriously on two occasions, once in a gas attack at the Battle of Ypres when he lost the use of his left eye, later when his tank was hit by a shell. The explosion injured Armour's head and shattered his left arm, and doctors inserted metal plates in his head and arm to repair his injuries. While convalescing, the young Scot decided to forego the completion of his university studies, and instead focus on golf.

Armour first gained international attention when he took second place in the 1919 Irish Amateur Open. The following year he captured the French Amateur, then tied for first at the Canadian Open before losing in a playoff. In 1922 Armour emigrated to America, and, with the help of Walter Hagen, secured a position as social secretary at the Westchester-Biltmore Club for the impressive sum of $10,000 a year. He turned professional in 1924, and three years later captured the first U.S. Open played at Oakmont Country Club outside Pittsburgh.

Playing to 6,929 yards with several hundred bunkers and treacherous greens, Oakmont was the most demanding course many of the competitors had ever seen. Bob Jones, widely expected to capture the title, struggled to his worst-ever finish in the U.S. Open. Armour, meanwhile, stood just one shot back of "Lighthorse" Harry Cooper after 54 holes. But his steady play waned in the fourth round. Armour made the turn in 39, then recorded double bogeys at the 10th and 12th. He played the next five holes at level par, and needing to birdie the 18th to tie Cooper at 301, Armour ripped a 3-iron to 10 feet and holed the putt. In the playoff the following day, Cooper built a two-stroke lead with six to play before Armour birdied the 13th, then drained a 50-foot putt at the 15th. When Cooper dropped two strokes at the 16th, Armour's victory was all but secure.

A striking figure with sharp features and prematurely grey hair, "The Silver Scot" captured 25 PGA tournaments during his career, including the 1929 Western Open, 1930 PGA Championship, 1931 British Open, as well as three Canadian Opens. Respected for his deliberate manner and thorough understanding of the golf swing, Armour later became one of the most influential—and high-priced—instructors in the game. His students included Lawson Little, Babe Zaharias, and Richard Nixon. In 1953 he published his best-selling book *How to Play Your Best Golf All the Time*.

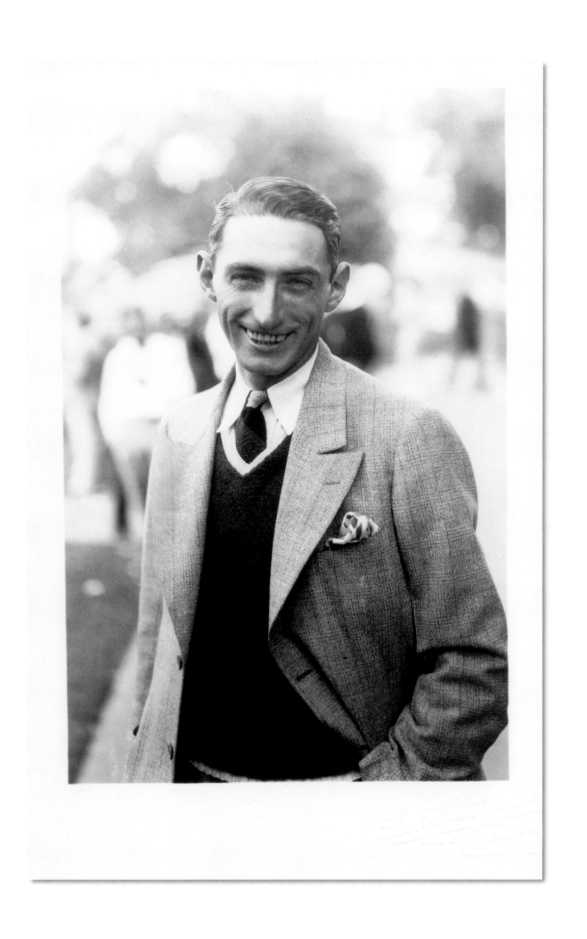

Jim Barnes

————

ON HIS WAY TO SOUTHERN FLORIDA IN THE WINTER OF 1921, Jim Barnes stopped in St. Augustine to inspect a golf course that had come highly recommended. Walking into the club, Barnes was surprised to run into his closest friend, 1908 U.S. Open Champion Fred McLeod. McLeod, it turns out, was in town on a golf holiday with none other than Warren Harding, the President of the United States. And Harding was in need of a partner. "Each day the President and I would play a match against Freddy and a friend of the President's," Barnes recalled. "When we finally left, the President said to me: 'I suppose you'll be playing at Columbia in the Open?' I said I would and he said 'I'll be there.'"

The 1921 U.S. Open at Columbia Country Club, situated in the Washington, D.C. suburb of Chevy Chase, was played in July. A week or so before the championship, a combination of blight and drought severely damaged the greens, and as play began expectations were low. Still, Barnes went into the championship feeling fresh. With scores of 69, 75, and 73, Barnes led by seven entering the final round. With a clover blossom tucked in the corner of his mouth, he shot a steady 72 to win the championship by nine strokes. He played his final holes to the cadence of a U.S. Marine Corp band, there to honor the President and Vice President. "You might say I had a victory march," Barnes later quipped. Newsreel crews surrounding the final green asked Barnes to hold off his final putt while they repositioned the President within the frame. After he sank the putt, Barnes walked over to the President and the first thing Harding said was "Congratulations, partner."

Barnes had learned the game as a caddie and apprentice clubmaker in his native Cornwall, before emigrating to the United States in 1906. Little was known of him when he finished second in the 1912 Canadian Open, but when he tied for fourth in the 1913 U.S. Open the golf world took notice of the long-hitting Englishman, who measured six four. "Long Jim" Barnes broke through one year later at the Western Open, at that time considered one of golf's major championships, then followed up with victories in the first two PGA Championships in 1916 and 1919. In 1919 Barnes also captured the Southern Open at Atlanta's East Lake Golf Club, defeating 19-year-old Bob Jones in a memorable head-to-head battle at the teenager's home club. Between 1920 and 1928, he finished among the top eight at the British Open seven times, claiming the Claret Jug at Prestwick in 1925.

Barnes was a deliberate and methodical player, well-respected by his peers. Self-assured but reserved, he often made his way around the course in complete silence with a blade of grass or sprig of clover clenched between his teeth. In 1919 he authored a pioneer book—*Picture Analysis of Golf Strokes*—that was the first golf instructional to rely heavily on sequence photography.

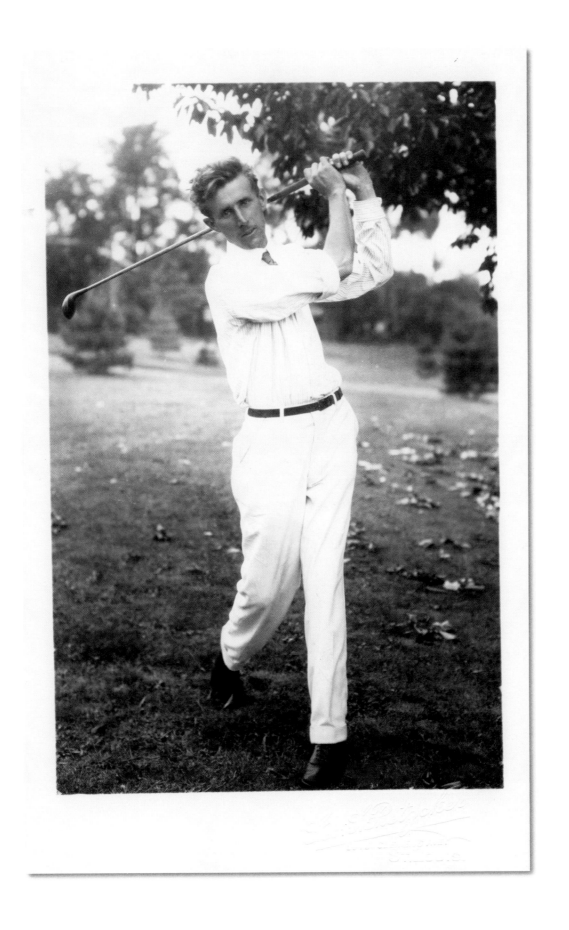

Archie Compston

————————

S EEKING HIS 11TH NATIONAL CHAMPIONSHIP IN EIGHT YEARS, Bob Jones faced formidable opposition when he arrived at the Royal Liverpool Golf Club for the 1930 British Open. Among those favored for the title was Archie Compston, a tall and gangly Welshman with a reputation for gruffness and arrogance.

Compston was, in his own way, a formidable giant. A rugged and unpredictable personality accompanied his frame of six feet five inches, and when these traits coupled with occasionally spectacular play, he was nearly impossible to defeat. Two years earlier, Compston had soundly thrashed two-time U.S. Open champion Walter Hagen, 18 and 17, in a 72-hole challenge match, handing Hagen the worst defeat of his career. Moreover, Compston had assumed celebrity status in 1929 when he successfully fended off an attempt by the Inland Revenue (Britain's version of the IRS) to tax considerable sums of money that Compston made betting on matches with wealthy aristocrats.

Playing something less than his best golf, Jones nonetheless led after two rounds, with Compston lurking five strokes behind. In the third round, however, Compston caught fire, taking just 13 strokes over the first four holes to catch Jones. With the strong support of the gallery, Compston carried his outstanding play to the back nine, opening 3-3-3-2. He would finish strong, posting a course-record 68 to complete the third round with a one-stroke lead over Jones. "I do have a very vivid recollection that all during the latter half of that round the cheers from Compston's gallery were ringing in my ears," Jones recalled. "I can still see the awesome figure made by Compston toward the finish of his round. Watching from the clubhouse as I saw him sweep past the sixteenth green, I had the feeling the spectators, tee boxes, benches even, might be swirled up in his wake."

Commencing the final round after lunch, Compston opened with a strong drive, but his approach fell short. He lagged a long putt to two feet, but left his par putt hanging on the lip. The magic of the morning round was lost in an instant, and a string of poorly played holes followed. "One hooked shot followed another," wrote British golf writer Bernard Darwin, "and there was a long and gloomy string of fives. The story is too sad to tell at length, even if it were worth it." Compston stumbled home in 82, a 14-shot swing, finishing six strokes behind Jones, whose final-round 75 was good enough for a two-stroke victory.

In the late 1920s, Compston was one of the foremost professionals in Britain. He captured the PGA Matchplay title twice, in 1925 and 1927, and the French Open in 1929. It was said, however, that Compston was never the same following his final-round collapse at Hoylake. The immortal sports writer Grantland Rice once characterized Compston's seemingly meteoric rise and fall as an "astounding performance [that] dazzled the world, and then like the final finish of a rocket's flight, dissolved in sparks and darkness, buried deep in the limbo of lost hopes."

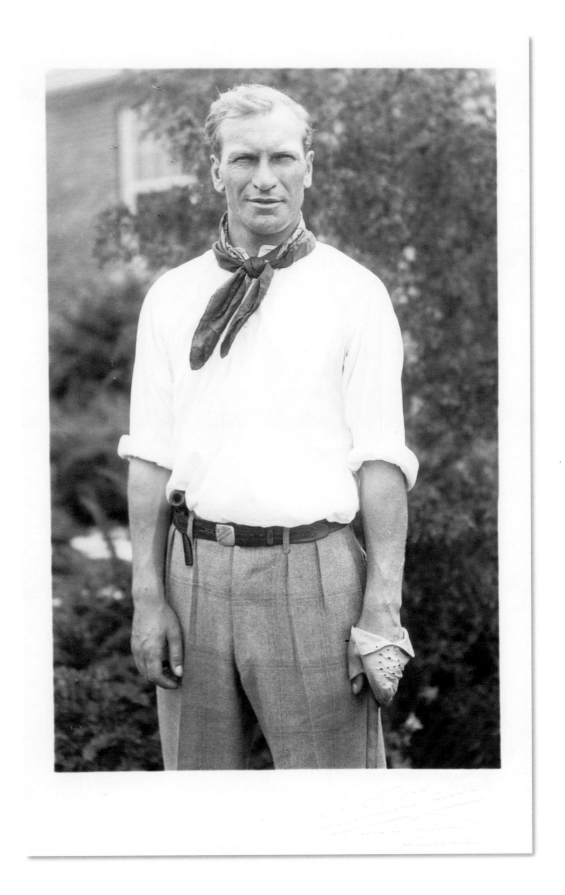

Bobby Cruickshank

R OBERT ALLAN CRUICKSHANK WAS BORN IN 1894 IN GRANTOWN-ON-SPEY in the heart of the Scottish Highlands. Like many Scots, he was introduced to golf at an early age. When his family moved to Edinburgh, Cruickshank befriended Tommy Armour. The two spent many days together on the links, refining and developing their skills. Cruickshank enlisted in the army during World War I, was taken prisoner by the Germans for several months, but organized an escape and led three others to freedom. After the war he returned to university and golf. He advanced to the third round of the 1920 British Amateur before losing a closely-contested match to the eventual champion, Cyril Tolley.

In 1921 Cruickshank emigrated to the United States with the intention of studying law, but quickly emerged as one of the leading golf professionals in America. Small in stature, measuring just five feet four, "Wee Bobby" collected more than a dozen titles, including three victories in the prestigious North and South Open. He never won a national championship, but finished in the top three at the U.S. Open on four occasions.

The 1923 U.S. Open was played at Inwood Country Club on Long Island. Jock Hutchison seized the early lead with rounds of 72-70, leading Bob Jones by two and Cruickshank by three. When Hutchison fell back during the third round, Jones secured a three-stroke lead over Cruickshank. Then Jones began to struggle. At 16 Jones hit his second shot out of bounds into a parking lot. He recorded another bogey at 17, then hooked his approach into the gallery at 18 to close with a double bogey. "I didn't finish like a champion," Jones remarked to a friend, "I finished like a yellow dog."

Desperate to catch Jones, Cruickshank might have lost his chance with a double bogey at 16. He came to the final hole needing a birdie. After finding the fairway with his drive, Cruickshank faced a dangerous approach over a pond that guarded the green. "My thoughts were very mixed," he recounted. "My heart missed a few beats I know, but I took plenty of time to steady myself." The ball landed on the green ten yards short of the hole and trickled to six feet. Cruickshank called it "the greatest shot I ever made in my life." When he sank the putt he forced a playoff the following day.

This time it was Jones who made the remarkable play at 18. After battling through 17 holes, the players came to the final hole dead even. Jones drove into the right rough, then rifled a driving iron 200 yards over the pond to six feet. He won the playoff by two, and Cruickshank lost his bid to become Open champion. He never came this close again.

Few players have enjoyed the longevity in the game that Cruickshank ultimately achieved. Competing in the 1950 U.S. Open at Merion, he finished 25th at the age of 55. During the three-year period from 1971 to 1973, Cruickshank matched or bettered his age on 12 occasions in PGA Senior and Stroke Play events.

Leo Diegel

———◆———

"I DIEGEL, THOU DIEGELEST, HE OR SHE DIEGELS, WE ALL DIEGEL or are about to diegel." As impressive a career as Leo Diegel assembled, he will forever be remembered for his peculiar method of putting. With his elbows sticking out at right angles to his torso and his feet spread wide, he bent his body so sharply at the waist that his chin almost touched the grip of his putter. As Bernard Darwin mused, "I am sure that many backs have been broken and elbows crooked to the point of agony in the attempt to get the ball into the hole as he does."

It has been written that Leo Diegel, in his most inspired moments, was the equal in both skill and talent of any player who ever lived. Unfortunately for Diegel, his temperament was his undoing. On many occasions, Diegel was in position to win either the U.S. or British Open right down to the closing holes, yet each time he came up short. "Third-Round" Diegel, as the press called him, finished eighth or better eleven times, fourth or better seven times, yet never managed to capture either championship.

Diegel made his U.S. Open debut at the Inverness Club in 1920, the same year as Bob Jones. Nearing completion of the final round, a "storm of biblical proportions" blew in from Lake Erie. Diegel remained the last American with an opportunity to claim the title, and a sizeable gallery, including Jones himself, remained on the course to cheer him home. Diegel, however, lost four strokes to par on the final five holes. Playing just ahead of him, the Englishman Ted Ray sank a five-foot putt on the final green to claim the championship by one stroke. It was Jones's first exposure to the intensity of a national open championship, and the drama that unfolded had a lasting effect on the teenage prodigy. "I watched Leo Diegel play the last three holes," Jones recalled many years later, "and remember wondering why his face was so grey and sort of fallen in. I found out for myself later."

In the 1930 British Open at Hoylake, Jones again found himself a member of Diegel's gallery, this time from a clubhouse window. Jones had completed his final round an hour earlier, posting a score of 291. Entering the final round two strokes back of Jones, Diegel picked up two strokes by the turn, and stood level with Jones when he reached the 16th tee. Needing a birdie to match Jones, Diegel played an aggressive second to the 532-yard par five, came up short in the front left bunker, then took four to get down. Now needing two birdies to catch Jones, Diegel could only manage pars on the final holes.

A member of the American Ryder Cup team four times between 1928 and 1933, Diegel posted 31 career victories. He won consecutive PGA Championship titles in 1928 and 1929, and was dominant for many years in the Canadian Open, which he won in 1924, 1925, 1928, and 1929.

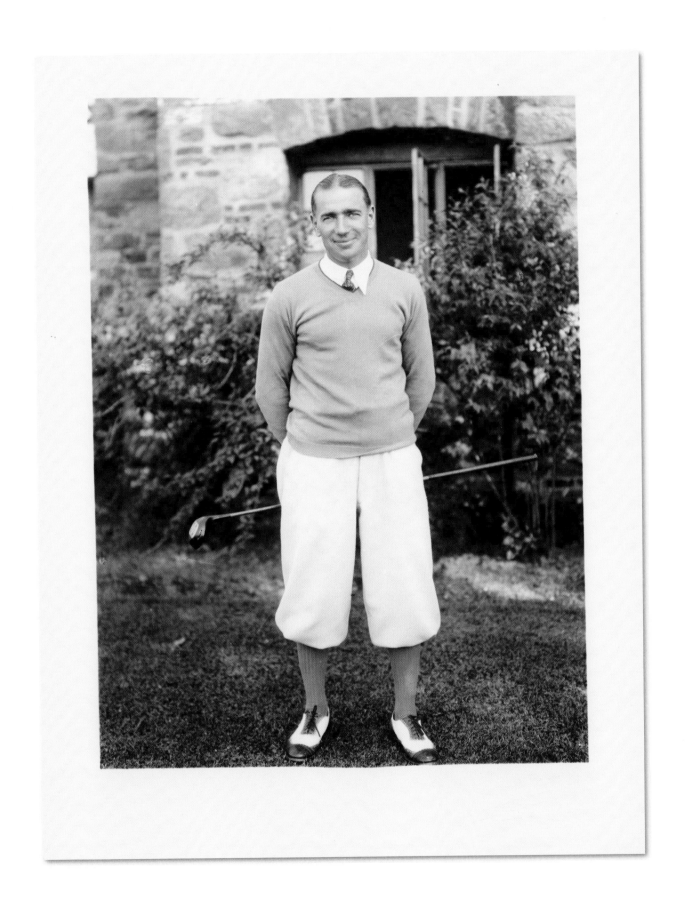

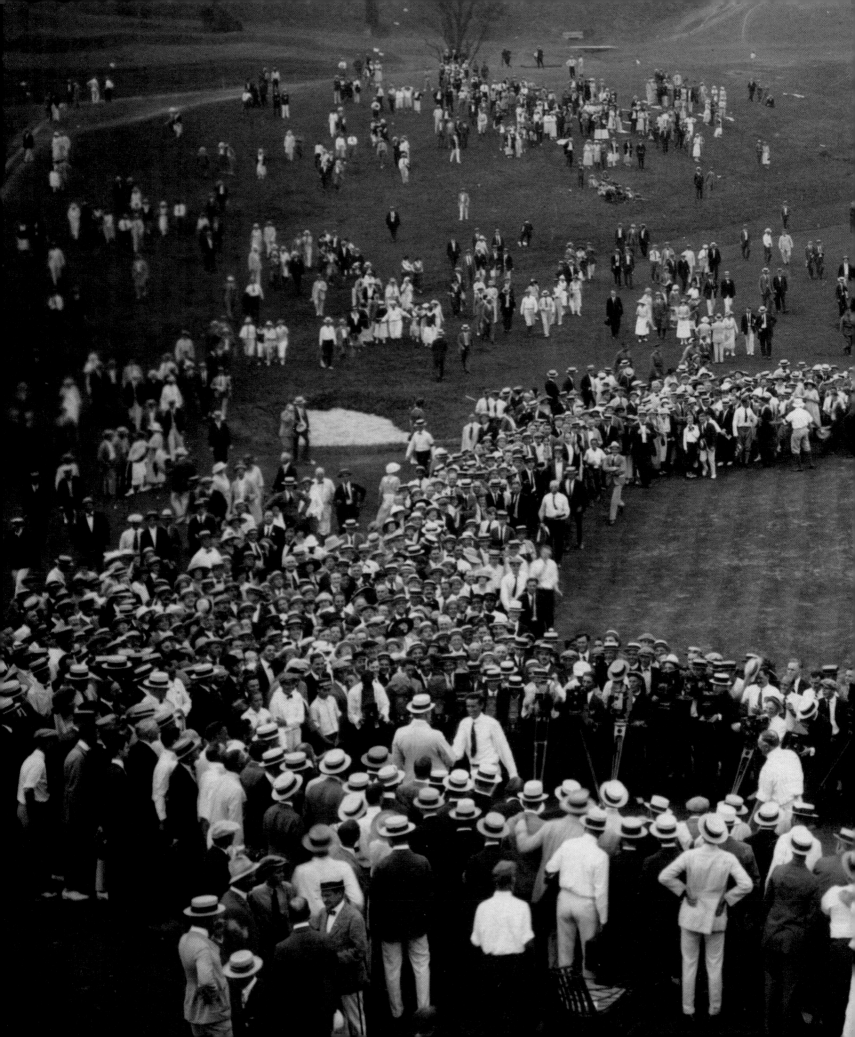

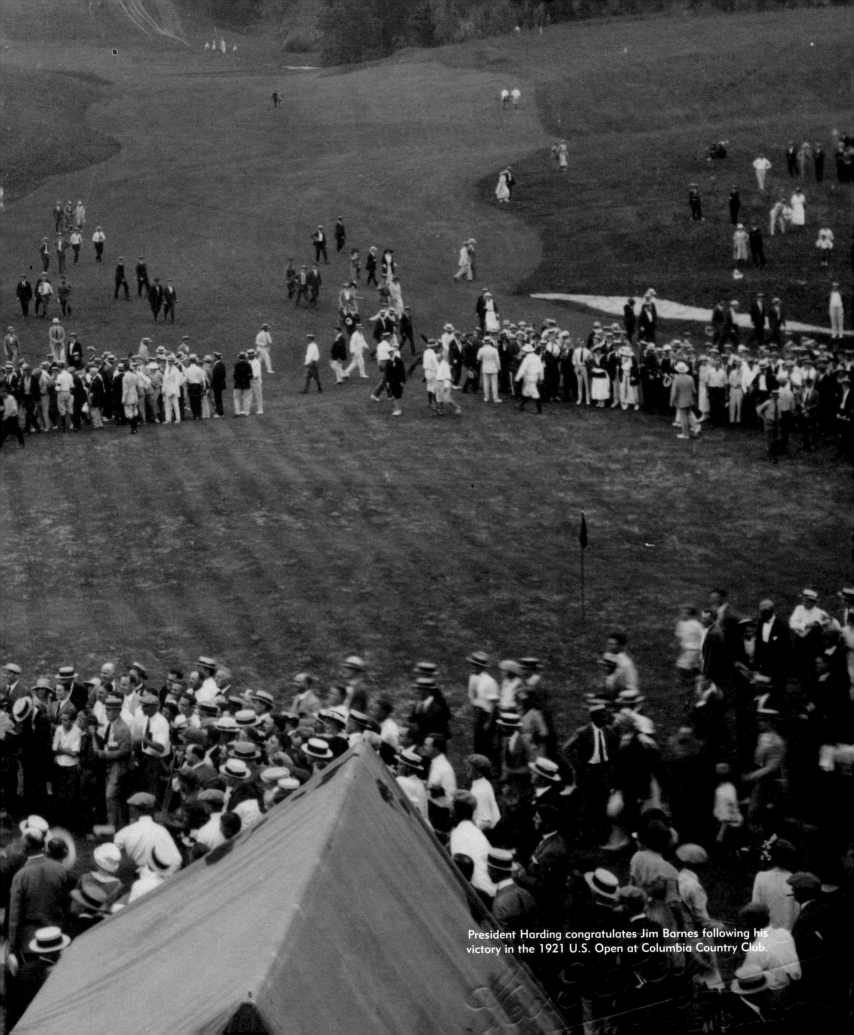

President Harding congratulates Jim Barnes following his victory in the 1921 U.S. Open at Columbia Country Club.

George Duncan

EORGE DUNCAN WAS BORN IN 1883 IN THE SMALL TOWN OF OLD MELDRUM in northeast Scotland. His father was the village policeman, a large and domineering man who expected his eldest son to become a carpenter. From a young age, however, Duncan preferred sports and games to work and labor. He was introduced to golf when he was eight years old, but his first impression was far from favorable. The family lived adjacent to the Old Links in Aberdeen, and one afternoon Duncan accepted an offer to caddie for an older member of the club. He was offered sixpence for his service, but nearing the mid-point of the round Duncan became exasperated by the deliberate, dawdling pace of his employer. "Our mutual dislike increased with one weary hole after another," Duncan recounted. "When the old boy topped another shot into a bunker, that was as much as wee 'Doddie' Duncan could stand. I threw down the clubs in disgust and beat a retreat with all the dignity an independent eight-year-old could muster."

One year later, encouraged by his good friend Harry Martin, Duncan tried golf again and found it more to his liking. He took a deeper interest in the game as a caddie and player, and over the continued objections of his father became apprenticed to a local clubmaker. When he turned 18, he accepted a professional appointment at Rhos-on-Sea Golf Club in North Wales, and left his home in Scotland to pursue a career in golf.

In 1903 the club sent Duncan to Prestwick to compete in the British Open for the first time. He failed to qualify, but garnered attention for his prodigious distance off the tee. Over the course of the next few seasons, he would also earn a reputation as one of the quickest players in the game. Impatient and often impetuous, Duncan played every shot, even putts, faster than any other player in the game. "I can't make him out," commented five-time British Open Champion James Braid. "He plays so fast that he looks as if he doesn't care, but I suppose it must be his way. He's the most extraordinary golfer I have ever seen." When he set down to write many years later, Duncan aptly titled his memoirs *Golf at the Gallop*.

In the years immediately following the First World War, Duncan solidified his reputation as one of the premier professionals in Britain. After finishing in the top ten six times, Duncan claimed the Open Championship at Deal in 1920, overcoming a 13-stroke deficit after two rounds. The media and public also promoted him as the leading British hope for repelling the Americans. He played against the United States in international matches five times, including the first three Ryder Cups, and won all his singles matches. In the 1929 Ryder Cup at Moortown, he routed Walter Hagen, 10 and 8.

Never the most consistent player, Duncan was capable of truly inspired play. One writer characterized his game as the "champagne of golf and the fizziest champagne at that."

Johnny Farrell

———◆———

J OHNNY FARRELL, A YOUNG PROFESSIONAL FROM WESTCHESTER, NEW YORK, was a pre-championship favorite when he arrived at Olympia Fields Country Club for the 1928 U.S. Open. Named "Best Dressed Golfer" at both the 1927 and 1928 U.S. Opens, Farrell entertained galleries as much with his dapper attire as with his play. The previous year Farrell had gone on a tear, winning seven tournaments between May and July, including six in a row. Farrell was also one of the best putters in the game, with an uncanny ability to get down in two from almost any position. Moreover, his record in the championship was impressive, with top five finishes in 1923, 1925, and 1926, and a tie for seventh in 1927. During this span of time, only Bob Jones boasted a better record in the Open.

It came as little surprise, therefore, when Farrell and Jones finished tied for the lead at the end of 72 holes. The playoff the following day was, in the words of one witness, "one of the greatest 36-hole matches ever played, anywhere or at any time." Both players fought tenaciously through the first 14 holes with neither giving ground. Light drizzle at the start of the morning prompted Farrell to pull on a bright green sweater, and the Irishman's lucky colors finally paid off when he finished the morning with four consecutive birdies.

In the afternoon, Jones found his game and began to hit the ball with authority. The three-stroke lead amassed by Farrell disappeared quickly. By the time they reached the 18th, Farrell clung to a one-stroke lead. Jones reached the fringe of the par five in two, while Farrell played a poor tee shot, followed by a weak second into the left rough. A fine pitch left Farrell 12 feet from the hole, but all he could do was watch as Jones took a run at eagle, only to have the ball slide by the hole. Now Farrell faced a testy 12-footer to secure the one-stroke victory. Just as a flash of lightning streaked through the sky above Olympia Fields, Farrell stepped up to the nerve-wracking putt and sent the ball spinning into the hole. "Many articles will no doubt be written on the particularly interesting and dramatic chapters of this tournament," wrote one local columnist, "but mere words will never be able to adequately describe the battle that was waged between Johnny Farrell and Bobby Jones."

Farrell was born in White Plains, New York, in 1901. Like many professionals of his generation, Farrell first learned the game as a caddie. His decision to pursue a career in golf came while watching the inaugural PGA Championship at Siwanoy in 1916. A victory in the Shawnee Open in 1922 marked his formal introduction to the golf world, and he remained one of the top players on the professional tour through the early 1930s. A growing family and the Great Depression forced Farrell to scale back his tournament schedule. In 1934 he accepted a position as head professional at Baltusrol, which he held until 1972.

Geo. S. Pietzcker
GENS CLOTHES AT
ST. LOUIS.

Harrison Johnston

————◆————

T HE 18TH HOLE AT PEBBLE BEACH SKIRTS MONTEREY BAY its entire length from tee to green. Any pulled or hooked shot spells certain disaster. In the final of the 1929 U.S. Amateur, Jimmy Johnston hit such a shot. After finding the fairway off the tee, Johnston hooked his second shot over the cliff. "After playing a provisional shot just short of the green," Johnston recalled, "my caddie came running through the gallery and said he thought I might play my original second shot, if I hurried. I found my ball resting securely among the small pebbles below the seawall. When I took my stance to play the shot, a wave swished up behind me and buried my feet six inches in the water. But when the wave receded, the ball was still there!" Johnston then executed a remarkable shot, playing a spade mashie from the beach to the edge of the green to secure a valuable half. Johnston remained just one down to Dr. O. F. Willing at the conclusion of the morning play, then rallied in the afternoon round to secure a 4-and-3 victory at the 15th hole.

Born in 1896 in St. Paul, Minnesota, Johnston was a man with broad interests and talents. Ever the consummate gentleman, Johnston excelled at baseball, swimming, diving, skiing, hockey, and tennis, yet was also an accomplished painter and pianist. The son of a renowned Minnesota architect, Johnston attended St. Paul's Academy and the Hotchkiss School, but passed up college to serve on the front lines during World War I. Following the war Johnston returned to Minnesota, renewed his passion for golf, and in 1921 won the first of seven consecutive Minnesota Amateur titles.

In 1924 Johnston claimed the Western Amateur at the Hinsdale Golf Club in Illinois, recording a string of birdies on the last five holes to recover from a four-hole deficit. In 1927, when he captured the last of his Minnesota Amateur titles, he also won the Minnesota Open, becoming the first player to win both championships in a single year. That same year he led the U.S. Open at Oakmont after two rounds of play, and finished tied for 19th. And in 1930 he advanced to the quarterfinals of the British Amateur, where he was defeated by his good friend Bob Jones.

However, it was Johnston's immensely popular victory in 1929 that defines his legacy. "Jimmy Johnston, next to Robert Tyre Jones, probably will be the most popular champion in the history of American golf," wrote Virginia Stafford of *Amateur Golfer and Sportsman*. "Far above the importance of winning championships he has placed the value of sportsmanship and an appreciation of the best traditions of the game." Even the defending champion professed his admiration. "There has never been in golf a finer sportsman or a more loveable chap than the new champion," wrote Bob Jones in *American Golfer*. "Throughout the week he displayed a command of his shots and a courageous spirit which entirely deserved the honor which he eventually won."

Joe Kirkwood

T THE AGE OF TEN, JOE KIRKWOOD LEFT HIS FAMILY HOME in Sydney, Australia, on a 400-mile journey to a sheep station in the outback. He walked alone, without a compass, map, or watch, following rivers and railroad lines. Upon reaching the ranch where he had accepted a position as a drover, Kirkwood found that the owner was a golf enthusiast. Quite taken by the game, Kirkwood crafted his own clubs from saplings and snakeskin and constructed an informal three-hole course. He won his first tournament just six years later, and decided to pursue a career as a golf professional.

After winning the New Zealand and Australian Opens in 1920, Kirkwood recognized that the time had come to test his game against the greatest players in the game. He set his sights on the U.S. and British Opens, and left Australia on a steamer in 1921. He defeated his boyhood hero, six-time British Open champion Harry Vardon, in his first tournament at Gleneagles, then finished sixth in the British Open at St. Andrews. A few weeks later, he opened with a 75 in the U.S. Open at Columbia Country Club, but faded to finish in a tie for 33rd. He finally broke through on American soil in 1922, winning the North and South Open at Pinehurst. In 1924, his best year, he won three times.

Although he was an accomplished tournament player, Kirkwood's lasting fame was as the leading trick-shot artist of his day. He first developed these skills entertaining wounded Australian veterans after World War I, and later brought his talents to America. He hit balls suspended by a piece of string, sliced or hooked shots on demand, and taking a full swing could pop the ball straight up and into the pocket of his caddie. He hit balls left-handed, right-handed, standing on his knees, and with his eyes closed. His favorite trick was to borrow a watch from a member of the gallery, tee a ball on its face, and hit a full drive without harming the watch. Once, while performing this trick at a stop in Iowa, Kirkwood holed a drive of some 248 yards.

For many years Kirkwood toured the country with Walter Hagen, scheduling exhibitions along the route between tournament stops, splitting the gate money that was collected. "Joe was an invaluable partner and the combination of our personalities made a good show," Hagen later recalled. "I played the straight man for his jokes and gags." Along the way, Kirkwood and Hagen were instrumental in promoting a new invention in the world of golf—the wooden tee.

In 1933, the year Kirkwood captured his second Canadian Open title, he was approached by Pan American Airlines to partner with Gene Sarazen on an exhibition tour of South America and Australia. Then, in 1937 and 1938, Hagen and Kirkwood embarked on a world tour. Kirkwood once estimated that he played as many as 6,500 courses around the world in his lifetime.

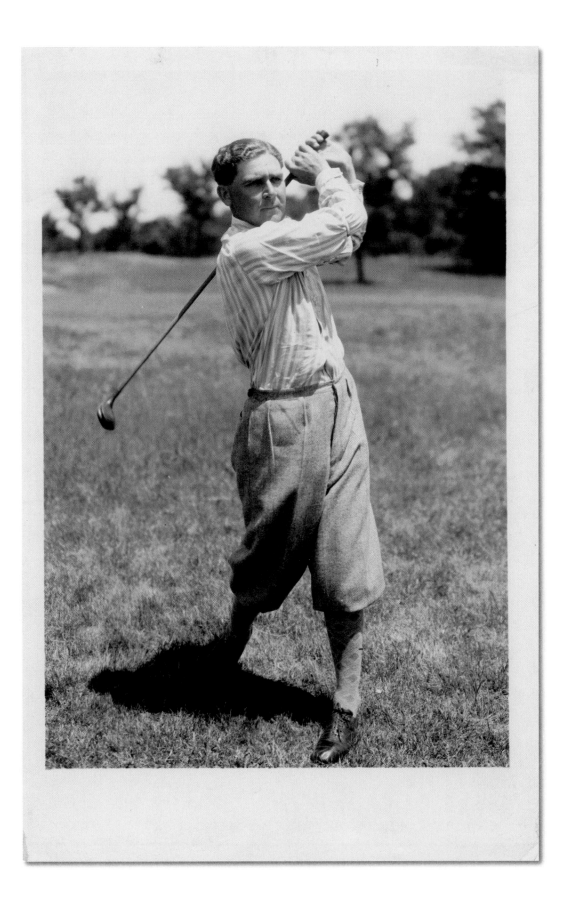

Willie Macfarlane

WILLIE MACFARLANE ARRIVED AT THE WORCESTER COUNTRY CLUB for the 1925 U.S. Open in comparative obscurity. He was familiar to his fellow professionals and to those who closely followed golf in the New York metropolitan area, but to most of the gallery he was an unknown. Tall, slender, and bespectacled, Macfarlane did not project the image of a champion golfer. Rather, he gave one the impression of a professor or schoolmaster. Still, the cognoscenti praised the soundness of his game, the ease and grace of his style, his fine iron play. "To see him swing a club, no matter what its nature or nomenclature, the professorial impression vanishes," wrote one observer. "Grace and power and poise are all united in his methods. He is a picture of golf perfection."

Macfarlane was born in Aberdeen on the east coast of Scotland in 1890. He took up the game as a youngster, emigrated to America in 1910, and accepted a position as a teaching professional in Chicago. He first played in the U.S. Open at Baltusrol in 1915, finishing 20 strokes behind the champion, Jerry Travers. In 1920 Macfarlane entered the Open for a second time. This time he finished tied for eighth, alongside Bob Jones, four strokes behind Ted Ray. In truth, Macfarlane preferred the life of a club professional to that of a touring pro.

During the months leading up to the 1925 Open, Macfarlane played little golf. While many of the game's elite spent the winter months competing in California and Florida, Macfarlane was content to remain home at the Oak Ridge Country Club in Tuckahoe, New York. In fact, between October and June, he played a total of 13 rounds. He played well enough in qualifying to earn a spot in the field at Worcester, but was overshadowed by names such as Jones, Hagen, Sarazen, Armour, Ouimet, and Farrell.

Playing in oppressive heat, Macfarlane was brilliant in the second round, firing a 67 and establishing a new Open record for 18 holes. After 72 holes, Macfarlane finished in a tie with Bob Jones. The two would play off for the title. Tied after the first playoff round, the two came to the final hole of the second round even again. Jones played an aggressive approach at the short par four, but came up short. When Macfarlane got down in two putts from the back of the green, he claimed the most important title of his career.

Macfarlane was overwhelmed with congratulatory letters and telegrams, calling him "King" and "Champion," but he remained, in the words of one prominent writer of the day, "just plain, ordinary, good-natured, modest, retiring 'Mac.'" The night of his victory he was asked what he might do, now that he had won. "I'm going back to Oak Ridge tonight," he replied, "I have some lessons scheduled for tomorrow." Such was his deep-rooted sense of duty. He was going to fulfill his promise, regardless of his new-found fame. Victory may have changed public opinion, but it did not change the essential character of the man.

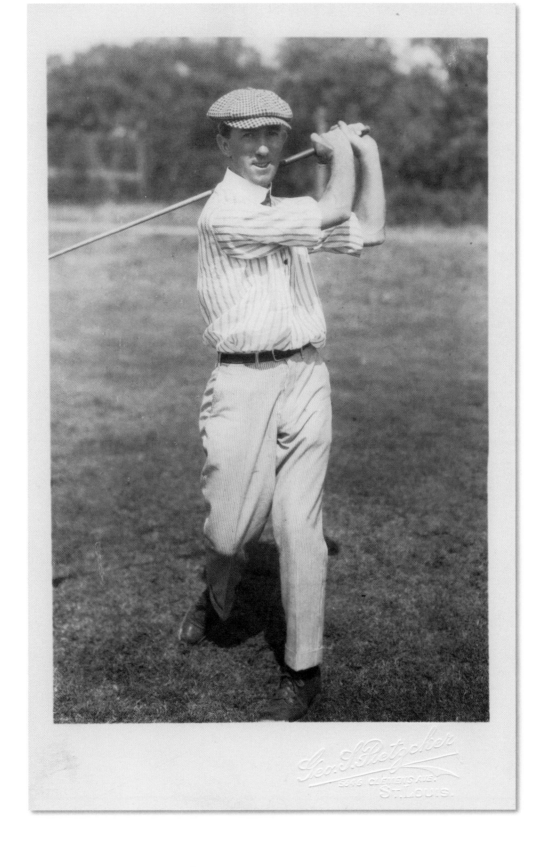

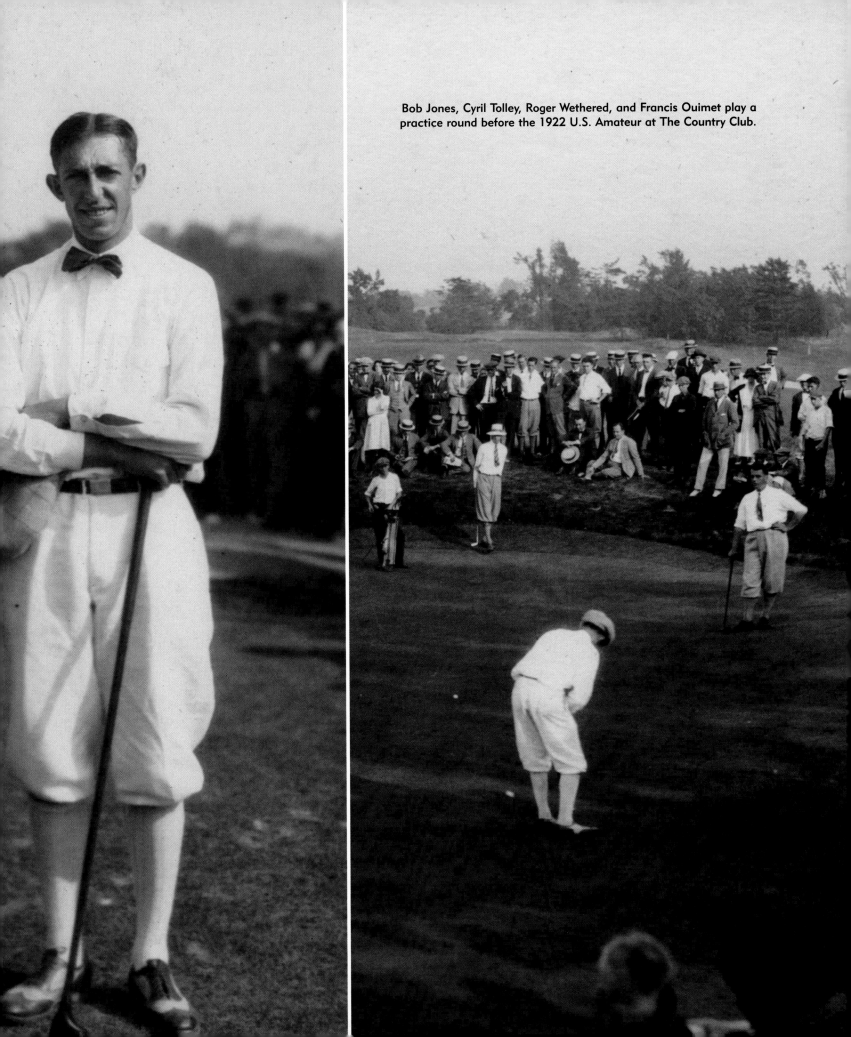

Bob Jones, Cyril Tolley, Roger Wethered, and Francis Ouimet play a practice round before the 1922 U.S. Amateur at The Country Club.

Max Marston

FOR FOUR MONTHS IN THE SUMMER OF 1923, MAX MARSTON was America's best amateur golfer. Between mid-May and mid-September, Marston was virtually unstoppable through a series of club, state, national, and international events.

It began with the Walker Cup Matches played on the Old Course at St. Andrews. The British side built an early lead in foursomes play, winning three of four matches. Only Marston and his partner, two-time U.S. Amateur champion Robert Gardner, won for the American side, with a 7-and-6 drubbing of Robert Harris and "Chubby" Hooman. On day two the Americans stormed back. Marston defeated William Hope, 5 and 4, despite being 1 down at the end of morning play. Winning five of eight singles matches on the second day, the Americans retained the Cup.

Marston returned home to compete in the Patterson Cup—the Golf Association of Philadelphia's most prestigious stroke-play event—and won by three strokes. One week later he claimed the Philadelphia Amateur at Merion Cricket Club, together with Pine Valley one of his two home clubs. Having won the Patterson Cup and secured the medal in the city amateur, Marston was awarded the Silver Cross, emblematic of the stroke-play champion of Philadelphia. Marston won the Pennsylvania Amateur in July at the Huntingdon Valley Country Club, then finished as low amateur in the Philadelphia Open at Pine Valley. Next he captured the club championship at Merion.

In September Marston headed west to compete in the U.S. Amateur at Flossmoor Country Club outside Chicago. He shot 157 in qualifying, finishing eight strokes behind co-medalists Bob Jones and Chick Evans. In the second round he faced Jones, who was widely considered the championship favorite. Marston played well in the morning round, but was 4 down to Jones through 16 holes. Then he rallied. Playing the next 19 holes in the equivalent of five strokes under par, Marston closed out Jones, 2 and 1. Jones later called it "one of the best matches I can remember." In the semifinals Marston knocked out Francis Ouimet, and in the final he dethroned defending champion Jess Sweetser on the 38th hole.

When the newly crowned Amateur champion returned home to Pine Valley, he captured the Crump Cup in early October. But the magic finally wore off. In the Lesley Cup Matches—an annual competition for teams from metropolitan New York, Massachusetts, and Philadelphia—Marston and his partner Bill Fownes finished third among three teams.

Born in Buffalo in 1892, Marston grew up in northern New Jersey. He served in the Navy during World War I, then moved to Philadelphia to work as an investment banker. He played on the American Walker Cup Team in 1922, 1923, 1924, and 1934. He won the New Jersey Amateur in 1915 and 1919, and the Pennsylvania Amateur in 1921, 1922, and 1923. In 1933, 19 years after he first played in the U.S. Amateur, he advanced all the way to the final before losing to George Dunlap. But he never had another year like 1923. Few ever have.

Bill Mehlhorn

L ONG BEFORE THE TERM BECAME COMMON, BILL MEHLHORN suffered terribly from the "yips." Stories of his putting problems were indeed legendary. Once, while playing a four-ball match in Miami, Mehlhorn encouraged his partner to pick up his ball, then from ten feet away took six putts to get his own ball into the hole. Bob Jones, who himself confronted horrible woes on the green following his retirement from competitive golf, recalled once seeing Mehlhorn unleash a fierce twitch that sent a three-foot putt scurrying off the green and into a bunker. He was, by his own admission, "the world's worst putter."

Fortunately for Mehlhorn, he owned one of the sweetest swings in the history of the game. So highly regarded was his swing that even Ben Hogan stopped to watch him practice. At times Mehlhorn corralled his putting stroke to match his golf swing, and he was virtually unstoppable. In the words of his friend and fellow professional Leo Diegel, Mehlhorn "went wild" on such occasions, posting record scores. In 1929 he won the El Paso Open with a record four-round total of 271, then followed with 277 for a victory in the Texas Open. In these two events he posted two 66s, two 67s, a 68, and a 69.

The son of an immigrant German bricklayer, Mehlhorn's first passion growing up as a child in Chicago was baseball. He led the New Trier High School team to victory in the Cook County Championship, pitching three consecutive games. He struck out 17 batters in seven innings, but permanently damaged his throwing arm. Fortunately, he had also taken an interest in golf, learning the game as a young caddie at Skokie Country Club. His baseball career finished, he quit school at age 16 and went to work as an assistant professional. He moved around the country pursuing club appointments for several years, and soon became a regular on the tournament scene.

"Wild Bill" Mehlhorn was one of the most colorful players on tour in the 1920s. He often wore cowboy hats on the course, loved to play cards, and earned a reputation as a big talker. With his rugged features, he did not look the part of a champion golfer, but was long a gallery favorite. He collected 20 official victories during his career, including the 1921 Los Angeles Open and the 1924 Western Open, two of the most important championships of his era. Twice he finished third at the U.S. Open—1924 and 1926—and in 1925 finished runner-up to Walter Hagen in the PGA Championship.

Mehlhorn represented the United States in matches against Great Britain in 1921 and 1926, and in 1927 he was named a member of the first American Ryder Cup team. He continued to play at the highest levels well into the 1930s, advancing to the semifinals of the 1936 PGA Championship before losing to Denny Shute, the eventual champion. Mehlhorn missed four-foot putts at the 34th and 35th holes, before losing the match with a bogey at the last.

J. Wood Platt

———

P INE VALLEY, A MAGNIFICENT COURSE JUST EAST OF PHILADELPHIA in the pine-covered sandhills of New Jersey, has long been considered one of the toughest tests of golf in the world. Sandy wilderness and thick forest surround islands of immaculately conditioned fairway and green. The course is visually intimidating, but also demands precise play with forced carries over sand, water, and scrub. Playing at Pine Valley in the summer of 1951, Woodie Platt performed one of the greatest feats in the history of the game.

At the first hole, a 415-yard dogleg right described by one author as "the most lethal opening hole in the world," Platt dropped an 18-foot putt for birdie. The second hole is a 357-yard par 4 that plays to a vast green perched high atop a steep slope. Here Platt holed his 6-iron approach for an eagle. At the 3rd, 175 yards downhill across a virtual desert of sand and scrub, Platt's five-iron found its mark for a hole-in-one. Measuring 433-yards, the 4th climbs steeply from the tee to a broad plateau, then plunges downhill over bunkers and rough to a vast, rolling green. Platt's magic touch continued, as he holed a 30-foot putt for birdie. He had completed the first four holes at Pine Valley in six strokes under par.

The fourth green at Pine Valley sits no more than 50 feet from the clubhouse. After four remarkable holes, Platt ventured inside for a drink to steady his nerves, and elected to stay. He never completed his round. "Why go on? I couldn't do any better, only worse," Platt later recalled.

Born in 1899, John Wood Platt started playing golf at the age of nine. As a teenager he spent his summers in the Poconos, working on the golf course at Shawnee-on-the-Delaware and refining his game. He captured his first tournament, a local club event, in 1916, then emerged as one of the premier and most colorful players in the Philadelphia area. He won dozens of events—including eight Philadelphia Amateur titles—during the next 20 years.

In the 1919 U.S. Amateur at Oakmont, Platt captured national attention when he defeated Francis Ouimet in the quarterfinals. Down four holes with seven to play, Ouimet rallied to square the match. In the midst of a fierce summer storm, the match was decided at the 38th. "With his white shirt clinging as closely to him as the last of the seven famed veils, the blond youth from Philadelphia braced his sturdy form against the downpour and putted up dead to the hole," wrote one reporter assigned to the championship. "When Ouimet missed a twenty-footer by inches, the match was over." The following day Platt was eliminated by Davy Herron, the eventual champion.

In 1921 Platt was selected to represent the United States on a team that faced the British in a match at Hoylake that was the precursor to the Walker Cup. He finally claimed his first national championship in 1955, winning the inaugural USGA Senior Amateur Championship at Belle Meade Country Club.

Geo. S. Petzoker
OTTO CLEMENS ART
ST. LOUIS

Gene Sarazen

———◆———

THE SON OF AN IMMIGRANT CARPENTER FROM ROME, EUGENIO SARACENI WAS born in Harrison, New York, in February 1902. To help support his family, he dropped out of school at the age of 15 and joined his father in the construction business. Some months later he contracted pneumonia and spent several weeks in the hospital perilously close to death. His doctors urged him to pursue regular outdoor exercise to expedite his recovery. He chose golf. After recording a hole-in-one in a local tournament, Saraceni's name appeared in the newspaper. "Not bad for a violin player," he noted, "but a rotten name for an athlete." That night he scribbled variations of his name on a piece of paper, thereafter to be known as Gene Sarazen.

Early in 1922 Sarazen scored his first professional success with a victory in the Southern Open. He arrived at Skokie Country Club in Glencoe, Illinois, for that year's U.S. Open brimming with confidence, even if largely unknown to the galleries. Entering the final round, Sarazen stood four strokes behind Bob Jones and Bill Mehlhorn. Aggressive putting and bold approaches earned Sarazen a sensational final-round 68. He posted 288 for the championship, then waited for the field to finish. Jones and John Black would come close, finishing one stroke back at 289, but Sarazen's score held up.

For 18 months, the new U.S. Open champion remained at the peak of his game. He won the PGA Championship at Oakmont in August, becoming the first player to win the U.S. Open and PGA Championship in the same year. Later that year he squared off against Walter Hagen in a 72-hole exhibition touted as the "World Championship," and recovered from a five-hole deficit for a remarkable 3-and-2 victory. The following year he successfully defended his PGA title at Pelham Country Club, defeating Hagen on the 38th hole. He had won three major championships by the age of 21, securing his position as one of America's most distinguished golfers.

But Sarazen seemed to lose his touch following his victory in the 1923 PGA. For a period of several years he experimented with his swing with little success, and failed to win any tournament of note. His reputation as a streaky player would follow him throughout his career. "When the wand touches him, he is likely to win in a great finish," Bob Jones once said, "But if it touch him not....the boldness of his play leaves no middle ground. When he is in the right mood, he is probably the greatest scorer in the game, possibly, that the game has ever seen."

Fortunately for Sarazen, the magic returned. In 1932, after several attempts, Sarazen finally won the British Open. Later that same year he captured his second U.S. Open title with a three-stroke victory at Fresh Meadow on Long Island. He won his third PGA Championship in 1933, and in 1935 he recorded a remarkable final-round double eagle on the 15th hole at Augusta National en route to victory in the Masters.

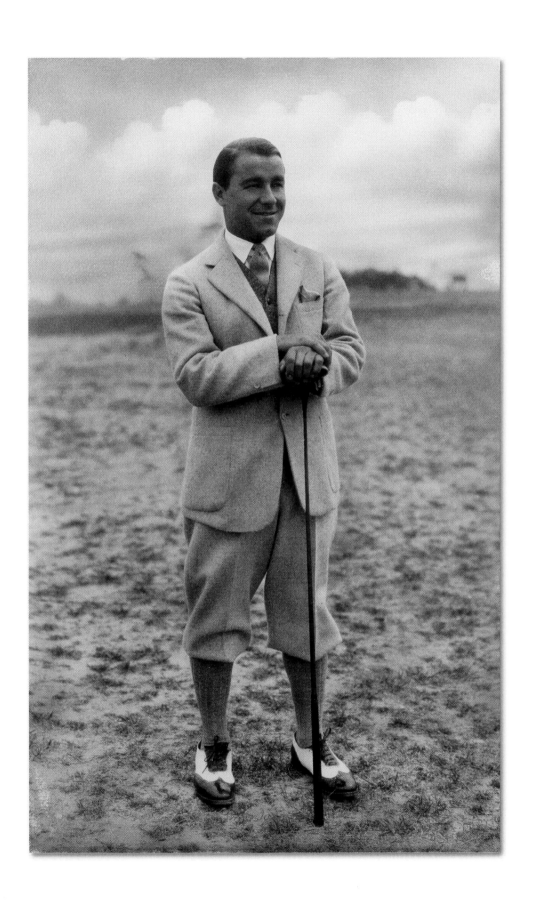

Macdonald Smith

———❦———

MACDONALD SMITH COULD HAVE BEEN THE LEADING PROFESSIONAL of his generation. He captured more than 50 tournaments between 1910 and 1939, including three Western Open titles and four Los Angeles Open titles. He won five times in the 1926 season alone. His peers considered his form to be flawless, and he was always immaculate in appearance. But the two most important championships of his day—the U.S. Open and British Open—eluded him. Between 1910 and 1934, Smith came within three strokes of winning these two championships on nine occasions. Quiet, serious, and on occasion sanctimonious, he also lacked the charisma that might otherwise have made him a favorite of the galleries.

Born in Carnoustie, Scotland in 1890, Mac Smith was the youngest of five children in a family of accomplished golfers. His father and four brothers—Willie, Alex, Jim, and George—were all professionals. The reputation of the Smiths spread throughout Scotland, then to America, where the brothers emigrated in search of employment. Willie and Alex, in fact, were able to accomplish what Mac himself could not by winning the U.S. Open.

In 1908 Mac followed his brothers to America. Two years later, in the U.S. Open at the Philadelphia Cricket Club, Mac tied his brother Alex and young Johnny McDermott after four rounds of play. In the playoff two days later, Mac finished third, six strokes behind his brother, who claimed his second national championship. This was the first of many heartbreaks he would endure over the next 30 years.

During World War I, Smith quit the professional scene and went to work in a shipyard on the West Coast. His hiatus from tournament golf lasted until 1923, but he returned with firm resolve and the game to support it. In 1925 Smith placed himself in an excellent position to capture the British Open at Prestwick. With scores of 76, 69, 76, he entered the final round with a five-stroke lead over Jim Barnes. Barnes, playing ahead of Smith, closed with a 74. All he needed was a 78 to claim the title, but the enthusiastic Scottish galleries rattled Smith's concentration. As famed golfwriter Herbert Warren Wind remarked, "They killed old Mac with their ardor." He handed the title to Barnes with an 82.

In 1930 Smith was runner-up to Bob Jones in two of his Grand Slam victories. In the British Open at Hoylake, Smith closed in on the lead with a final round 71 to Jones's 75, but fell two strokes short and tied for second with Leo Diegel. In the U.S. Open at Interlachen, Smith trailed Jones by seven strokes heading into the final round. Striking the ball solidly from tee to green, Smith turned in a round of 70, but it was not enough to catch Jones, who faded in the oppressive heat to a 75. Mac Smith, for the second time in less than a month, finished two strokes back of Jones in a national championship.

Jess Sweetser

———◆———

I N September 1922 the U.S. Amateur came to Brookline, site of Francis Ouimet's historic victory in the 1913 U.S. Open. To play at Brookline was a thrill for the young generation of American amateurs who had been so inspired by Ouimet's stunning defeat of Harry Vardon and Ted Ray nine years earlier. One of these was Jess Sweetser.

Jess Sweetser was born in St. Louis in 1902 and introduced to golf at a young age. His game only flourished, however, when his family moved to the New York area and joined the Siwanoy Country Club. In 1920 Sweetser enrolled at Yale University, where he quickly became a standout on two university sports teams. His specialty on the track was the half-mile, and he also ran as a member of the two-mile relay team. And in his freshman year he captured the Intercollegiate Golf Championship individual title.

Sweetser first played in the U.S. Amateur in 1921, advancing to the quarterfinals before losing to Chick Evans, 1 up. He was considered one of the favorites at Brookline and played well in stroke-play qualifying, but faced a difficult draw in the match-play rounds. To advance, he would have to negotiate his way through the current British Amateur champion Willie Hunter, the defending U.S. Amateur champion Jesse Guilford, Bob Jones, and two-time champion Chick Evans. Still, Sweetser rolled, dispatching his opponents in the first three rounds by a combined margin of 21 holes. In the semifinal round he took out Jones, 8 and 7. Sweetser then secured the title by defeating Evans, 3 and 2. "In earning his place on the throne," wrote the reporter from the *New York Times*, "Sweetser accomplished a task no one thought possible a week ago, for he blazed his way through one of the greatest fields that has ever played in the event. His margins of victory were all decisive enough to stamp him as one of the greatest players of the age." And he was just 20 years old at the time of his victory.

In 1926 Sweetser traveled to Britain as a member of the American contingent to play in the British Amateur at Muirfield, as well as the Walker Cup. He became ill before he arrived in Scotland for the 40th playing of the Amateur Championship. His cold worsened daily, and Sweetser was on the verge of defaulting as the matches commenced. Yet he pulled himself together, marched through the bracket, and defeated Alexander Simpson in the final, 6 and 5. Sweetser didn't give up. He joined his teammates the following week in St. Andrews for a 6-5 victory in the Walker Cup. Coughing up blood the night of the American victory, Sweetser was diagnosed with tuberculosis and was gravely ill. He suffered another hemorrhage on the return journey, and had to be lowered from the ship when it returned to New York harbor. A full year passed before Sweetser was able to resume his work as a New York stockbroker or return to the golf course.

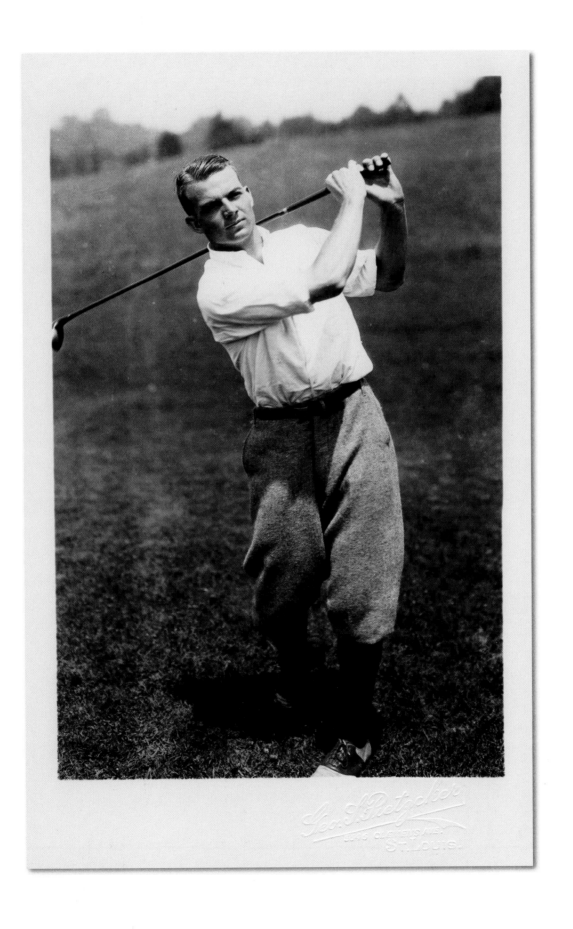

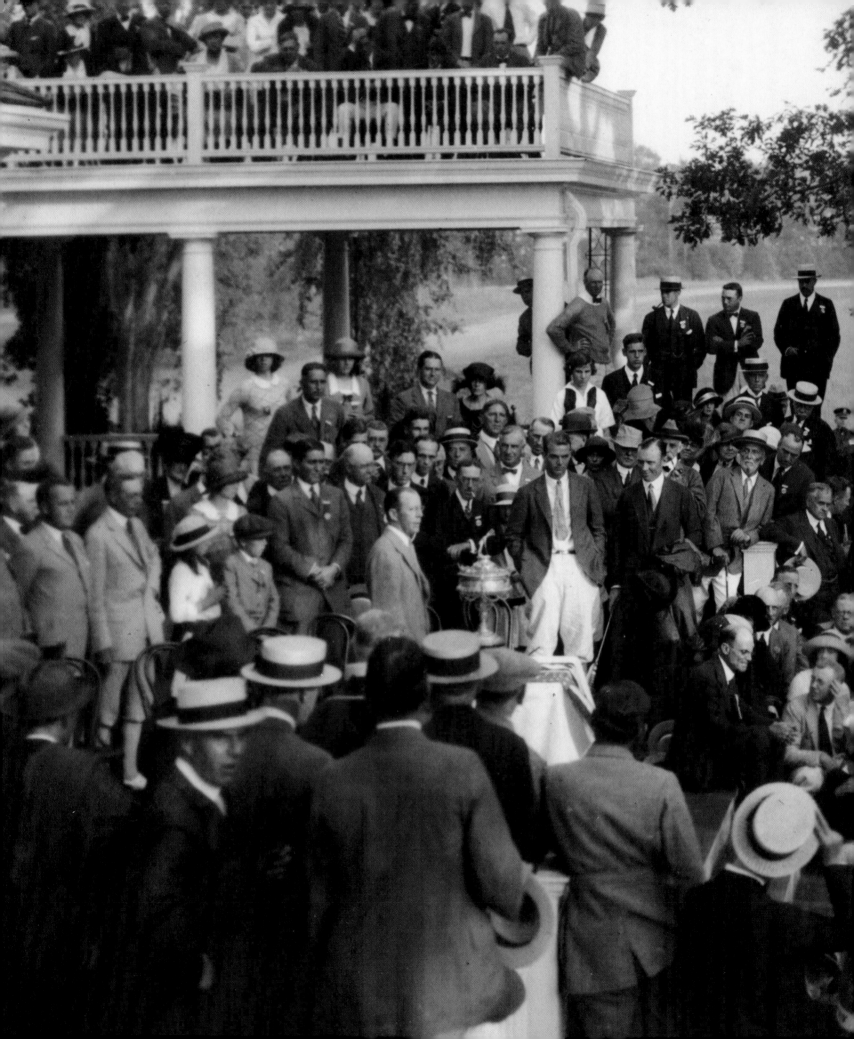

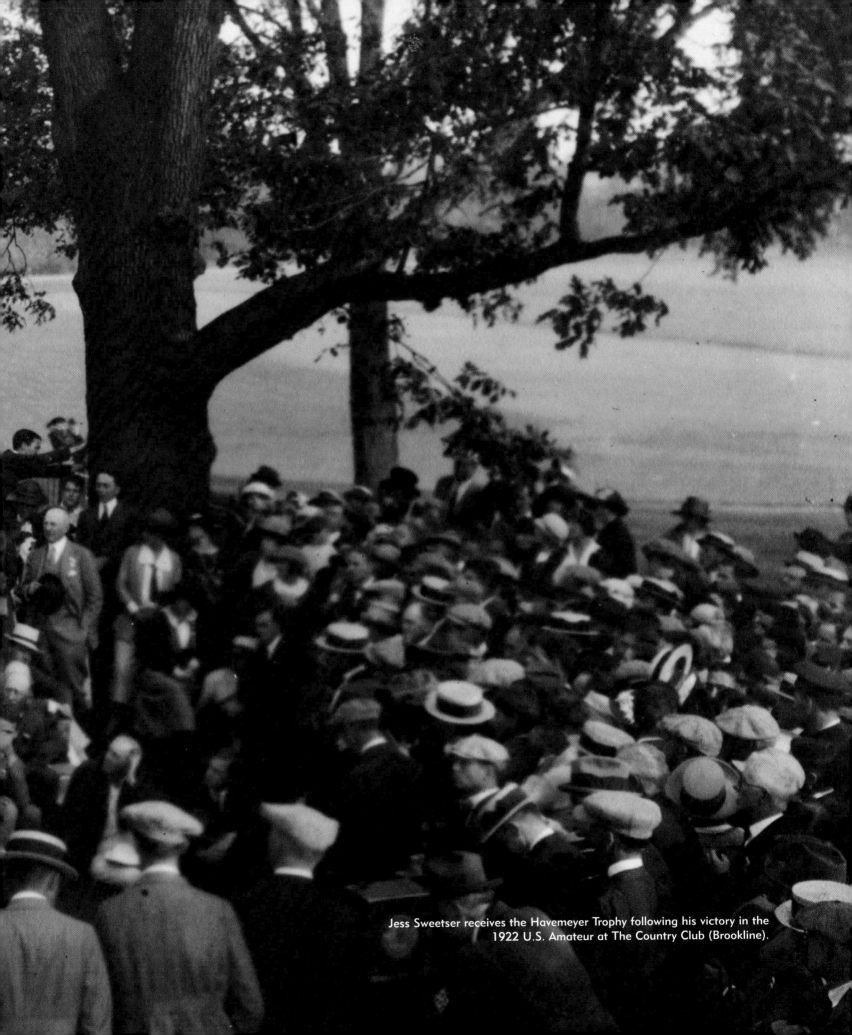

Jess Sweetser receives the Havemeyer Trophy following his victory in the
1922 U.S. Amateur at The Country Club (Brookline).

Cyril Tolley

B OB JONES'S QUEST FOR THE GRAND SLAM COMMENCED in earnest at St. Andrews with the playing of the British Amateur Championship, the one title he had yet to secure. His first-round victory over ex-coal miner Henry Sidney Roper was a formality. In the second round he handily dispatched Cowan Shankland, 5 and 3. His third-round duel, however, was eagerly anticipated. "Even before play commenced," Jones wrote in his autobiography, "everyone around St. Andrews seemed to be looking forward to the possible meeting of Cyril Tolley and me on Wednesday afternoon."

One of the longest drivers in the world, Tolley was the defending champion, having claimed the title the previous year at Sandwich. He had first established a reputation as a championship golfer in 1920, wining his first British Amateur title while a student at Oxford. He went on to capture the Welsh Open in 1921 and 1923, and remains the only amateur to have won the French Open with victories in 1924 and 1928. Jones and Tolley had squared off once before, at the 1926 Walker Cup, where Jones won easily, 12 and 11.

Beyond a formidable opponent, Jones found further cause for anxiety as he stepped to the tee. "The greens were hard and fast and the wind was blowing at something more than half a gale," Jones recalled. "Sand was being whipped from bunkers, and spectators and players alike were seeking refuge behind the dunes whenever a lull in the play developed."

So strong was the wind that Tolley drove the green at the 306-yard 9th. Both players drove over the 12th at 314 yards. Playing the short 11th in the opposite direction, Tolley played a strong iron that seemed to reach the green, only to be blown back to the fairway. The match was exceptional for its drama and intensity, even if nature wreaked havoc on the play. The players alternated in taking the lead, and the match was brought back from 1 down to all square six times.

The most discussed shot of the match was Jones's second at the 17th, the famous Road Hole, where his approach struck a spectator and stopped short of serious trouble. "Hundreds are prepared to take their oath that the ball would have been on the road if it had not hit a spectator," wrote Bernard Darwin, "and an equal number of witnesses are quite certain that it would not." Now working to halve the hole, Tolley executed an exquisite pitch to the green. "I shall carry to my grave the impression of the lovely little stroke with which he dropped the ball so softly in exactly the right spot," Jones noted. "Tolley himself confirmed to me that this was the finest shot of his life."

The hole was halved, so was the last. At the 19th, Tolley played a loose approach to the left of the green, then followed with a weak chip. There, he was stymied by Jones and the match concluded.

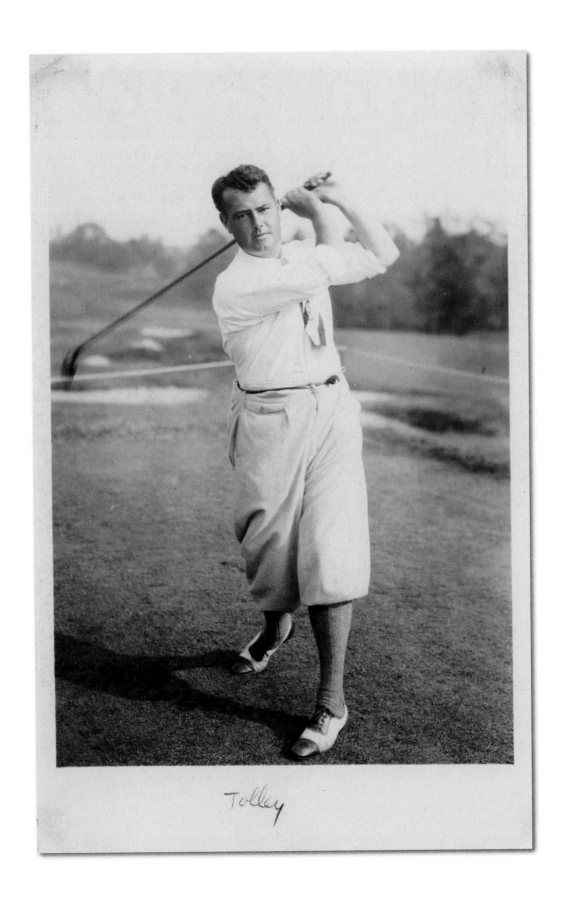

Tolley

George Voigt

I T HAS OFTEN BEEN WRITTEN THAT BOB JONES dominated the opposition in his quest for the Grand Slam. And while it is true that Jones soundly routed most of his match play opponents in both the British and U.S. Amateur championships, there was one man who almost altered the course of history.

In the semifinal round of the British Amateur at St. Andrews, Jones faced off against George Voigt, a native of Buffalo, New York, considered one of the championship favorites by many observers. Winner of the prestigious North and South Amateur in 1927, 1928, and 1929 and medalist at the 1928 U.S. Amateur, Voigt's skills and resume may have been enough to unsettle Jones. Displaying uncharacteristically sloppy play, Jones missed a number of short putts on the early holes, then fluffed a short pitch at the 13th. Voigt stood 2 up with five holes to play on the 14th tee, then, unthinkably, drove out of bounds over a stone wall. "I did not think that Voigt was the kind of player who would toss away that sort of lead," Jones later remarked, "and I was quite certain I was not capable of the golf needed to wrest it away from him. All I could do was what I did, namely, resolve to swallow the medicine, whatever it might be, and to keep on trying as best I could." Two holes later, Voigt faltered again, driving into the Principal's Nose bunker at the 16th, and Jones drew even. Playing the home hole, Voigt's approach came up short, falling back into the Valley of Sin. When he failed to get up and down for par, Jones advanced to the final with a 1-up victory.

Recalling their historic match in an article written shortly after Jones passed away, Voigt noted "The way things turned out I'm sort of glad I didn't beat Bob. If I had, there would not have been any Grand Slam that year, and maybe never. It had always been my ambition to play against Bob, and I felt that I gave him a good match."

Had he not been overshadowed by Bob Jones, Voigt might be remembered more readily as one of the outstanding amateurs of the late 1920s and early 1930s. In 1928 and 1936 he advanced to the semifinals of the U.S. Amateur before bowing out, while in 1929 and 1935 he advanced through the match-play bracket before losing close matches to the eventual champions (respectively Jimmy Johnston and Lawson Little). He was a member of the victorious American Walker Cup teams of 1930, 1932, and 1936, posting a decisive 10-and-8 victory over Sir Ernest Holderness, the 1922 and 1924 British Amateur champion, in the 1930 match at Royal St. George's. Voigt won the District of Columbia Amateur three times and the Middle Atlantic Amateur twice, as well as the Maryland Amateur, Metropolitan Amateur, and Long Island Open. In his later years he remained a fine player, capturing the club championship at Prince George's Country Club outside Washington, D.C. at the age of 70.

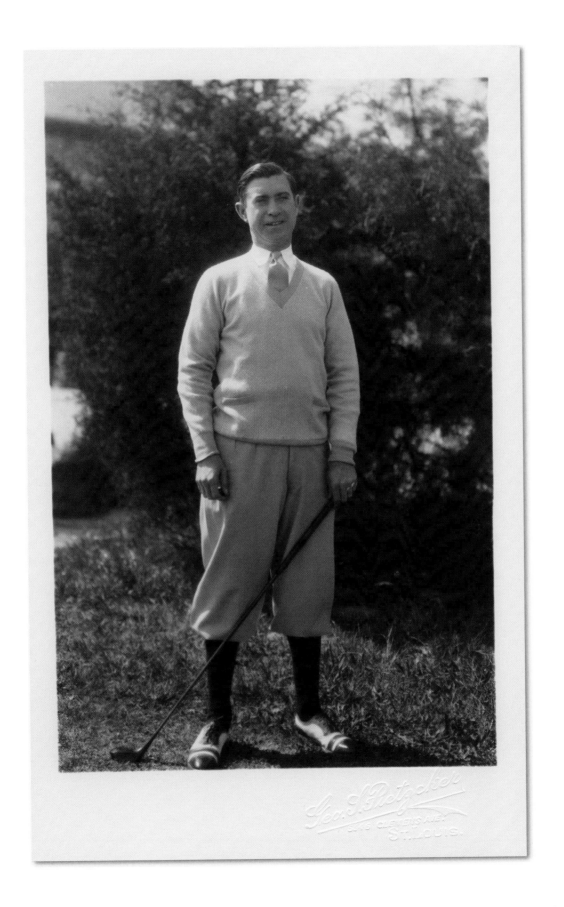

George Von Elm

———

I N THE YEARS BETWEEN THE TWO WORLD WARS, a small group of outstanding amateurs dominated American golf. Francis Ouimet, following his victory in the 1913 U.S. Open, long remained the dean of amateur golf in New England. Bob Jones, the teenage sensation from Atlanta, emerged as the South's first popular hero in the post-Reconstruction era. From the Midwest came Chicago's Chick Evans. And George Von Elm, a rising star from California by way of Salt Lake City, carried the hopes of the West Coast.

A clean-cut youngster and all-round athlete, Von Elm caddied at the Salt Lake City Country Club. Fast on his feet, with an equally quick temper, he earned a reputation as a fighter who would sooner become a boxer than a golf champion. Still, a local professional saw potential. He outfitted Von Elm with a set of clubs, secured for him a junior membership at the club, and nurtured his passion for the game. At the age of 15 Von Elm captured the Utah State Amateur. While the sports world sang the praises of the 14-year-old Jones, Von Elm quietly honed the skills that would make him the chief rival to the heir apparent.

After moving to Los Angeles, Von Elm elevated his game and emerged as one of the nation's leading amateurs with victories in the Pacific Northwest Amateur in 1921 and 1922. He entered the U.S. Amateur for the first time in 1921, losing in the first round to Jesse Guilford, the eventual champion. In 1923 Von Elm again qualified for match play, but lost in the third round to Francis Ouimet.

When the Amateur next came to Merion in 1924, Von Elm was ready for a run at Jones and the title. He made it to the final, where indeed he met Jones. Jones beat him, 9 and 8. Disappointed but not discouraged, Von Elm traveled to Oakmont in 1925, where in the third round he faced Jones. Jones beat him, 7 and 6.

Revenge would come in 1926. Jones and Von Elm again found themselves locked in a bitter battle for the title. All square through 22 holes, Von Elm took three of the next nine. He closed out the match at the 35th, posting a 2-and-1 victory. "I had at last defeated Bob Jones," Von Elm recalled. "I had vindicated the faith of my long-time friends in Salt Lake City who always had thought that some day I would beat Bob Jones. It was my greatest day in golf."

But for Bob Jones, George Von Elm might have emerged as the outstanding amateur of golf's Golden Age. Despite his immense skills and considerable accomplishments, the public never embraced Von Elm, while the press portrayed him as cool and haughty. In style and temperament, he was the perfect foil for Jones. After representing the United States at the Walker Cup in 1926, 1928, and 1930, Von Elm turned professional. He lost an epic 72-hole playoff to Billy Burke in the 1931 U.S. Open, but otherwise had little success on the professional circuit.

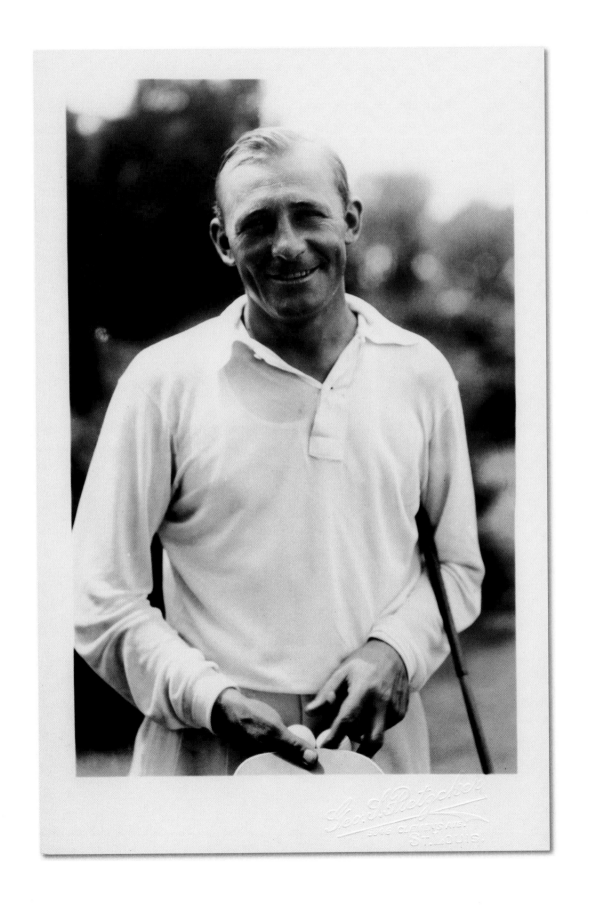

Cyril Walker

———

F ROM BABE RUTH TO BILL TILDEN TO JACK DEMPSEY, the American sports scene of the 1920s was dominated by muscle and clout. In the words of famed sportswriter Grantland Rice, it was "the day and time of bulk and power." Even in golf, the powerfully built—Hagen and Kirkwood—and the stocky and strong—Jones and Sarazen—reigned supreme.

At five feet six and 118 pounds, Cyril Walker was the unlikeliest of champions of this Golden Age. Earlier in his career a stomach disorder virtually destroyed his nervous system and for more than a year he was on the verge of a complete breakdown. Faced with the strain of competition, Walker often found himself unable to sleep. He had an unfortunate habit of delaying and dawdling over each shot he played, justifiably earning a reputation as one of the slowest players in the game. "Even when playing an apparently simple chip," Walker once remarked, "I get to waggling and thinking about the shot, until I become absolutely frozen." Only under the care of two physicians did he find a way to steady his nerves and regain control.

Born in Manchester, England, in 1892, Walker learned the game as a youngster on the Lancashire coast. First as a caddie, then as an apprentice in a club-making shop, Walker refined his swing and technique. He was never a long hitter, but playing in the wind along the British coast forced him to master a controlled, low punch shot. At the urging of a friend, he came to America in 1914.

When Walker arrived in Detroit for the 1924 U.S. Open, his claim to fame comprised a win in the 1920 Pennsylvania Open, and a second-place finish in the qualifying rounds of the 1913 British Open. He had also finished runner-up to Walter Hagen twice in the North and South Open. At 6,880 yards, Oakland Hills Country Club was the longest course to date to play host to the championship. When asked by a friend to assess his chances, Walker admitted. "It's too much for me. The course is too big. I haven't the endurance."

But then something unexpected transpired. As the winds picked up at Oakland Hills, Walker found the swing he had honed in his youth. In conditions that disquieted many of the game's elite, Walker returned rounds of 74, 74, 74, and 75 to capture the national championship title. On the final day, when the wind blew hardest, Walker may have played his best. "Any man who can shoot that last nine in par today deserves to be champion," said Bob Jones, who finished runner-up three strokes behind, "My hat's off to Cyril Walker." O. B. Keeler called it "the most consistent performance that ever returned a winner in our national open."

Walker was widely regarded as one of the most personable players of his era. He had many friends, and landed a succession of club professional posts following his Open win. But never again did he win another significant championship or tournament.

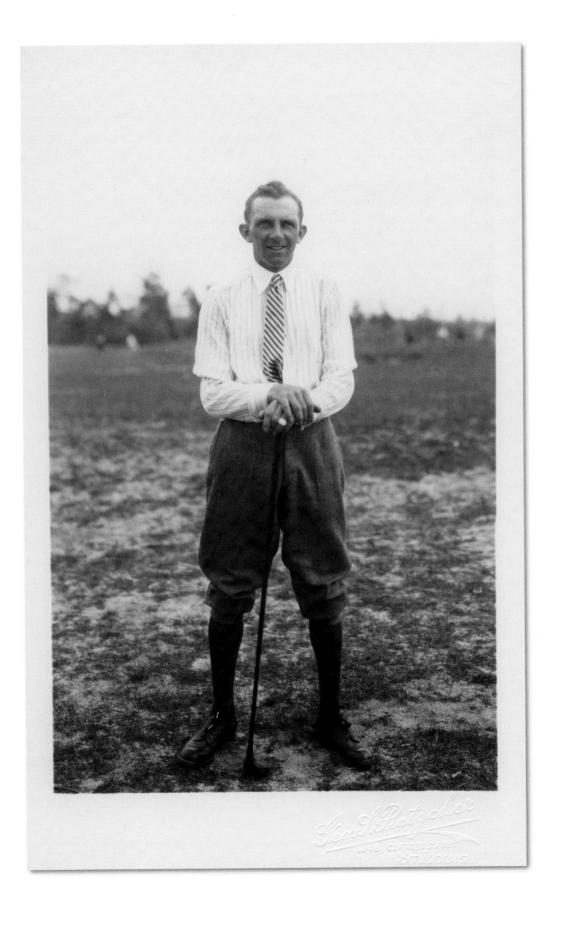

Dr. O. F. Willing

A S CAPTAIN OF THE AMERICAN SIDE FOR THE 1930 WALKER CUP Matches at Royal St. George's Golf Club, Bob Jones was responsible for assigning partners for the foursomes play. "This is about the only time when the captain of a golf team has an opportunity to affect the play in one way or another beyond his own participation in the matches," Jones remarked. "Perhaps I was just a wee bit grateful to the foursomes idea for providing some reason for my existence."

Jones's task was made easier by the fact that many of the pairings were readily evident. George Von Elm and George Voigt led the Americans off the tee in the first match of the day. Harrison Johnston and Francis Ouimet provided a solid anchor for the fourth and final match. The only pairing for which Jones claimed the "least degree of inspiration" was in pairing himself with Doctor O. F. Willing, a prominent amateur from the Pacific Northwest who was playing in his third Walker Cup.

Doc Willing was not a long hitter, though his demeanor was aggressive. The secrets to his success were his short game and his putter. "If there should be any question of any two of our players working well together in double harness, the problem would involve Dr. Willing," commented Jones. "I, therefore, resolved to take him myself because I happened to like Doc very much, and I thought he liked me." As it turned out, the partnership of Jones and Willing proved the most formidable American pairing of the day. They routed the British tandem of Rex Hartley and Tony Torrance, 8 and 7, thanks in no small part to some fine play from the good doctor.

Born in Portland, Oregon, in 1889, Oscar Willing took up golf at an early age. His family lived near the Waverly Country Club, and Willing began caddieing to earn some spending money. He continued to play golf during his years in dental school in Montreal, but did not take seriously to tournament golf until he returned to Portland in 1918.

In 1919 Willing captured the Oregon Coast Invitational, then followed with victories in the 1920 and 1921 Portland City Amateur. The year 1921 also brought his first of five titles in the Oregon State Amateur (the last would come in 1938). That same year he played in the U.S. Amateur for the first time, losing in the second round to a young Bob Jones. On the strength of his record in local events, Willing was named to the Walker Cup Team in 1923 and 1924. He claimed the Pacific Northwest Amateur in 1924 and 1928. In 1929 Willing reached the final of the U.S. Amateur at Pebble Beach, bowing to gallery-favorite Jimmy Johnston, 4 and 3.

Throughout his career, Willing was respected as an astute observer of the game. "A good golfer studies his game much more than the public thinks he does," he once noted. "The average player leaves more to luck."

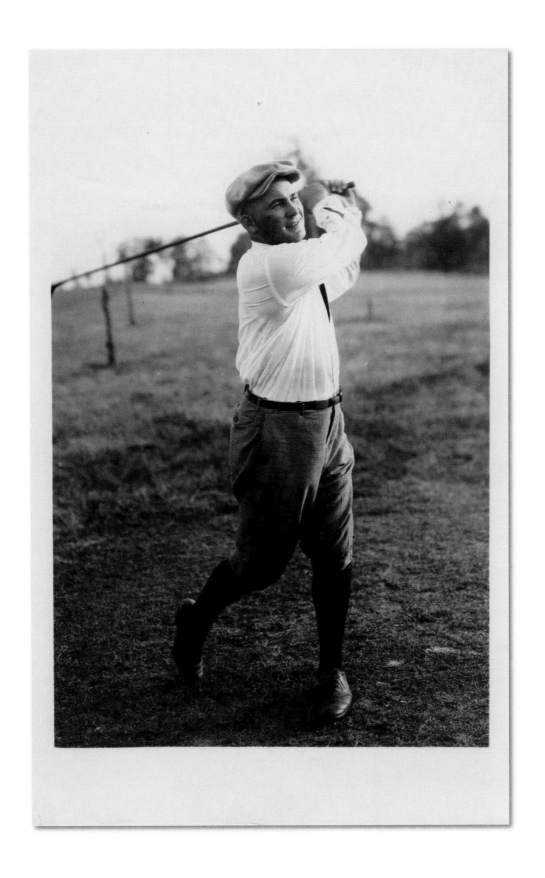

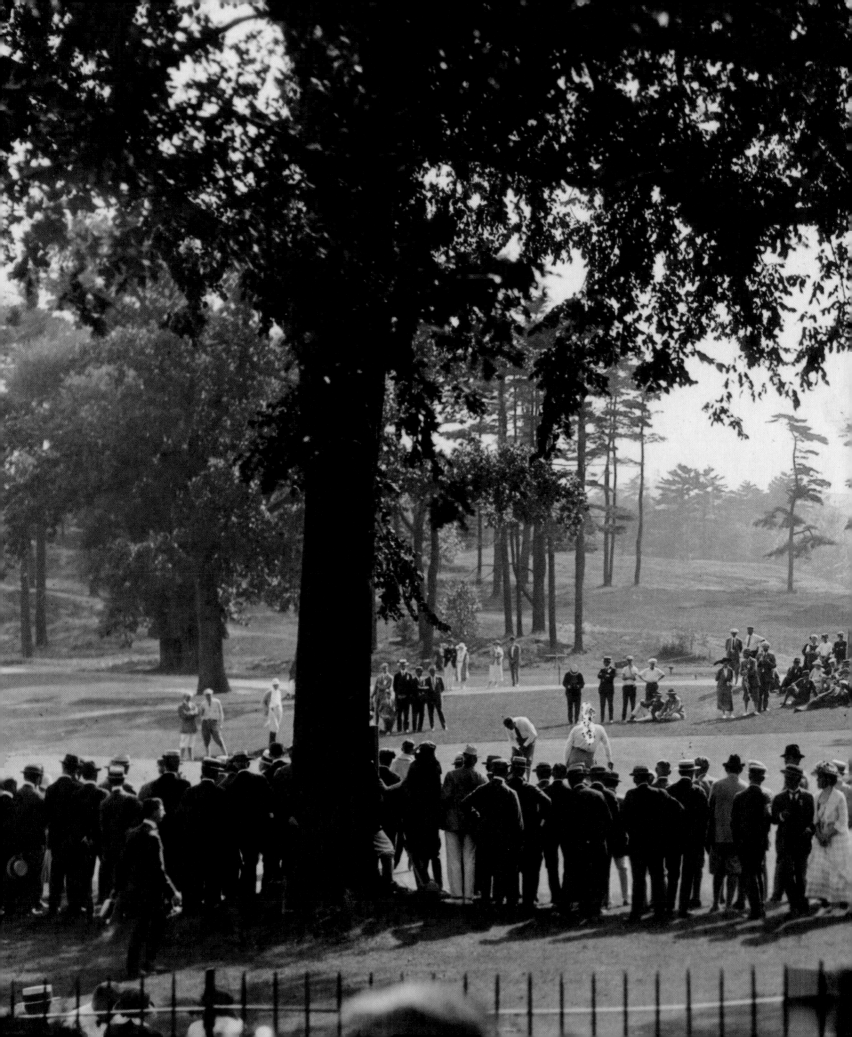

THE 1930s

THE YEAR 1930 SAW THE GREATEST PERFORMANCE the game would ever witness. In that year, Bob Jones won the Amateur and Open championships of Great Britain and the United States. It had never been done before, or since.

Americans were struggling through the Great Depression. Some four million were out of work, and by year's end more than 1,300 American banks had failed, yet the Grand Slam sparked excitement in a weary country. Sportswriter Al Laney wrote: "The cumulative excitement of that summer-long quest, participated in by millions on both sides of the Atlantic, has no parallel in the history of sport."

Then Jones retired at the age of 28.

Golf was left with something of a void after that, yet new players began to attract attention. The heroic-looking Lawson Little stormed through the amateur ranks in

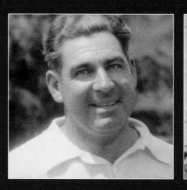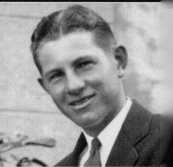

1934 and '35, winning both the U.S. Amateur and British Amateur in consecutive years. While he didn't meet expectations after turning professional, he would manage to win the 1940 U.S. Open.

The headlines shifted from amateur golf to the professional tour, which was in its infancy. Players drove up and down the dusty highways pursuing what little money was to be had. Diminutive Paul Runyan and tall, quiet Horton Smith were the leading players of the Depression years. Smith was leading money winner five times from 1929 to 1937. Runyan hit tee shots of only 230 yards, but slew much bigger men to win 28

ABOVE LEFT TO RIGHT: Henry Picard, Findlay Douglas, Olin Dutra, Horton Smith

titles. His defeat of Sam Snead, 8 and 7, to win the 1938 PGA was a classic David vs. Goliath tale.

Craig Wood once hit a 430-yard drive in the British Open. His great length was an advantage but he suffered from bad breaks. He lost a 1933 British Open playoff to Denny Shute and was the victim of Gene Sarazen's double eagle in the 1935 Masters which cost Wood the Masters tournament.

Three young men were poised to dominate professional golf. Ben Hogan struggled on the tour at first, but he would win four U.S. Opens, a British Open, two Masters and two PGA Championships, survive a terrible collision with a bus, and fascinate golf students with his repetitive swing. Some believe he became as fine a player as Jones.

The personable Byron Nelson went on the tour in 1935. In 1937 he made it to the

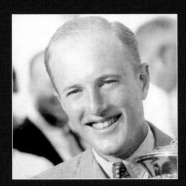 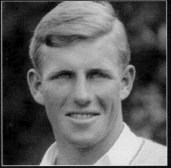 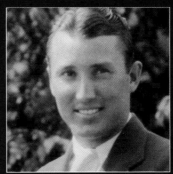

top, winning his Masters. In the end he won it twice along with the U.S. Open and two PGA Championships. In 1945 he would win a record 11 tournaments in a row.

Sam Snead came to the tour early in 1937. He would win the Masters and PGA three times each and the British Open once. Although he never won the U.S. Open, he delighted galleries with his flowing swing and folksy ways.

These three— Hogan, Nelson, and Snead—almost single-handedly ushered golf into the 1940s, driving the popularity of the game and staking a claim to a long-lasting era of their own.

— RHONDA GLENN

ABOVE LEFT TO RIGHT: George Dunlap, Charlie Seaver, Ky Laffoon, Les Bolstad

Les Bolstad

———◆———

I N THE EARLIEST DECADES OF GOLF IN AMERICA, the game was largely the domain of the wealthy and elite. Exclusive country clubs were the breeding grounds of America's first golf champions. In fact, for many years it was a requirement that a golfer be a member of a private club to be eligible to play in a USGA national amateur championship. In 1922 the game's governing body recognized the growing importance of municipally-owned golf facilities and created the U.S. Amateur Public Links Championship. Public golfers were granted their first opportunity to compete for a national amateur title.

In 1926 a feisty, blond-haired Minnesotan named Les Bolstad headed east to compete in the U.S. Amateur Public Links Championship at the Grover Cleveland Park Golf Course in Buffalo. Just 18 years old, Bolstad was the reigning public links champion from Minnesota. He advanced through stroke-play qualifying with scores of 73-77 (four strokes behind the medalist, Richard Walsh of New York), then steadily progressed through match play. Bolstad never trailed in his semifinal match against Stanley Ford of Detroit, played through severe weather conditions described by one onlooker as a "miniature hurricane." In the final he faced Karl Kauffmann, a stenographer from Pittsburgh. Bolstad started strong, building a 5-up lead on the first nine, but giving ground to Kauffmann on the homeward nine. When the players broke for lunch, Bolstad clung to a 1-up lead. The match remained tight—all square through 30 holes—until Bolstad won the 31st with a 12-foot birdie. His exceptional iron play and solid approach putting proved too formidable for Kauffmann, who eventually fell, 3 and 2.

Bolstad had been introduced to golf as a caddie, but spent considerable time refining his game on the public courses around Minneapolis. At the age of 16, he captured the inaugural Minnesota Junior Championship. The following year, as a student at Minneapolis Marshall High School, he finished runner-up in the Minnesota Amateur to the formidable Jimmy Johnston. He then broke through in 1926, winning the state and national public links titles. With the latter victory, he became Minnesota's first national golf champion.

Bolstad played collegiate golf at the University of Minnesota in the late 1920s, capturing the Big Ten individual championship in 1927 and 1929 and leading the Gophers to their first conference title in 1929. In 1931 he won the Minnesota Amateur, then two years later won his first of four Minnesota Opens. He turned professional in 1934, and in 1939 claimed the Minnesota State PGA title.

In 1946 Bolstad returned to his alma mater as course professional, team coach, and instructor in the university's physical education program for more than 30 years. He spent the last years of his life teaching the game to juniors at his honorary home club, Hazeltine National. "Les Bolstad didn't just teach the game of golf," recalled one his former students, "he taught the game of life." And this may be his most enduring legacy.

Billy Burke

B OB JONES'S RETIREMENT FROM COMPETITION FOLLOWING the 1930 U.S. Amateur left a considerable void in both amateur and professional golf. Where galleries swelled to record numbers in 1930, public attention waned in the years that followed. Still, this period witnessed one of the most dramatic U.S. Opens in history, when Billy Burke and George Von Elm battled for 144 holes at the Inverness Club near Toledo in 1931.

In the two weeks prior to the championship, Burke had impressed many onlookers with his dominant play at the Ryder Cup, which included a 7-and-6 thrashing of the formidable Archie Compston. Some members of the media, including Bob Jones, listed Burke first among the favorites. And he did not disappoint. Burke opened with a 73, two shots off the lead. He moved into second behind Von Elm after the second and third rounds, then caught Von Elm with a closing round 73. The conditions of play dictated that a 36-hole playoff would determine the champion, and, quite unbelievably, the two again finished tied. Indeed, Von Elm had birdied the 72nd hole to force the initial playoff, then did it again on the 36th hole of the playoff. Burke finally edged Von Elm, but by only one stroke, to claim the trophy.

"He is one of the few I have ever known, who could keep his game at razor edge through two hard weeks of competition," wrote Bob Jones in *American Golfer*. "How he was able to turn in that last 71 after such a long stretch of fine golf, after such a week of pressure, is something beyond me. It not only proves that he knows how to hit a golf ball, but also that he is supplied with an unlimited amount of courage, stamina, nerve control and the ability to keep his concentration unbroken."

The son of Lithuanian immigrants (his real name was Burkauskus), Burke suffered a serious injury while working in an iron mill as a young man. He lost part of the fourth finger on his left hand and permanently damaged the fifth. To compensate for a lack of strength in his grip, and to reduce the pain from his injuries, he played with a sponge inserted in his glove. While he was never tremendously long with a driver, he was extremely accurate from tee to green.

Rarely seen on the golf course without a cigar in his mouth, Burke first learned the game as a caddie, enjoying a successful amateur career in his native Connecticut before turning professional in 1926. He gained the attention of the golf world with impressive play on the Florida circuit during the winter of 1926-1927, including victories in the Florida Open and Central Florida Open. In addition to a number of smaller tournaments, he captured the esteemed North and South Open, the New York State Open, the Cascades Open, and the Glens Falls Open twice. However, he will always be remembered for his epic playoff with Von Elm. Their monumental battle remains the longest of its kind in national championship history.

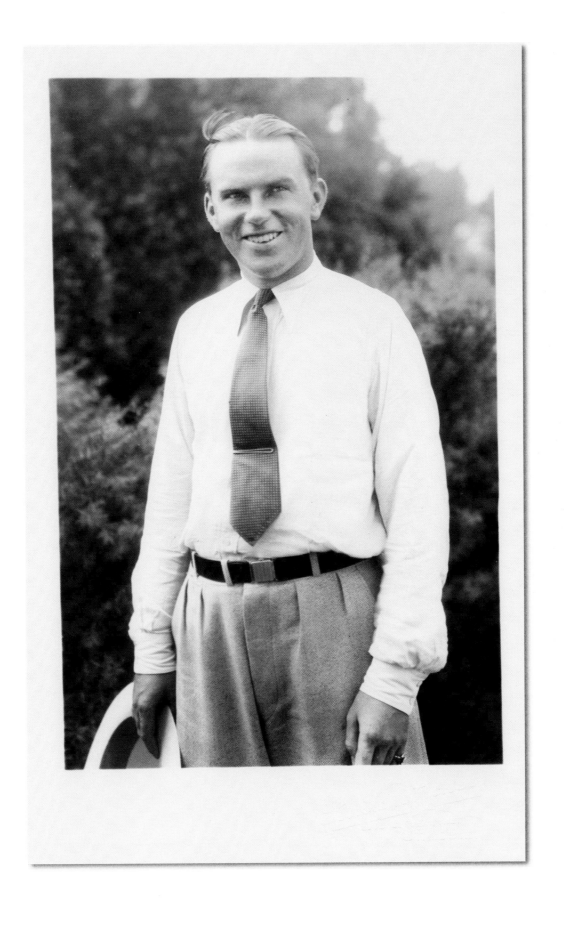

Harry Cooper

H ARRY COOPER WAS BORN IN ENGLAND, IN THE TOWN OF Leatherhead in Surrey. His father, Sidney, was a golf professional, at one time apprenticed to the legendary Old Tom Morris. In April 1912, having accepted a position at the Hamilton Country Club in Canada, Sydney Cooper packed up the family and their belongings and headed on a steamer for North America. "We followed the *Titanic* over," Harry Cooper recalled later in life, "and went through the same ice floe it ran into. We saw tugloads of bodies coming in covered with sheets." In 1913, having returned to England for a brief visit, Harry and his mother again set sail across the Atlantic. "We were supposed to land in New York, but the German U-boats were after us and drove us into Halifax. We had to wait for a British warship to escort us into New York."

Narrow misses, in many ways, characterized Harry Cooper's life. One of the leading professionals in the United States throughout the 1920s and 1930s, Cooper captured more than 30 PGA tournament titles during his career. From 1923, when he won the Texas PGA Championship at the age of 18, until 1942, when he captured the Minnesota Open, Cooper was widely considered one of the most consistent players in the game. "Lighthorse" Harry was also one of the fastest. Still, he is remembered as much for his near misses as for his victories. During these same years, he amassed almost 40 runner-up finishes and more than 20 thirds.

In 1925 Cooper advanced to the semifinals of the PGA Championship, but lost to Walter Hagen. In 1936 he was leading the Masters by two strokes with five holes to play, but was edged out by the hot putter of Horton Smith. In 1938, again at the Masters, he finished runner-up by two strokes to Henry Picard. But his losses in the U.S. Open may have been the most heartbreaking.

In the 1927 U.S. Open at Oakmont, believing he needed a birdie at the 17th to preserve his lead, Cooper rammed a ten-foot putt well past the hole, three-putted, and finished tied for the lead when Tommy Armour birdied the 18th; Cooper lost the playoff the following day. In 1930, playing some of the best golf of his career from tee to green, Cooper's balky putter ended his bid to halt Bob Jones's Grand Slam run: "I was hitting the ball so well there, from tee to green. I was hitting 15, 16 greens a round and couldn't get the ball in the hole with a rake. I used my putter, I used my 2-iron, I used my 5-iron, and I just couldn't get the ball in the hole." Then in 1936, Cooper posted a record score in the U.S. Open at Baltusrol, but it only lasted 30 minutes until Tony Manero edged him by two strokes.

Following his retirement from competitive golf in 1949, "Lighthorse" Harry Cooper became one of the most distinguished teaching professionals in the country. "First you've got to be good," Cooper often told his students, "but then you've got to be lucky."

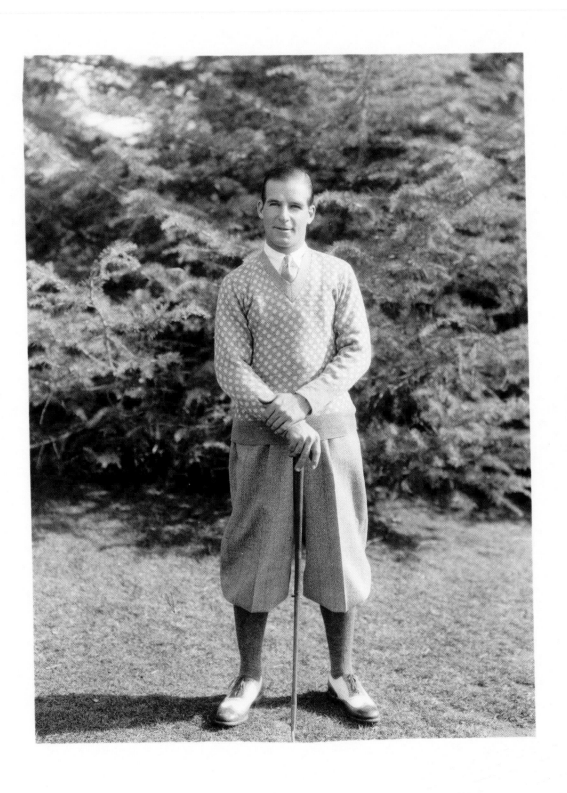

Findlay Douglas

ITH HIS VICTORY IN THE 1930 U.S. AMATEUR, Bob Jones completed his historic quest. His name would be added to the Havemeyer Trophy for the fifth and final time. "I wasn't quite certain what had happened or what I had done," Jones recounted. "I only knew that I had completed a period of the most strenuous effort and that at this point, nothing remained to be done." USGA President Findlay Douglas had the honor of presenting the trophy to Jones, just as he had at the U.S. Open two months earlier. Douglas understood well both the pressure and sense of relief that Jones experienced that afternoon. Thirty-two years earlier he had stood in a similar position, cradling the Havemeyer Trophy as the United States Amateur Champion of 1898.

Findlay Douglas was born in St. Andrews, Scotland, in 1874. He excelled at the game from a young age, winning junior competitions in St. Andrews and later serving as captain of the university golf team. In March 1897, Douglas departed for America, carrying songs and stories of Scottish golf, as well as a deep appreciation for the traditions of the game.

Douglas competed in the U.S. Amateur the summer he arrived, advancing to the semifinals before losing to the defending champion, H.J. Whigham. The following year the Amateur Championship came to the Morris County Golf Club near Morristown, New Jersey. After qualifying with rounds of 89-91, he advanced through the match-play bracket with impressive victories, including an 8-and-6 defeat of Walter Travis in the semifinals. In the 36-hole final against Walter Smith, Douglas got off to a strong start, seizing a 3-up lead through eight holes. Although Smith narrowed the margin to 1 up by taking the first two holes of the afternoon round, Douglas played increasingly steady golf throughout the afternoon to secure a 5-and-3 victory.

Douglas remained one of the elite players in America for five years. He was runner-up in the U.S. Amateur in 1899 and 1900, and reached the semifinals again in 1901. He also captured the prestigious Metropolitan Amateur Championship in 1901 and 1903. When his game eventually waned, Douglas emerged as one of the game's leading administrators. A prominent businessman and noted ambassador of the game, he was made a member of the Royal and Ancient Golf Club of St. Andrews in 1920. He served as president of the Metropolitan Golf Association from 1922 to 1924, was elected a Vice President of the United States Golf Association in 1926, and served as USGA President in 1929 and 1930. In 1932 he was elected the first President of the United States Seniors' Golf Association.

In 1959, just months before he passed away, Findlay Douglas received the Bob Jones Award, the highest honor bestowed by the United States Golf Association. In presenting the award, Ward Foshay, Chairman of the Bob Jones Award Committee, noted that "In matters pertaining to golf but also in business and life, Findlay Douglas has demonstrated throughout nothing but the qualities of a gentleman and true golfer."

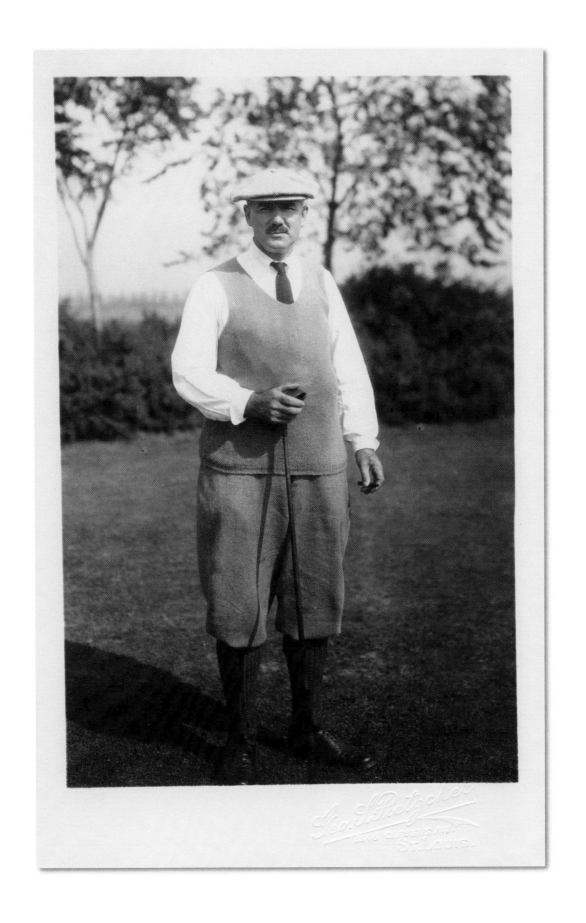

Geo. L. Pietzcker
4435 Clemens Ave.
ST. LOUIS.

George Dunlap

W ITH A SWING "AS QUICK AS A HUMMINGBIRD'S WING," GEORGE DUNLAP dominated the golf scene in Pinehurst, North Carolina, for more than 20 years. His earliest successes came in 1920 and 1921, when he captured the Junior Boys Tournament. In 1925 he won his first of four consecutive and first of eight total Mid-Winter Tournaments. In 1926, at age 17, he led the qualifying rounds in the prestigious North and South Amateur. He won the North and South Amateur for the first time in 1931, then followed with victories in 1933, 1934, 1935, 1936, 1940, and 1942.

His success was not limited to the sand hills of North Carolina, however. As captain of the Princeton University golf team, Dunlap captured the National Intercollegiate Championship in 1930 and 1931. He won the Long Island Amateur in 1932 and the Metropolitan Amateur in 1936. And he represented the United States in the Walker Cup in 1932, 1934, and 1936.

But 1933 was his greatest year. Having spent the winter refining his swing under the guidance of Tommy Armour, Dunlap clinched his second North and South title. He led the British Open qualifier at St. Andrews, then reached the semifinals of the British Amateur at Royal Liverpool before falling to Michael Scott, the eventual champion.

In the 1933 U.S. Amateur at Kenwood Country Club in Cincinnati, Dunlap emerged from a 12-man playoff to capture one of the last eight places in the match-play field. Gaining momentum, he rolled past fellow Walker Cup teammate Gus Moreland and former Amateur Public Links champion Eddie Held. He then defeated Lawson Little, rising star of the Stanford golf team, in the semifinals. In the final, Dunlap squared off against Max Marston, the 1923 U.S. Amateur champion. Playing the best golf of his career, Dunlap hit every fairway and missed just one green. He was 9 up through 22 holes, threatening to break the record for largest margin of victory established by Charles Blair Macdonald in 1895. "I'm playing fast, as I'm afraid the alarm clock will ring and wake me up," Dunlap told USGA President Herbert Jacques, who was officiating the match. He eventually closed out Marston on the 31st hole by the score of 6 and 5.

Pinehurst honored its favorite son the following January with a night of food and music. Among the songs played that evening was a special tribute to their "Champion George":

There are times when we are happy,
There are times when we are blue,
When our tee shot goes into a bunker
And our putts all go askew.
There are times we have a tender feeling
For our friends so loyal and true;
So to you we offer, George T. Dunlap,
All our honor and glory too.

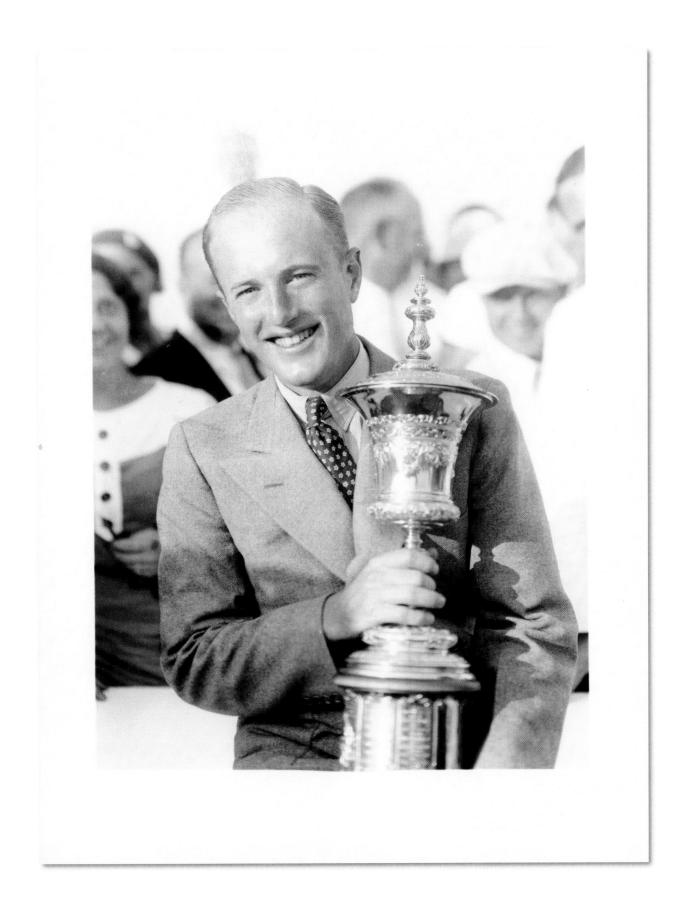

A gathering of officials and marshals at an early U.S. Amateur

Olin Dutra

I N 1915, WHEN HE WAS 14 YEARS OLD, OLIN DUTRA took a job in a hardware store in Monterey, California. A descendant of one of the first Spanish landholders in California, Dutra was imbued with a strong work ethic and perseverance to match. An avid golfer, Dutra roused himself from bed in the early morning hours three days a week, so that he might practice his game for several hours before work. For eight years he continued his grueling routine, steadily improving his skills until he won his first match-play tournament at Del Monte in 1922.

Two years later Dutra turned professional and accepted an appointment at the Fort Washington Club in Fresno. Still he continued to wake at four o'clock in the morning to drive 45 miles north to a second club, where he taught for four hours before returning to his regular job in Fresno. With no assistant available, Dutra's responsibilities included teaching, club cleaning, club repair, and retrieving balls. Fortunately for the members, Dutra's first passion was as an instructor. Six days a week he offered lessons from nine o'clock in the morning until five-thirty at night, reserving one half-hour break for lunch. It is reported that he averaged a thousand hours of teaching annually in his years as a professional.

During these years, Dutra captured the Southern California PGA Championship five times, in 1928, 1929, 1930, 1932, and 1933. He collected more than 20 victories on the professional circuit, but his first major breakthrough came in the 1932 PGA Championship at the Keller Golf Course in St. Paul, Minnesota. After shooting the lowest score in the qualifying rounds, Dutra advanced through the 32-player match-play bracket with sub-par scores and impressive victories. In the final, he defeated Frank Walsh, 4 and 3.

Dutra added a second major championship to his resume in 1934, winning the U.S. Open at Merion Cricket Club outside Philadelphia. Recovering from severe intestinal illness, it seemed unlikely that Dutra would play. He had lost 15 pounds, had not been able to play in the 10 days prior to the championship, and should have been hospitalized. With rounds of 76 and 74, he quickly fell eight strokes behind the leader, Bobby Cruickshank. Dutra trailed 17 players when he headed to the first tee to play 36 holes on the final day. While Cruickshank faltered with a 77 in the third round, Dutra shot an impressive 71 and moved to within three strokes of Gene Sarazen, the new leader. Last off the tee in the final round, Dutra played in considerable pain and relative obscurity as the galleries flocked around Sarazen and Cruickshank. He completed the front nine in 38, but registered important birdies at the 10th and 15th. Now leading the championship for the first time, Dutra three-putted the 17th and 18th greens for bogey, but still managed a one-stroke victory over Sarazen.

"Our new champion can really play golf," wrote Bob Jones in *American Golfer*. "Not just for one round or one day, but pretty much all the time."

Johnny Goodman

ETWEEN 1924 AND 1930, BOB JONES CLAIMED THE U.S. AMATEUR every year save two. In 1926 he lost to George Von Elm in the final at Baltusrol. But in 1929, in a match that stunned onlookers, Jones lost in the first round to Omaha's Johnny Goodman.

The fifth of ten children born to Lithuanian immigrants, Goodman was orphaned at the age of 14. To support his siblings, he left school to work as a messenger, continuing his studies at night. He was introduced to golf through the caddie ranks, and in 1925, at the age of 16, he won the city championship.

Following upon his success in local and state events, Goodman entered the 1926 Trans-Mississippi Amateur, representing the Omaha Field Club with two close friends. Unable to afford train fare, the three shipped out to St. Louis as drovers on cattle cars. Dubbed "The Cattle-Car Threesome" and "The Boxcar Trio," all three qualified for match play, with Goodman advancing to the semifinals. The following year, at the Broadmoor Golf Club in Colorado Springs, he secured his first significant title with a 3-and-1 victory over James Ward, a millionaire from Kansas City.

In June of 1929, Goodman reentered the national spotlight, capturing medalist honors among 1,400 amateur and professional golfers in qualifying rounds for the U.S. Open. At age 20, he was the youngest to qualify. He made the cut, but finished in a tie for 45th, 24 strokes behind the champion, Bob Jones.

In September Goodman was offered a chance at redemption in the U.S. Amateur. Unable once again to afford train fare, Goodman arrived at Pebble Beach after chaperoning a carload of cattle from Omaha to California. Goodman advanced through qualifying with rounds of 80-77, only to find himself matched against the medalist, Bob Jones, in the first round. Hailed widely as the championship favorite, Jones's very presence attracted enormous galleries. Goodman started strong, winning the first three holes as Jones opened nervously. Jones then steadied himself, winning the fourth, sixth, and eighth. The two fought tenaciously to the end of the match, and Goodman retained a 1-up lead when they came to the 18th. Both reached the green in regulation, and when Jones failed to sink a 35-footer for birdie, Goodman was left with three putts to secure the match. He took just two. "I had been more than normally nervous at the beginning of the match," Jones recounted, "and had failed to shake this nervousness as quickly as had been my experience before. In looking back on it, I realized that I lost the match because I was in too big a hurry to overcome Goodman's lead and to seize command."

Although Goodman would lose in the second round of the 1929 Amateur, he would move on to greater success at the national level. In 1933 he won the U.S. Open at North Shore, and remains the last amateur to claim the national championship. Four years later, at Alderwood, Goodman finally claimed the elusive Amateur title with a 2-up victory over Ray Billows.

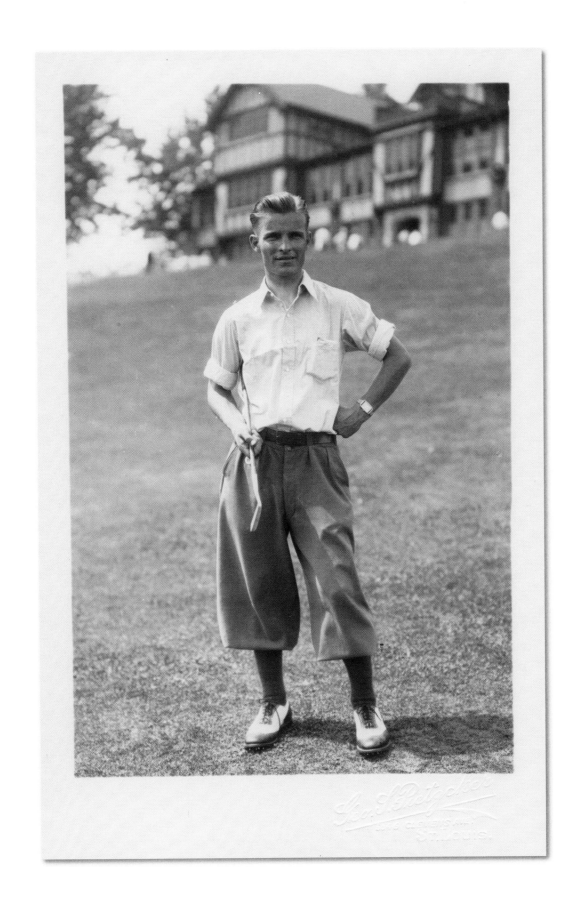

Ky Laffoon

———◆———

K Y LAFFOON WAS BORN IN THE SMALL MINING TOWN OF ZINC, Arkansas, on Christmas Eve, 1909. His parents, of French and Irish descent, lived a virtually nomadic existence during Ky's childhood years, moving between farms and small mining towns in the Ozarks before settling near Miami, Oklahoma, in 1915. Laffoon's early years were rough and tumble, replete with colorful stories about family pets, schoolyard antics, and sibling rivalries. His father often told of the time that young Ky was nearly trampled by a frightened team of mules, but survived thanks to his calm demeanor and resourceful presence of mind.

At the end of Laffoon's second year in the Miami school, his parents learned that their 12-year-old son had not passed. To help support the family, he took up work as a caddie, and quickly became skilled at the game. When he was 15 he shot 30 at the local nine-hole course, and the following summer he accepted a position as a course professional in Kansas. He returned home at the end of the summer, renewed his studies while working part-time as an assistant professional, and graduated from high school two years later. It was at Miami that Laffoon met and befriended Ed Dudley, who later became prominent on the professional tour. Laffoon came to idolize Dudley, who in turn helped the teen refine his smooth, flowing swing and control his fiery temper.

By the early 1930s Laffoon had elevated his game to the level where he was ready to join the professional circuit. He best year was 1934, when he won the Atlanta Open, Eastern Open, Hershey Open, and Glens Falls Open, and captured the Radix Trophy for lowest scoring average. Capable of brilliant streaks of play, Laffoon continued to follow the tour regularly until 1950, playing well enough to tie for second in the 1948 Canadian Open. By the time he retired he had won about a dozen significant tournaments.

There is more to the story of Ky Laffoon, however, than tournament victories. Known for his canary-yellow socks and sweaters, he was prone to fits of anger and bursts of cursing. A master of self-promotion, Laffoon invented a Cherokee lineage for himself, and for many years it was falsely believed that he was of Native American descent. There is also a lack of credible evidence to support the story most frequently associated with Laffoon—that in disgust he tied his putter to the bumper of a car and dragged it for hundreds of miles between tournament sites. What is true, however, is that Laffoon once shot his putter three times with a pistol after three-putting the final green of a tournament. On other occasions he attempted to strangle or drown recalcitrant clubs. He also had a curious habit of leaning out of moving cars to grind the leading edge of his clubs on the pavement below. Understanding where truth ends and fiction begins can be a challenge. But without question, he was one of the most colorful characters ever to play the game.

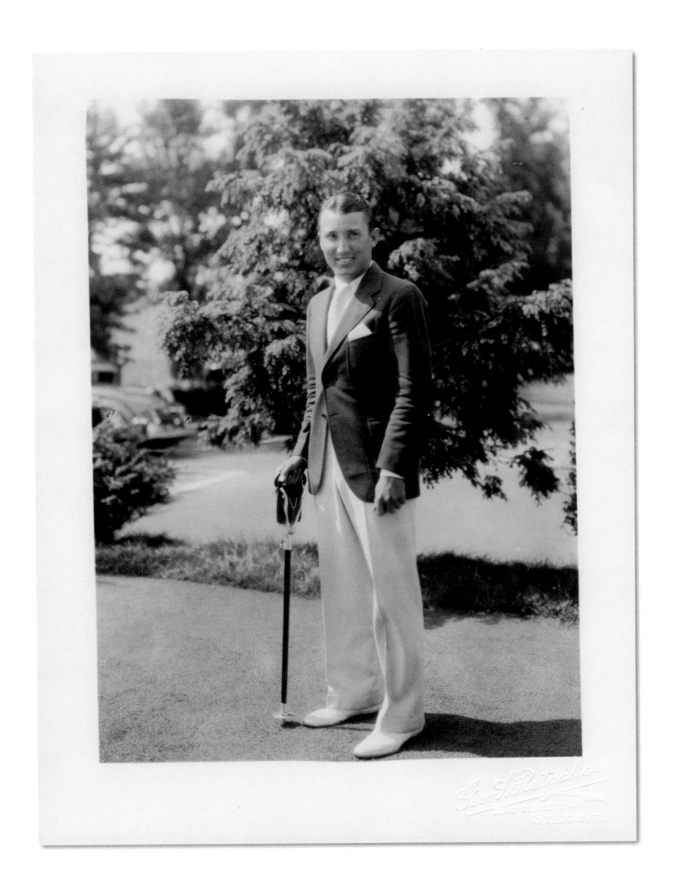

Lawson Little

HEN BOB JONES RETIRED FROM COMPETITION IN 1930, there was no heir apparent. Rather, a handful of elite players battled for the game's most prestigious championships. In 1934, however, Lawson Little stepped forward to win the first of 31 consecutive matches in the British and American amateur championships.

William Lawson Little, Jr. was born in Newport, Rhode Island, in the summer of 1910. His father was a U.S. Army officer, and the family moved frequently. Little learned to play golf as a child in San Antonio, and refined his game in such exotic locales as the Philippines and China. After returning to the United States, Little came under the tutelage of several club professionals, emerged as a star on the Stanford University golf team, and by the age of 17 was good enough to play in the U.S. Open.

With his broad shoulders and a pugnacious appearance, Little looked more like a linebacker than a golfer. From his earliest days in golf, he enjoyed the thrill of match play. Stroke play never brought out the best in his game, for he preferred beating a person to beating par. He first caught the attention of the national media when he squared off against Johnny Goodman in the second round of the 1929 U.S. Amateur at Pebble Beach. Earlier in the day, Goodman had completed one of the greatest upsets in the history of the championship, knocking out Bob Jones in the first round. But Little ensured that Goodman's success was short-lived, defeating "the giant killer," 2 and 1.

Little advanced to the semifinals of the 1933 U.S. Amateur before falling to George Dunlap, but played well enough to earn a spot on the 1934 U.S. Walker Cup Team. Playing on the Old Course at St. Andrews, Little partnered with Johnny Goodman to defeat Roger Wethered and Cyril Tolley, 8 and 6, then routed Tolley, Britain's own titan, 6 and 5, in singles. The Stanford senior next traveled to Prestwick for the British Amateur, buoyed by his success at St. Andrews. "I thoroughly liked the sporty and thoroughly well-laid-out golf courses of Scotland," Little recalled, "and I thoroughly liked the British golfers and galleries." With his 3-and-1 defeat of R. W. Ripley, Little commenced a streak of match-play victories as impressive as any in the history of the game. Seven wins later he secured the British Amateur title, comfortably dispatching local favorite James Wallace, 14 and 13.

Four months later, at The Country Club in Brookline, Massachusetts, Little continued his dominant play and won the U.S. Amateur, defeating David "Spec" Goldman, 8 and 7, in the final. The following year would be no different. Little again captured the British Amateur and U.S. Amateur, completing a remarkable feat that has come to be known as the Little Slam.

Having proven himself in amateur competition, Little turned professional in 1936 and promptly won the Canadian Open by eight strokes. He added the U.S. Open to his resume in 1940, but as a professional never matched the success he had as an amateur.

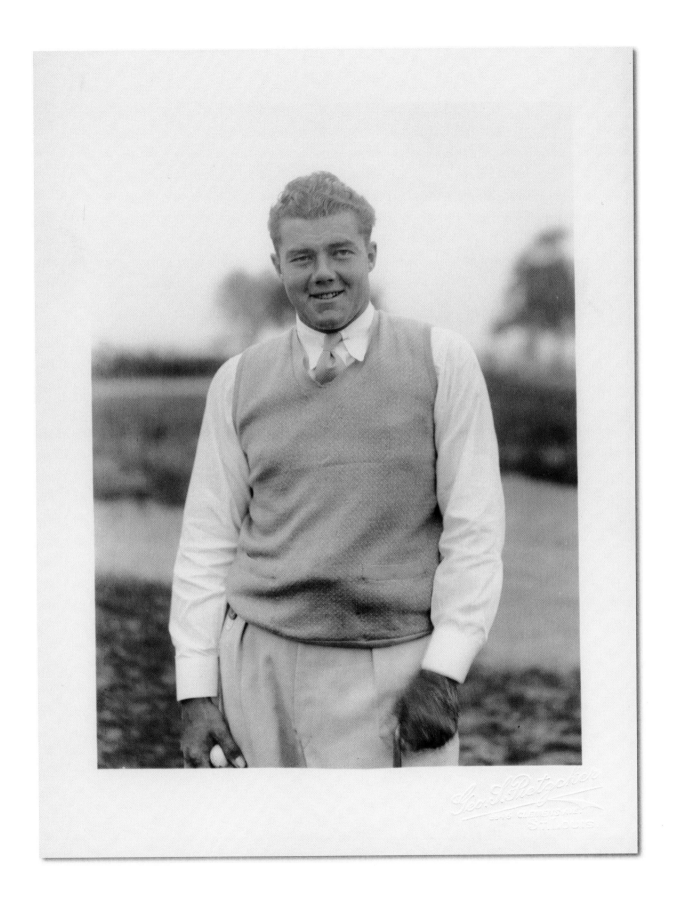

Don Moe

T HE 1930 WALKER CUP MATCHES WERE PLAYED AT ROYAL ST. GEORGE's Golf Club, a noble links hard by the sea in southeast England. The strong American side, captained by Bob Jones, secured a solid lead in foursomes play on the opening day. And although the final result was never in doubt—the Americans routed the British 10-2—the singles matches on the second day included one of the most memorable battles in Walker Cup history.

In the seventh of eight singles matches, Don Moe, the youngest player on the American team, squared off against Bill Stout, the 1928 English Amateur champion. Outdriven and outplayed by Stout, Moe finished the morning round 4 down. Despite an attempt by Jones to rally the youngster over lunch, Moe promptly lost the first three holes of the afternoon. "I can still remember the mental kicking I gave myself," Moe recalled later in his life, "saying 'Here I have come 7,000 miles and I'm now 7 down.'" Incredibly, with the aid of several birdies, Moe won seven of the next nine holes. Through 30 holes, he had drawn level with Stout. Francis Ouimet, who had just fallen in his contest with Tony Torrance, dropped back to watch the match behind. "I could not believe the match was even," Ouimet later wrote in his autobiography. "I knew Moe was 4 down in the morning, and when Stout started three, three, three after luncheon, he had run his lead to 7 up. What had happened?"

Moe had completed his heroic comeback, emerging with a 1-up victory. Playing inspired golf, Moe and Stout halved three of the next five holes and came to the final hole all square. The closing hole at Sandwich is a stern test, 460 yards played into the prevailing wind. Few players could reach the green in two, even with two well-played strokes. Moe selected a 2-iron for his second and executed the stroke perfectly. The ball carried all the way to the green, directly on line with the flagstick. It took one hop, rolled just past the hole, and stopped three feet away. "Never have I seen a more wonderful iron shot in my life," Ouimet recalled, "taking into consideration the tenseness of the competition and what it meant." Moe had completed his heroic comeback, emerging with a 1-up victory. As the players changed shoes in the locker room at the end of the day, Stout sat quietly in meditation. He then stood up, walked over to Moe, and said, "Donald, that was not golf, that was a visitation from God."

A native of Portland, Oregon, Moe was one of the outstanding amateurs in the Pacific Northwest in the 1920s and 1930s. He claimed the Western Amateur in 1929 and 1931, the first when he was just 19 years old. He won the Oregon Amateur in 1928 and 1937, and reached the final of the Pacific Northwest Amateur in 1928, 1937, and 1938. Moe was named to the Walker Cup team a second time in 1932, where he partnered with Bill Howell for a 5-and-4 victory over Eric Fiddian and Eric McRuvie.

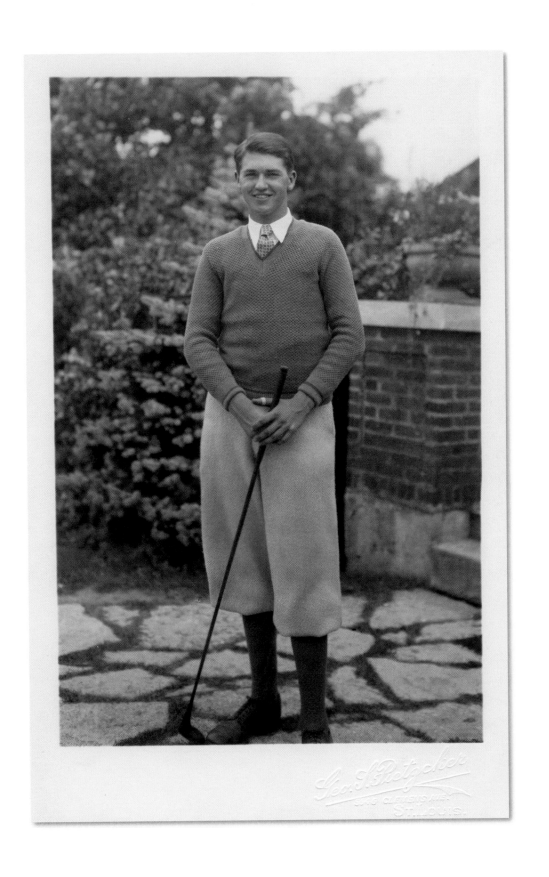

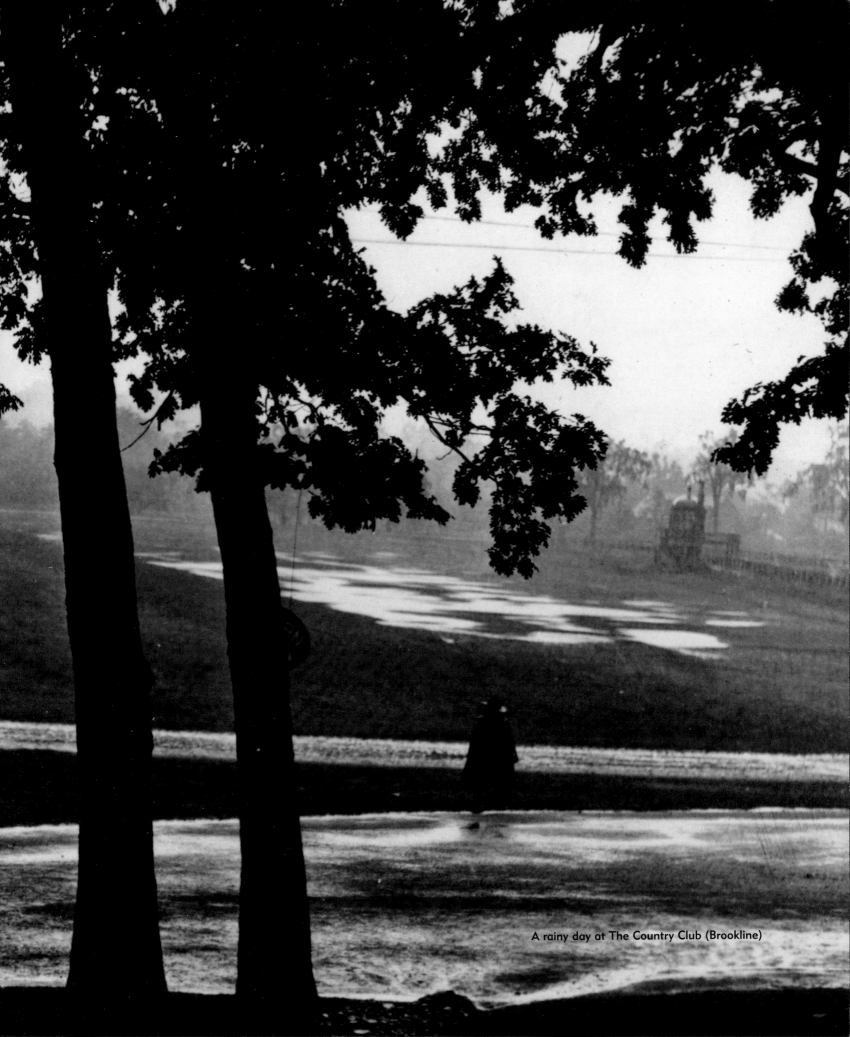

A rainy day at The Country Club (Brookline)

Henry Picard

ENRY PICARD WAS PLAYING GOLF AT THE SAVANNAH COUNTRY CLUB one day in 1930 when a ball bounded onto the ninth green and ran through his legs. The ball belonged to Bob Jones, who apologized profusely to Picard. As the next few holes ran parallel to one another, Jones continued to venture over to express his regret. But it was not the sentiment that impressed Picard. It was the fact that it had been Jones's second shot to the 540-yard par five. "Mr. Jones, what time do you start tomorrow?" Picard eventually asked. "I want to see you play because I didn't think anyone could hit a ball as far as you did there on nine."

The following day Picard watched Jones rifle a three-wood to the green at the par-four second hole. "I started studying his swing," Picard later recalled, "and the more I looked at it, I could see it was big and long. So I made up my mind that I would have a long swing, too." Over the next five years, with Jones as his model, Picard transformed an already solid swing into one of the most graceful swings in the game. This new swing ultimately propelled him to the pinnacle of professional golf.

Henry Picard was born in Plymouth, Massachusetts, in 1907. He was introduced to golf first as a caddie, then as the clubhouse steward at the Plymouth Country Club. Granted the privilege to play the course after hours, Picard developed his game until he was able to score consistently in the low 70s. The club professional, Donald Vinton, invited Picard to go south with him for the winter to Charleston, South Carolina. A few years later, Picard replaced Vinton as the club professional year-round.

Picard's first significant victory came in 1934 at the North and South Open. In 1935 he moved from Charleston to Hershey, Pennsylvania, and almost overnight became a superstar. The "Chocolate Soldier," as he came to be known, won five tournaments that year. Picard won his first major in 1938, shooting rounds of 71-72-72-70 to claim the Masters by two strokes over Harry Cooper and Ralph Guldahl. The following year he won the PGA Championship, defeating Byron Nelson with a birdie at the 37th hole after hitting his drive under a radio broadcast truck.

Picard collected 26 official victories during his career, but his most lasting impact on the game extended to two young professionals who would themselves become legends. It was Picard who gave Sam Snead the driver that transformed his chronic hook into one of the straightest drives in the game. And it was Picard, in 1937, who offered financial support to a discouraged and near-penniless young professional named Ben Hogan, providing Hogan the security and confidence he needed to remain on tour.

By 1940 Picard was through with tournament golf and left the tour to spend more time with his wife and four children. "I thought there were other things in life besides golf," Picard once said, "and I still think the same way."

Charlie Seaver

B UT FOR THE 18TH HOLE AT MERION, CHARLIE SEAVER would have been the last player with a chance to stop Bob Jones and his quest for the Grand Slam. Just 19 years old, yet one of the longest hitters in the field, the broad-shouldered, blond-thatched Californian (by way of Kansas City) had already made a mark on the 1930 U.S. Amateur championship by advancing to the semifinal round. There, Seaver squared off against Eugene Homans in what many observers called the most compelling match of the championship.

Seaver dominated the morning play, and went to lunch with a 5-up lead. With some spirited play of his own, Homans went out in 36 in the afternoon. By the time they reached the final hole the match was all square. Under intense pressure, Seaver hooked his drive into the trees, then pulled his approach into the greenside rough. When he failed to get up and down to equal Homans's par, Seaver fell one hole shy of the opportunity to face Jones in the historic final match. "I really wanted to play Bobby," Seaver recalled later in life. "I had an opportunity to play him many times, but the one time when I wanted to the most, I didn't make it."

Seaver's success in the 1930 U.S. Amateur came as little surprise to those who knew him, for he came from fine golfing stock. His father, Everett, was an accomplished golfer, having won the 1908 Trans-Mississippi Amateur and the 1920 Southern California Amateur. He had introduced young Charlie to the game at the age of six. In 1926 Charlie captured the Southern California Junior Amateur and in 1929 he qualified for his first U.S. Amateur.

Fortunately for Seaver, the loss to Homans in the 1930 Amateur was simply a forerunner of greater things to come. In January 1931 he enrolled at Stanford University, where he emerged as a star on the golf team that also featured Lawson Little. He was co-medalist in the 1931 U.S. Amateur at Beverly Country Club near Chicago, but lost in the first round. He then captured the Northern California Amateur in 1932, the California Amateur and Northern California Amateur in 1933, and the Southern California Amateur in 1934.

Yet it was the 1932 Walker Cup at The Country Club that long remained Seaver's most enduring memory. On the first day of the matches, he teamed with Gus Moreland in foursomes play for a decisive 6-and-5 victory over Tony Torrance and John De Forest. The following day he recorded an even more impressive victory, 7 and 6, over Eric Fiddian, the English Amateur champion. Later in life, Seaver would identify his success at Brookline as the most important accomplishment in his career.

In 1934, with his family forced into bankruptcy by the Great Depression, Charlie Seaver dropped out of Stanford, effectively ending his competitive golf career. He took a job in the oil fields around Bakersfield to support his wife and four children, among then a son, Tom, who would later become one of the greatest pitchers in the history of professional baseball.

Denny Shute

———

T HE 1933 RYDER CUP WAS PLAYED AT SOUTHPORT AND AINSDALE, a fine links course on the west coast of England. The British side secured a one-point lead in foursomes play, before the teams faced off in 36-hole singles matches on the second day. The penultimate match featured a little known English professional, Syd Easterbrook, and his American rival, Denny Shute, the runner-up in the 1931 PGA Championship. An epic struggle developed in the morning round, continuing into the afternoon as neither player gained a significant advantage. With the overall score tied at 5 points each, Easterbrook and Shute became the last pair out on the course. Their match would decide the Ryder Cup.

Easterbrook squared the match with a 15-foot birdie putt at the 15th, they halved the 16th and 17th, and came to the final tee all square. Under considerable pressure, both players hooked their drives into fairway bunkers. Shute played first, from one pot bunker to a second pot bunker left of the green. Easterbrook played a safer shot, leaving his ball in the fairway short of the green. Both played solid third shots to 20 feet. Easterbrook, playing first, lagged his putt to within three feet. With one putt to win and two for a tie—which would have resulted in the Americans retaining the cup—Shute charged his first putt six feet past the hole. Needing to hole his second putt for the tie, Shute again missed. Easterbrook didn't, and the Ryder Cup went to the British.

Bitterly disappointed but not defeated, Shute remained in Britain to play in the Open Championship at the Old Course in St. Andrews. Playing remarkably steady golf, Shute matched par of 73 in all four rounds, and finished in a tie with fellow American Craig Wood. In the first all-American playoff for the esteemed Claret Jug, Shute defeated Wood over 36 holes, 149 to 154, to claim his first major championship title. In a two-week span, Denny Shute three putted to lose the Ryder Cup, then triumphed in the oldest championship in professional golf. Golf can be a fickle game.

Born in Cleveland, Ohio, in 1904, Densmore Herman Shute took up golf at the age of three. He was the son of an English golf professional and enjoyed considerable success as an amateur, with victories in the West Virginia and Ohio Amateurs. Inspired by the success of Walter Hagen and Gene Sarazen, he turned professional in 1928. In 1929 he captured the Ohio Open, his first victory on the professional tour. Shute won his first PGA Championship at Pinehurst in 1936, and successfully defended his title the following year at the Pittsburgh Field Club with a victory over Jug McSpaden.

Horton Smith

T HE INAUGURAL SAVANNAH OPEN GOLF CHAMPIONSHIP was played in late February, 1930. The tournament boasted an impressive field, including Bob Jones and Horton Smith, respectively the leading amateur and professional of the day. Jones, who had collected three U.S. Open, two British Open, and four U.S. Amateur titles to this point in his career, was embarking upon a landmark year in which he sought to win golf's four major championships. Smith, a 21-year-old professional from Springfield, Missouri, was coming off a spectacular season in which he won eight times and finished runner-up six times in 22 PGA events.

By some fortunate circumstance—neither could recall who had initiated the plan—Smith and Jones shared a hotel room the week of the tournament. It was, in the words of Jones, "the beginning of a long and close friendship. We had a lot of fun talking golf, practicing swings, and exchanging pointers in the room and going to the movies in the evening after dinner." Not surprisingly, the tournament developed into a keen duel between the two friends. In the first round Jones stepped out and established a new course record of 67, while Smith opened with a 71. The second round belonged to Smith, who lowered Jones's record with a 66 of his own. The Atlanta lawyer posted a 75, largely due to a 7 on the second hole where he found trouble with a tree. To the delight of the large gallery, the pyrotechnics continued in the third round, as Jones lowered the course record once again, now 65. Entering the final round, the two were deadlocked. The tournament would be decided on the final two holes. Jones, a few groups ahead of Smith, played an aggressive second at the par-5 17th, but hooked his approach out of bounds and wound up with a six. After Jones birdied the final hole, Smith needed two pars for the victory. He succeeded, and won by a single stroke, 278 to 279.

The Savannah Open was the last time Jones would lose before his historic Grand Slam run. Just a few weeks later Jones roared back and defeated Smith by 13 strokes to win the Southeastern Open. In May Jones was in Britain, and his quest was underway. That summer Smith would finish third in the British Open, five strokes behind Jones, and third in the U.S. Open, again five strokes back of Jones. Curiously enough, Smith would be the first player to defeat Jones after the Grand Slam. In 1934 Jones emerged from his retirement to play in the inaugural Augusta National Invitational Tournament (later called the Masters). Smith defeated Craig Wood by a single stroke, while Jones finished tied for 13th ten strokes back.

In 13 years on the professional tour, "The Joplin Ghost" claimed 32 official victories, including two majors (he also won the 1936 Masters). Known for his sound, simple swing and superior putting, Smith was one of the first players to excel with the steel shaft. In 1961 he received the Ben Hogan Award for his courageous fight against Hodgkin's disease.

Ross Somerville

HEN THE U.S. AMATEUR CAME TO THE FIVE FARMS COURSE at Baltimore Country Club in 1932, the pundits issued their usual predictions. Bob Jones, two years retired from competitive golf, had his favorite. "There is the best shotmaker in the field," Jones remarked, looking over a list of competitors. "Somerville has a bite on his long irons that makes the ball stick fast. He is the crispest iron player to come up among the amateurs since Chick Evans emerged from the caddie shack." So confident was Jones that he backed up his opinion with a substantial wager.

Charles Ross Somerville, better known to his friends as "Sandy," was born in London, Ontario, Canada, in 1903. He was introduced to golf at the age of seven, but it was more than ten years before he took to the game enthusiastically. His first passions were cricket, football, and, true to his Canadian roots, hockey. Somerville was a first-class batsman, who for many years held the record score for a school cricketer in Canada—212 not out. He toured England as a member of a select team, and in 1921 played in the last international cricket match between Canada and the United States. He was also widely regarded as one of the finest amateur hockey players in Canada.

But it was golf that brought Somerville his highest accolades. In 1926 he won the Manitoba Amateur. The following year he won his first of four Ontario Amateur titles. Most important, he captured the Canadian Amateur six times between 1926 and 1937.

Jones's prediction in 1932 was no accident, for he had faced Somerville in the first round of match play in the 1930 U.S. Amateur at Merion. "Ross Somerville was at that time probably the least-appreciated amateur golfer in the world," Jones noted, "but those of us who played with him had no doubt about the effectiveness or soundness of his compact and very beautiful and regular method." Playing the seventh hole, both players reached the green in regulation. Jones putted first and made his birdie, but Somerville missed. It was, for Jones, the turning point in the match. "I have always looked upon it as the break that made the Grand Slam possible," Jones wrote. "Had I missed my 8-footer Sandy probably would have sunk his 7-footer and the tide of play might have gone the other way."

At Baltimore, however, Somerville would find greater success. He advanced through the match-play bracket with impressive victories. His opponent in the final was Johnny Goodman, the Omaha sensation who had knocked out Bob Jones in the first round at Pebble Beach in 1929. Through 27 holes Goodman held a 2-up lead, but Somerville rallied bravely through the final holes. When Somerville struck a solid approach to 15 feet at the par-3 17th, he secured a 2-and-1 victory. Sandy Somerville became the first Canadian, and the first foreign player since Harold Hilton in 1911, to capture the U.S. Amateur. And Jones, who refereed the match, pocketed $180 on his prediction.

Craig Wood

C RAIG WOOD WAS THE FINEST GOLFER EVER TO COME OUT of the Adirondacks. Born in 1901 in the village of Lake Placid, Charles Ralph Wood (he changed his name later in life when he turned professional) was the son of a legendary forester. His father, Charles, stood six feet eight inches tall, weighed some 275 pounds, and was widely considered one of the strongest men to have ever lived in the Adirondacks. During their childhood years, Craig and his brothers frequently accompanied their father to chop trees and split firewood. Their father trained them to maintain their balance and fix their eyes on the target while swinging an axe—a simple lesson that would serve Craig throughout his professional life.

Although Lake Placid is better known as a home for winter sports—it hosted the Olympic Games in 1932 and 1980—in the late 1890s it emerged as a fashionable summer destination. With no fewer than seven golf courses, it was also one of the largest golf resorts in the world. Some of the game's leading instructors—including John Duncan Dunn, the pro at the Stevens Hotel, and his brother Seymour, director of golf at the Lake Placid Club—were brought in to serve the summer guests. There was also considerable demand for caddies, and Wood took to caddieing at an early age. His passion for the game developed along with his skills, so much that Craig and his older brother, Scott, constructed a small course on the family farm.

Unlike many caddies who rose through the ranks to become golf professionals, Wood came from a well-to-do family and was well-educated. His parents sent him to private school in Massachusetts, then on to Clarkson College. Recognizing that the long winters in upstate New York shortened the golf season, Wood transferred to Ryder College in New Jersey to complete his studies. He accepted his first position as a professional in Winchester, Kentucky, and won the Kentucky Open in 1925. After returning to New Jersey in 1927, his game flourished and he emerged as one of the leading professionals in America.

Known for his good looks and style, the "Blond Bomber" won many tournaments in the early 1930s. But his reputation centered on his inability to claim a major title. On his first visit to Britain in 1933, he tied for first in the British Open at St. Andrews but lost the playoff to Denny Shute. In the 1934 PGA Championship, he advanced to the final against his own pupil, Paul Runyan, but missed putts on the 36th and 37th holes to lose the title. He was runner-up to Horton Smith at the first Masters in 1934, and runner-up again in 1935 when Gene Sarazen holed his miracle double eagle on the 15th hole in the final round. Then, in 1939, Wood lost a playoff for the U.S. Open after tieing with Byron Nelson and Denny Shute.

His efforts finally paid off in 1941, when he won the Masters, and two months later defeated his nemesis, Shute, in the U.S. Open at Colonial Country Club.

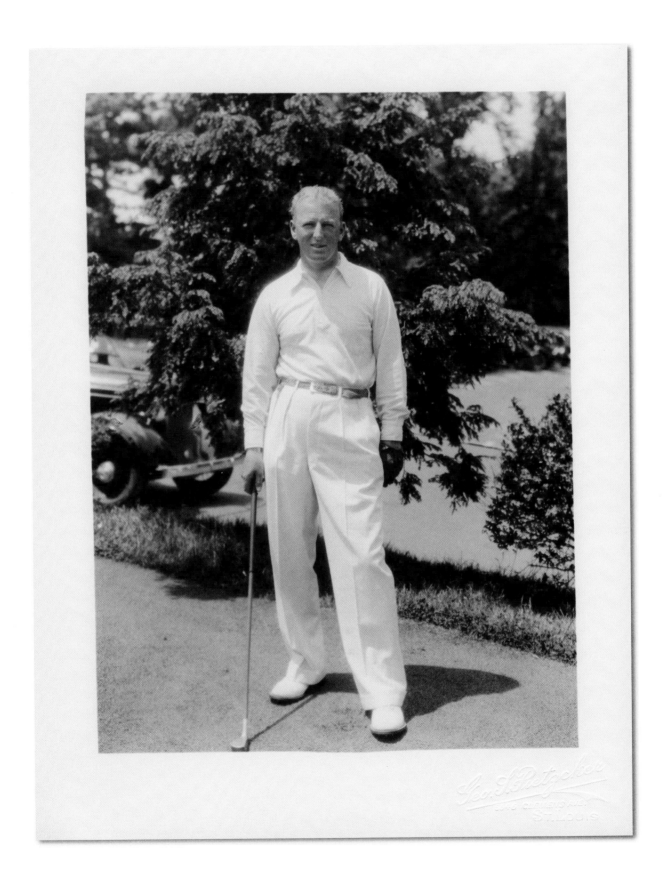

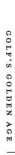

Bob Jones: USGA Patron Saint

Bob Jones may be the closest thing the USGA has to a patron saint. You can't be at the USGA's headquarters, Golf House, long without seeing his image or reading a story about him. In fact, the most elegant and impressive room on the Golf House campus is the Bob Jones Room in the USGA Museum. This room's high ceilings, marble fireplace, and wood paneling accent a square area with displays of medals, portraits, and a putter that belonged to Jones. The ambiance of this room is reminiscent of a place of worship; visitors automatically slow their steps and lower their voices when they enter. When one needs a quiet spot to read and reflect upon matters of importance, there are few places that equal it.

The centerpiece of the USGA's Annual Meeting remains the presentation of the Association's highest honor, the Bob Jones Award. Since 1955, it is given annually in recognition of distinguished sportsmanship. The award seeks to recognize a person who emulates Jones's spirit, personal qualities, and attitude toward the game and its players. And it is coveted by those who recognize what it means to be linked forever to the name of Bob Jones.

Just how did Bob Jones become the USGA's patron saint? Bob Jones's march to this status, in my mind, started in earnest at the 1925 U.S. Open, played at Worcester Country Club in Worcester, Massachusetts. Jones was far from a novice U.S. Open competitor by this time. He had competed since 1920 and finished tied for second with another amateur, John L. Black, one stroke behind Gene Sarazen in the 1922 U.S. Open played at Skokie Country Club in Glencoe, Illinois. The following year Jones captured the first of his four Open championships by two strokes in a playoff over Bobby Cruickshank at Inwood Country Club on Long Island. Thus, at age 21, Bob Jones became the victor in his nation's championship.

The 1924 U.S. Open headed west to Oakland Hills Country Club, located in the suburbs of Detroit. Jones again finished as runner-up, three strokes back of Cyril Walker. So when he arrived at the 1925 Open in Worcester, Jones had experienced more agony than ecstasy in his Open career. That agony would only grow with another runner-up finish to Willie Macfarlane. They both recorded scores of 291 during the four rounds. They proceeded to match rounds of 75 during an 18-hole playoff. Macfarlane eventually bested Jones by a single stroke, 72 to 73, in a second 18-hole playoff that same afternoon. But a story lay behind the results of this Open championship. And it forever stamped Bob Jones as a man of integrity with an abiding respect for the game's Rules.

Jones opened with a disappointing round of 77 at the demanding Worcester layout. How his score came to be 77 rather than 76 tells the tale. During his round, his approach shot to the elevated 11th green fell short. The ball settled in deep grass on a steep embankment. After taking his stance, his clubhead brushed the grass and, according to Jones, moved the ball. I emphasize the words "according to Jones" because no one else saw it happen. But Jones promptly informed his fellow competitor, Walter Hagen, and a USGA official that he had violated Rule 12 (4) found on page 18 of the 1925 "USGA Rules of Golf" booklet prohibiting moving a ball at rest after address (the current version is Rule 18-2b on page 52 in the 2004 USGA Rules of Golf). He assessed himself the required one-stroke penalty. Jones, after the round, signed his score card for a 77.

News spread about Jones's assessment of a penalty stroke for a violation that no one else had witnessed. Praise flowed from many quarters in testament to his inherent honesty and respect for the Rules. Jones scoffed at such a notion. "You'd as well praise me for not breaking into banks," he said. At the time, the matter looked as though it would prove a fleeting but soon-to-be forgotten matter of honor because of his first-round score of 77. But Jones put back-to-back rounds of 70 together with a final round of 74 for a 291. The penalty stroke had cost him his second U.S. Open championship because without it, there would have been no need for a playoff. He would have prevailed by a stroke. His decision to penalize himself made Jones runner-up for the third time in four years.

His regard for strict adherence to the Rules of Golf never flagged throughout his life. In his book, *Golf Is My Game*, published in 1960, Jones featured a section entitled "Respect the Rules and Etiquette of the Game". He wrote: "It is of the very essence of golf that it should be played in a completely sociable atmosphere conducive to the utmost in courtesy and consideration of one player for the others, and upon the very highest level in matters of sportsmanship, observance of the rules, and fair play."

Bob Jones, of course, moved on from the 1925 Open to achieve an astounding competitive record by the start of the next decade. He won three more Opens in 1926, 1929, and 1930. Only three other players—Willie Anderson, Ben Hogan, and Jack Nicklaus—have won the U.S. Open four times. In fact, from 1922 to 1930, Jones finished as either champion or runner-up of every U.S. Open except the 1927 competition played at Oakmont Country Club won by Tommy Armour in a playoff over Harry Cooper.

Jones's respect for the U.S. Open and the challenge it offered was heartfelt. He would, years later, send the USGA a quote for use in a championship program published in conjunction with the 1967 U.S. Open at Baltusrol Golf Club in New Jersey. This passage summarized his sentiments honed over many years of experience of the national championship. "The Open Championship inevitably must be the primary goal of every golfer who becomes seriously interested in competitive play," Jones wrote. "No matter how many successes one may enjoy in other events, it is always the Open that is regarded by the player as the ultimate in accomplishment."

His achievements, however, weren't limited to the U.S. Open. Jones also captured five U.S. Amateur titles in 1924, 1925, 1927, 1928, and 1930. Nearly three-quarters of a century after his final U.S. Amateur victory, this total remains an all-time record for this event. He played on five U.S.A. Walker Cup teams in 1922, 1924, 1926, 1928, and 1930. He also served as playing captain of the 1928 and 1930 squad. His record in foursomes during Walker Cup Matches ended at 4-1, while his singles record was an unblemished 5-0. And when the USGA worked with its counterparts from the Royal and Ancient Golf Club of St. Andrews to create the World Amateur Team Championship in 1958, Jones captained the inaugural U.S.A. team.

While nearly any year during the 1920s contained noteworthy stories about Jones's competitive achievements, he reached his zenith in 1930. In those days, the U.S. Open, U.S. Amateur, British Open, and British Amateur were considered the four most important competitions in golf. Travel logistics alone made it difficult to compete in, never mind win, all four in the same calendar season. Jones, to say the least, played steady golf during that summer of 1930 and won one title after another. By the time he reached Merion Cricket Club near Philadelphia, site of the 1930 U.S. Amateur, he stood on the threshold of capturing all four and completing the coveted Grand Slam. Jones defeated Gene Homans by a decisive 8-and-7 score in the final match to become the only

player to win all four events in the same calendar year. The Masters and the PGA Championship, in subsequent years, have replaced the U.S. Amateur and the British Amateur as milestones in the modern Grand Slam. And although players such as Ben Hogan and Tiger Woods have won three in the same calendar year, no one has matched Jones.

Probably the best way to summarize Bob Jones's record as a player in USGA championships is to consult the association's all-time record book. Jones, as demonstrated previously, won a total of nine USGA championships by the end of 1930. These many decades later, only three players—JoAnne Gunderson Carner, Jack Nicklaus, and Tiger Woods—have won as many as eight. Thus, while Woods may one day catch or pass him, Jones still stands alone at the pinnacle of USGA competitive achievement.

The Grand Slam became particularly noteworthy, in retrospect, because Jones soon thereafter announced his retirement from competitive play at age 28. Jones had always competed in golf as an amateur. He had always maintained interests and personal goals outside of the game. He wished to concentrate upon his Atlanta law practice as well as pursue some of these other interests. One of them entailed a lucrative series of golf instruction films that he had agreed to make for Warner Brothers Pictures. On November 17, 1930, USGA Vice President H.H. Ramsay released a statement on Jones's behalf—a seeming oddity until you realize that Jones served on the USGA's Executive Committee from 1928-1930. Those who knew Jones personally marveled at his facility with language, written and spoken. His retirement statement reflected Jones's customary meticulous care in its structure, wording, and emphasis.

"Upon the close of the 1930 golf season I determined immediately that I would withdraw entirely from golfing competition of a serious nature. Fourteen years of intense tournament play in this country and abroad had given me all I wanted in the way of hard work in the game. I had reached a point where I felt that my profession required more of my

Bob Jones drives from the first tee at The Country Club (Brookline) in the 1922 U.S. Amateur.

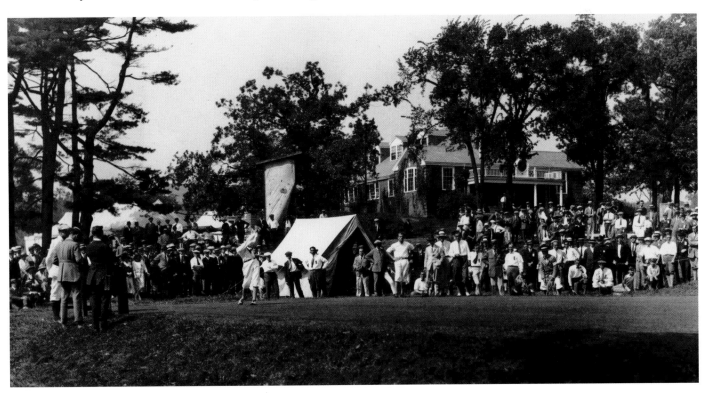

time and effort, leaving golf in its proper place, a means of obtaining recreation and enjoyment....The amateur status problem is one of the most serious with which the United States Golf association has to deal for the good of the game as a whole. I am not certain that the step I am taking is in a strict sense a violation of the amateur rule. I think a lot may be said on either side. But I am so far convinced that it is contrary to the spirit of amateurism that I am prepared to accept and even endorse a ruling that it is an infringement. I have chosen to play as an amateur, not because I have regarded honest professionalism as discreditable but simply because I have had other ambitions in life. So long as I played as an amateur there could be no question of subterfuge or concealment. The rules of the game, whatever they were, I have respected, sometimes even beyond the letter. I certainly shall never become a professional golfer. But, since I am no longer a competitor, I feel free to act entirely outside the amateur rule, as my judgment and conscience may decide."

Thus, Jones had departed the golf stage at the height of his popularity and powers. Contrast this decision with those of so many other prominent athletes who hang on past their prime, struggling to recapture talents and triumphs that have permanently passed them by. Youngsters, mercifully, would never be subjected to watching an aging Bob Jones struggle in competitive play while being told that he was once the greatest. Jones, in contrast, would always maintain the aura of perpetual greatness on the golf course in the public's mind.

His appreciation of and regard for amateurism never wavered. The USGA Senior Amateur Championship was played at Atlanta Country Club in September 1968. Jones accepted an invitation to speak at the players' dinner the evening before play started. His remarks included this passage:

"There seems to be little appreciation today that golf is an amateur game, developed and supported by those who love to play it. Amateurs have built the great golf courses where the playing professionals play for so much money; amateurs maintain the clubs and public links organizations that provide jobs for the working professionals; amateurs spend millions of dollars each year on golf equipment and clothing; and amateurs rule and administer the game on both sides of the Atlantic. In this way, golf has prospered for centuries. It would appear to be the best possible arrangement."

Tennis star Bill Tilden, during the 1920s, continually feuded with the governing body of his sport, the United States Lawn Tennis association. Scores of prominent athletes since then have locked horns with presiding officials of their respective sports. Bob Jones, in contrast, had a positive relationship with the USGA. Why?

Perhaps the answer lies in the eerie degree of unanimity of viewpoint between the USGA and Jones regarding the main responsibilities of golf's governing body. The USGA came into being at the tail end of 1894 during a December dinner at New York City's Calumet Club. Representatives of five golf clubs had gathered there that cold evening. Their purpose was to create a national governing body for the game. This governing body was charged with three specific tasks: write uniform Rules for the game; conduct national championships; and formulate the Code of Amateur Status. And although it has added several national championships and garnered other responsibilities during the next century of its existence, these three core functions still lie at the heart of the association.

Contrast that USGA charter with the views of Bob Jones. He was a strong adherent— some would say stickler—regarding the Rules of Golf. His competitive record in USGA national championships, and his respect for the degree of challenge they represented, was unparalleled. And he revered the concept of amateurism to such a degree that he took the USGA off the perilous hook of having to rule at the height of his popularity whether or not his film contract with

Warner Brothers violated the Code of Amateur Status. A breach of amateur status in spirit was as good as a breach in practice to Jones. The USGA and Bob Jones, therefore, remained on good terms because they were always, in modern parlance, "on the same page."

Jones held varied positions of influence— formal and informal— within the association during his lifetime. As mentioned previously, he served on the USGA Executive committee for three years. Once again, his writings provide a prism through which to glean his conclusions about this experience.

"The executive committee of the USGA is composed of men who have been interested in golf all of their lives. They are men of intelligence and of mature and sound judgment. The service which they render by directing to the best of their ability the destinies of the game is one which they perform disinterestedly and at great personal sacrifice. There is not one of these men who would permit a thing to be done which had not been considered carefully and judged to be the proper thing and for the best interests of the game."

When the 1948 U.S. Amateur Public Links Championship came to Atlanta's North Fulton Park Golf Course, Jones served as honorary chairman of the event. His most steadfast USGA service came through the association's Museum Committee. Jones served on this Committee from 1937 until his death. He took his responsibilities as a committee volunteer to heart. His personal museum donations rank among the most important ever received. His correspondence to the USGA concerning donation of his artifacts reflects an innate modesty.

He first sent his famed putter, Calamity Jane II, to Golf House, located at the time in New York City at 40 East 38th Street. Jones disclosed only that he had used the putter regularly from 1924 through 1930. In fact, he used it to win eight of his nine USGA national championships; only the 1923 Open was exempt.

Next, he donated an oil painting of himself by respected artist Thomas E. Stephens. It had been commissioned by a group of 99 members of Augusta National Golf Club in Augusta, Georgia, annual site of the Masters Tournament. Jones had played the most important and prominent role in founding both Augusta National and the Masters. An interested observer sent a letter that was read by USGA President Totton P. Heffelfinger upon the unveiling of the portrait at Golf House immediately following the association's 1953 annual meeting.

"You all must be proud as I am to have Bob's portrait hanging in Golf House. Those who have been fortunate enough to know him realize that his fame as a golfer is transcended by his inestimable qualities as a human being. Bob's contribution to our great game is reflected by its deserved prominence in the field of sports. But his gifts to his friends are the warmth that comes from unselfishness, superb judgment, nobility of character, unwavering loyalty to principle.

"Thank you for giving me this opportunity to pay a small tribute to such a fine American." (signed) Dwight D. Eisenhower, President of the United States.

Finally, in July 1967, Jones wrote to Joe Dey, the USGA's longtime executive director. "Would you like to have my medal collection for Golf House museum?" Jones inquired. Dey immediately replied in the affirmative. Jones, in turn, sent three dozen medals to the museum. Most were USGA medals for competitions conducted in the U.S. and abroad. Others honored Jones as a competitor in both the British Open and British Amateur. Only one medal was not issued by a golf organization. Jones received this medal, called the James E. Sullivan Award, in 1930 from the Amateur Athletic Union. It recognizes remarkable accomplishment by an amateur athlete. Jones was the first golfer to receive the Sullivan Award. Lawson Little is the only other golfer ever to receive one.

All these medals moved with the USGA from New York City to Far Hills when the Association relocated its headquarters in the early 1970s. They represent the heart and soul of that shrine described earlier

and known as the Bob Jones Room. This space, in many ways, represents the heart and soul of the USGA's museum. Only the moon club used by astronaut Alan Shepard on the lunar surface rivals the Jones artifacts in popularity among museum visitors.

Jones was not devoid of a sense of humor concerning his long, harmonious relationship with the USGA. Dey sent Jones a letter dated May 10, 1965. It said "in a purely academic sense," that Dey enclosed an application for reinstatement of amateur status. Since 1930, Jones had been classified as a non-amateur by the USGA. Jones played along with the joke and promptly completed the application and returned it. By this time in his life, a painful and debilitating disease called syringomyelia had taken its toll upon his body. He had long since ceased to play golf. In fact, he could barely hold a pen to write anymore. His penmanship on the application was faltering and barely legible. But the tone of his answers was clear and unmistakable.

On the line that read occupation, Jones wrote "assistant." Where it asked for an employer's name, he wrote "Clifford Roberts" (chairman of Augusta National). To the question that inquired "Without any mental reservations, have you decided permanently to abandon all activities contrary to the Rules of Amateur Status?" Jones retorted "I have no mental reservations about anything." Down further on the page, where he was asked to detail his status in the game, Jones replied "Now, really!" Finally, in the section that asked him to detail his violations of the amateur status code, Jones stated, "You name them."

Dey acknowledged receipt of the document at Golf House in a letter to Jones dated June 4, 1965. "We were delighted to receive your application for reinstatement to amateur status," Dey wrote. "It is by all odds the most engaging such document that has come our way. The Executive Committee will be asked to waive the usual probationary period. Some day, if you have no objection, it may find its way into what you once called my unexpurgated edition of some phases of golf history."

Perhaps the best way to conclude entails a personal experience with one Bob Jones Award recipient. My good friend Fred Brand, Jr. received the award in 1997. Fred was in his late 80s at the time; today, sadly, he is deceased. He graciously allowed me to tape an interview with him a few months after his receipt of the Jones Award for the USGA Museum's Oral History Series. The interview took place at Fred's country home called Carnoustie Acres located in Ligonier, Pennsylvania, a quaint resort town east of Pittsburgh. His home was called Carnoustie Acres because Fred's dad, a golf professional in Pittsburgh, had hailed from the famed Scottish golf town. Another golf professional from Carnoustie who came to the U.S. at the same time as Fred's dad was his good friend Stewart Maiden. Maiden took up residence in Atlanta. He became the head professional at East Lake Golf Club. His best student at the club was named Bob Jones. Through this Fred Brand Sr.-Stewart Maiden connection, Fred, Jr. came to know Bob Jones intimately. He may prove the last Jones Award recipient who did. During our interview, we covered many topics. Fred acknowledged that Bob Jones had become a sort of mythic figure in golf. But what kind of a person was he, really?

"Well, first he was always at the top of the ladder in my thinking," Brand stated. "Yet, when you got to meet him and talk with him, he made you feel that you were more than just so-and-so. He made you feel that you were an equal… So, when you met Bob Jones, he was simply the best. He was a most gracious individual."

Sounds like an apt description of a patron saint, doesn't it?

—MARTY PARKES

Winners of The USGA Bob Jones Award

1955: Francis Ouimet

1956: William C. Campbell

1957: Mildred D. Zaharias

1958: Margaret Curtis

1959: Findlay S. Douglas

1960: Charles Evans Jr.

1961: Joseph B. Carr

1962: Horton Smith

1963: Patty Berg

1964: Charles Coe

1965: Glenna Collett Vare

1966: Gary Player

1967: Richard S. Tufts

1968: Robert B. Dickson

1969: Gerald H. Micklem

1970: Roberto De Vicenzo

1971: Arnold Palmer

1972: Michael Bonallack

1973: Gene Littler

1974: Byron Nelson

1975: Jack Nicklaus

1976: Ben Hogan

1977: Joseph C. Dey Jr.

1978: Bing Crosby and Bob Hope

1979: Tom Kite

1980: Charles Yates

1981: JoAnne Carner

1982: William J. Patton

1983: Maureen Ruttle Garrett

1984: R. Jay Sigel

1985: Fuzzy Zoeller

1986: Jess Sweetser

1987: Tom Watson

1988: Isaac B. Grainger

1989: Chi Chi Rodriguez

1990: Peggy Kirk Bell

1991: Ben Crenshaw

1992: Gene Sarazen

1993: P.J. Boatwright Jr.

1994: Lewis Oehmig

1995: Herbert Warren Wind

1996: Betsy Rawls

1997: Fred Brand Jr.

1998: Nancy Lopez

1999: Edgar Updegraff

2000: Barbara McIntire

2001: Thomas Cousins

2002: Judy Rankin

2003: Carol Semple Thompson

2004: Jackie Burke Jr.

2005: Nick Price

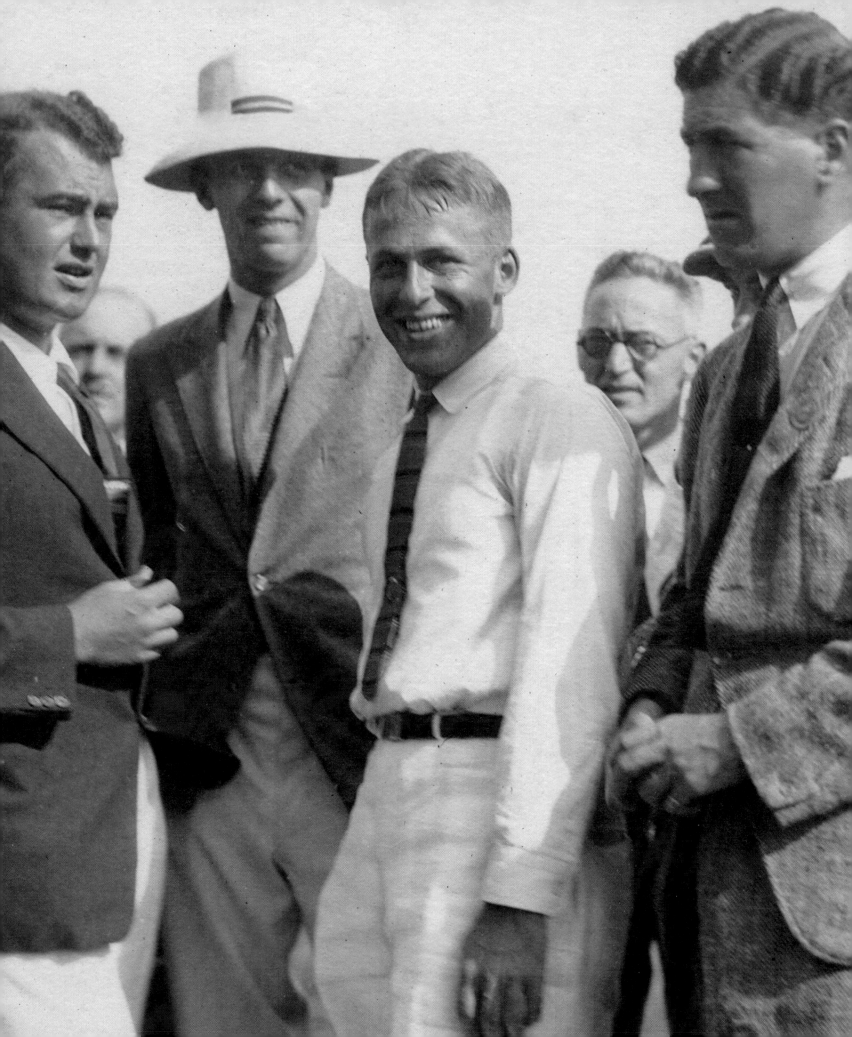

Acknowledgements

Many individuals contributed to the making of this special book. Without their participation, creativity, and enthusiasm, such a project would have been impossible. In particular, we would like to extend our gratitude to the staff of the USGA Archives—Cheryl Badini, Jessica Foster, Doug Stark, Nancy Stulack, and especially to Patty Moran for her tireless research skills. Others at the USGA who provided valuable counsel and assistance include Kim Barney, David Hayes, Beth Murrison, Becky Sandquist, and David Shefter.

For their valuable assistance, we would like to acknowledge several longtime friends of the USGA, including Pete Moss, professor emeritus from Colby College; Bob Sommers, the longtime editor of *Golf Journal*; Janice Powell, Librarian of the Marquand Library of Art and Archaeology at Princeton University; Audrey Moriarty of the Tufts Archives; and Mark Emerson. Special thanks must be extended to Bud Dufner, founder and editor of *Golfiana Magazine*. In 1993 Bud authored the first and only article written about George Pietzcker, resurrecting the memory of this forgotten artistic genius. Most of what we know today about Pietzcker's life and career was detailed for the first time in this story, and we extend our thanks to Bud for his kind permission to reprint several of the photographs used in this book.

This project would not have been possible without the support of the USGA Members Program. In his role as Chairman of the Members Program, Arnold Palmer has long served as an important advocate for the USGA, and we thank him for contributing the Foreword for this book; our thanks are extended as well to Doc Giffin, Mr. Palmer's long-time assistant, for his time and assistance. At the USGA's offices in Far Hills, Fiona Dolan and Marianne Gaudioso have provided valuable support in making this book available to our Members.

Finally, we would like to extend our thanks to the members of the USGA Executive Committee, as well as USGA Executive Director David Fay, for their support of the USGA Museum and its important mission.

Dedication

For their love and support through the years, we dedicate this book to our fathers—Alan Jerris, Ranford E. Glenn, Michael Normoyle, and Rick Parkes—the first golfers we ever met.

Photo Credits

All photographs courtesy of the United States Golf Association Archives except for pgs. 8 and 11, courtesy of *Golfiana Magazine*.

Golf's Golden Age

Rand Jerris

Director of the USGA Museum and Archives

Published by the National Geographic Society

John M. Fahey, Jr., *President and Chief Executive Officer*

Gilbert M. Grosvenor, *Chairman of the Board*

Nina D. Hoffman, *Executive Vice President*

Prepared by the Book Division

Kevin Mulroy, *Senior Vice President and Publisher*

Kristin Hanneman, *Illustrations Director*

Marianne R. Koszorus, *Design Director*

Rebecca Hinds, *Managing Editor*

Staff for this Book

Rebecca Lescaze, *Editor*

Eric Baker, *Art Director*

Rhonda Glenn, Manager of Communications, USGA;

David Normoyle, Coordinator of Education and Outreach, USGA;

and Marty Parkes, Sr. Director of Communications, USGA, *Contributing Writers*

Mike Heffner, *Illustrations Editor*

Gary R. Colbert, *Production Director*

Lewis R. Bassford, *Production Project Manager*

Rachel Sweeney, *Illustrations Coordinator*

Manufacturing and Quality Control

Christopher A. Liedel, *Chief Financial Officer*

Phillip L. Schlosser, *Managing Director*

John T. Dunn, *Technical Director*

Vincent P. Ryan, *Manager*

Clifton M. Brown, *Manager*

Library of Congress Cataloging-in-Publication Data

Jerris, Randon Matthew Newman, 1969-

　Golf's golden age : Robert T Jones, Jr. and the legendary players of the '10s, '20s, and '30s / Rand Jerris with photographs by George S. Pietzcker ; foreword by Arnold Palmer.

　　p. cm.

　ISBN 0-7922-3872-9 (reg.) —ISBN 0-7922-4182-7 (deluxe)

　1. Golfers—United States—Biography. 2. Golfers—United States—Portraits. 3. Golf—United States—History—20th century—Pictorial works. I. Pietzcker, George S., 1885-1971. II. United States Golf Association. III. Title.

GV964.A1J47 2005

796.352'092'2—dc22

{B}

　　　　　　　　　　　　　　　　　2005041534

One of the world's largest nonprofit scientific and educational organizations, the NATIONAL GEOGRAPHIC SOCIETY was founded in 1888 "for the increase and diffusion of geographic knowledge." Fulfilling this mission, the Society educates and inspires millions every day through its magazines, books, television programs, videos, maps and atlases, research grants, the National Geographic Bee, teacher workshops, and innovative classroom materials. The Society is supported through membership dues, charitable gifts, and income from the sale of its educational products. This support is vital to National Geographic's mission to increase global understanding and promote conservation of our planet through exploration, research, and education.

For more information, please call 1-800-NGS LINE (647-5463) or write to the following address:

NATIONAL GEOGRAPHIC SOCIETY

1145 17th Street N.W.

Washington, D.C. 20036-4688 U.S.A.

Visit the Society's Web site at www.nationalgeographic.com

THE UNITED STATES GOLF ASSOCIATION (USGA) has served as the national governing body of golf since its formation in 1894. It is a non-profit organization run by golfers for the benefit of golfers. The USGA remains committed to promoting policies and programs For the Good of the Game.

　The USGA undertakes successful activities that positively impact everyone who plays the game. The USGA writes the Rules of Golf; conducts national championships such as the U.S. Open; produces Rules of Amateur Status; funds turfgrass and environmental research; formulates a handicap system; maintains equipment standards; preserves golf's history; and ensures the game's future by awarding grants.

To find out more, please contact:

USGA, Golf House

77 Liberty Corner Road

P.O. Box 708

Far Hills, NJ 07931

(908)234-2300; FAX (908) 234-9687

www.usga.org.